PHILOSOPHIZING ART

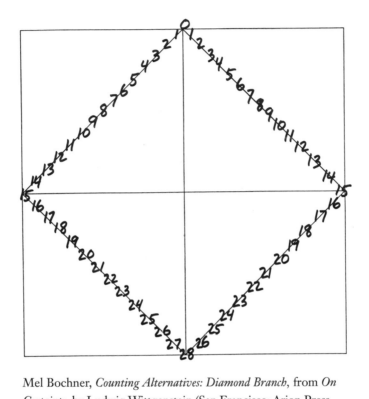

Mel Bochner, *Counting Alternatives: Diamond Branch*, from *On Certainty*, by Ludwig Wittgenstein (San Francisco: Arion Press, 1991).

PHILOSOPHIZING ART

SELECTED ESSAYS

ARTHUR C. DANTO

UNIVERSITY OF
CALIFORNIA
PRESS Berkeley / Los Angeles / London

University of California Press
Berkeley and Los Angeles, California

University of California Press, Ltd.
London, England

First Paperback Printing 2001

The epigraph to chapter 3 is from Thom Jones, "Mosqui-
toes," in *The Pugilist at Rest: Stories* (Boston: Little, Brown,
1993), 104.

Library of Congress Cataloging-in-Publication Data

Danto, Arthur Coleman, 1924–
 Philosophizing art : selected essays / Arthur C. Danto.
 p. cm.
 Includes bibliographical references and index.
 ISBN 0-520-22906-1 (pbk. : alk. paper)
 1. Art—Philosophy. I. Title.
N71.D33 1999
701—dc21 98-38834
 CIP

Printed in the United States of America

08 07 06 05 04 03 02 01
10 9 8 7 6 5 4 3 2 1

The paper used in this publication meets the minimum requirements of
ANSI/NISO Z39.48-1992 (R 1997) (*Permanence of Paper*). ∞

To Hans Belting

Contents

Preface

WHEN EDWARD DIMENDBERG invited me to submit a selection of essays to the University of California Press, I felt I wanted them to have some degree of unity beyond their individual merits. My thought was that the essays should fall into two groups: a set that addressed some aspects of the concept of representation—understood in the sense of *mental* representations—so to bring certain questions in philosophical psychology under a perspective afforded by the philosophy of art; and a set that addressed a number of artworks from the perspective of what they were attempting to represent, in a time when the classical assumptions of pictorial representation no longer held. Approaching the complex structure of what we might call "representational beings"—us—through certain analogies to works of art would at the very least, I thought, relax a bit the grip that a molecule-by-molecule agenda has for those who cultivate that field of speculation. For how far would one get as an art critic with a molecule-by-molecule account of a cubist painting? In any case, the two sets of essays would be united by a certain philosophical attitude that straddles two lines of thought not characteristically pursued in tandem. And the idea seemed entirely natural that they would be more or less evenly divided between two volumes.

This volume, then, presents an approach to art at once philosophical and concrete. It is concrete because, in each instance, the analysis addresses a specific body of work. It is philosophical in that, again in each instance, I attempt to bring to bear a piece of philosophical thought that serves as a principle of art criticism for the work in question. These are fairly extended pieces of writing, and they respond to fairly ambitious bodies of work that are, in my view, animated by philosophical intentions—never mind to what degree those intentions form part of the immediate intentions of the artists discussed.

"The 'Original Creative Principle': Motherwell and Psychic Automatism" was written for *Robert Motherwell on Paper.* Edited by David Rosand, the book accompanied the beautiful exhibition, curated by Rosand, of Motherwell's works on paper at the Wallach Art Gallery of Columbia University in February 1997. Motherwell was one of the rare artists to have had a genuine philosophical literacy, and "psychic automatism" served him as a principle of creativity as well as of critical understanding. It connected him to the surrealists, who provided the great artistic adventure of his life, but, as he would say, it also connected him to his self. The idea of the self that emerges is one I have sought to deal with in various essays, most particularly in "Symbolic Expressions and the Self," in *Beyond the Brillo Box* (New York: Farrar, Straus, & Giroux, 1992); and in the essay on the Jewish Museum in New York printed here (chapter 6).

"Art-in-Response" is an expression invented by the California artist, Robert Irwin, to characterize how his art was to be understood, once he decided to respond with art to demands and requests from those who wanted it. This guaranteed that his art would emerge out of life; and it meant that each of his works had to refer to a different occasion of demand with no a priori constraints on what it could look like. My essay, likewise titled "Art-in-Response," was written for the catalog to an exhibition of Irwin's work held at the Los Angeles Museum of Contemporary Art (LAMoCA) in 1993. Irwin is a great artist, but for reasons the essay attempts to make plain, it is not easy to get to know his work, par-

ticularly those parts of it which, as art-in-response, were never brought to completion.

My essay grew out of three memorable days of conversation with Irwin in San Diego. Richard Koshalek, the director of LAMoCA, told me that after I left Irwin phoned him in some apprehension: he worried that I had not taken a single note! But I saw how to write the essay flying back to New York, and had a draft of the first part finished by the time I landed.

I have written rather extensively on Andy Warhol, beginning with my first essay in the philosophy of art: "The Art World," published in the *Journal of Philosophy* in 1964. "The Philosopher as Andy Warhol" was invited by Tom Armstrong, then the director of the not-as-yet opened Andy Warhol Museum in Pittsburgh. Tom asked if I would locate Warhol in the history of art. For me, this meant making explicit the philosophical ideas his work seemed to me to embody. It is the fullest such statement I have made, though his contribution continues to stimulate me conceptually as well as artistically. The essay was printed in the museum publication that accompanied the unforgettable celebratory inaugural exhibition.

"Illustrating a Philosophical Text: Mel Bochner's Wittgenstein Drawings" was written for a beautiful edition of Wittgenstein's *On Certainty* published by the Arion Press in San Francisco, which produces works of literary merit in a format responsive to that merit. Each volume includes a set of images its director, Andrew Hoyem, commissions from artists. Having secured the right to print Wittgenstein's classic, it seemed entirely natural to ask Mel Bochner to create drawings to accompany the text. As I knew the text fairly well, I thought I could compose an introductory essay easily enough. But Bochner felt I ought by rights to address his drawings as well as what Wittgenstein wrote, since he saw them literally as illustrating the text. This raised the problem to which my title refers, namely, how is it possible to "illustrate" a philosophical text? Bochner is a pioneer conceptual artist, with a fair amount of

philosophical knowledge and an even larger amount of philosophical intuition, and I learned an immense amount from the discussions we had over the period in which I composed the essay. I hope someday to return to the beautiful question his drawings provoke regarding the relationship between abstract ideas and concrete images.

"Giotto and the Stench of Lazarus" was my first effort to write about a historical artist with a specific philosophical question in mind. How, I wanted to know, is a visual artist to represent the nonvisual qualities necessary to the action he is required to narrate? I found myself fascinated by the way Giotto brought olfactory data into his painting *The Raising of Lazarus*. I am grateful to my colleague, the art historian James Beck, for steering me toward the representations that give a tradition for Giotto's great image. The subject is a rich one, connecting psychology, representation, and the limits of picturability in a single complex.

"Postmodern Art and Concrete Selves: The Model of the Jewish Museum" was commissioned by the Jewish Museum in conjunction with the inaugural exhibition it held after the major renovations it underwent in 1993. The exhibition was made up of installations by eight major contemporary artists, all of them Jewish but with whose work the idea of Jewishness had not been associated. Each, however, agreed to touch on a Jewish theme in the new work. The concern with such an identity as Jewishness in artists was something someone of my generation inevitably felt uneasy about, but it was very much in the air, as was the concept of museums with ethnic identities, and I felt I had to rise to the challenge. It helped that parallel questions were beginning to arise in ethical theory, which gave me some purchase on the questions I sought to resolve. Postmodernism is but rarely present in contemporary philosophical discussion, so at the very least I thought it worth pointing out that however critics of Kant and Rawls thought of themselves, they were attempting to criticize their targets in what were postmodernist terms. Philosophy is not exempt from the culture of its times.

I have by and large been chary of the boundary between art and craft, and have often written about glass, jewelry, ceramics, and studio furni-

ture as vehicles of metaphor as compelling as any associated with paintings and sculptures. In the 1986 exhibition "Vienna 1900" at the Museum of Modern Art, I felt in particular that the crafts were as eloquent as the art, or more so, and that in certain ways jewelry had become the model for painting, especially in the case of Gustave Klimt.

I explained these views in my review of the show for the *Nation.* Then that November I received an unusual invitation from the Architectural League in New York. The league had organized what it termed a "Chair Fair" at the International Center of Design in Long Island City, and it thought it might enhance the occasion were I to deliver a lecture on chairs. I thought I had better seize the opportunity, uncertain that I would have another chance to think systematically about chairs, and immediately sensed that a distinction between chairs *in* art and chairs *as* art would help open up the subject. It was printed, with illustrations of all the chairs in the Chair Fair, in a book called *397 Chairs* (New York: Harry N. Abrams, 1988). But I feared it would only be read by members of the chair world and so prevailed upon Ben Sonnenberg, the editor and founder of *Grand Street,* to publish it first in his great magazine, where it appeared in the summer issue of 1987. The readership of *Grand Street* seemed to me the proper audience for the kind of essay "The Seat of the Soul" exemplified, and I was grateful to be able to reach that readership on the several occasions Ben accepted an idea of mine for publication.

"Munakata in New York: A Memory of the 1950s" was written in celebration of the great Japanese artist, and of the time we were friends. It was a time when I still thought of myself as an artist, and so, more than most of what I have written, this piece is unashamedly autobiographical. It was delivered as a talk at the Japan Society in 1976, and published in the *Print Collectors Newsletter* four years later.

"Louis Kahn as Archai-Tekt," printed here for the first time, was written for a panel on the master architect held at LAMoCA in 1995, in conjunction with the exhibition devoted to his achievement. Kahn's widow, Esther, was in the audience, and I was deeply moved when she told me that I had somehow captured the way he thought. In any case, it gave

me a chance to write about architecture, which had long been a passion of mine; indeed, it was in connection with architecture that I got the first intimations of how to think philosophically about art. I suppose I had a special sense of kinship with Kahn in that we were both profoundly influenced by the towering architectural thinker Rudolph Wittkower. I must express my gratitude for this opportunity to Sherri Gelden, associate director of LAMoCA at the time (and since then the director of the Wexner Center at Ohio State University).

In "Moving Pictures" I undertake to extend certain structures from the philosophy of art from still to moving images. For some years, Julian Hochberg and I taught a seminar on moving images at Columbia, his interests being perceptual and mine conceptual, and in a sense Kantian. The essay, originally published in 1979 in the *Quarterly Review of Film Studies,* has continued to have interested readers despite the fact that, in the nature of so technological a form of art, some of the discussion had badly dated. The piece has since been entirely rewritten to accommodate the impact of the VCR on the conditions of viewing film and the impact of digitalization on the assumptions of visual truth.

Of the essays in this book, "Gettysburg" is the one I would have been least likely to write had someone not asked me to. This was *Grand Street* editor Ben Sonnenberg, who remembered being moved by the experience of visiting the battlefield many years before. It is a mark of his brilliance as an editor that he should take such a memory as an imperative to find someone he would like to read on the subject. He has, as well, a sense for friendship and knew that I would not refuse. So my wife, Barbara Westman, and I drove to Gettysburg, paced off the lines between North and South, and I spent the summer doing the research the piece shows. I was able to bring into the discussion a sense of what it was like to be part of a battle zone, from my years as a soldier in Italy, in World War II.

The two concluding pieces are an effort to bring a degree of philosophical clarity to the vexed status of the National Endowment for the Arts. The first appeared in the *Nation* in August 1989, and it attempts to deduce the appropriateness of allowing one's taxes to support work of

which one does not approve. The second was a commencement address for the School of Visual Arts in New York, delivered June 5, 1995. An abbreviated version was printed on the op-ed page of the *New York Times* on August 27, 1995.

I thank all who have permitted me to re-present these essays, and I especially thank Edward Dimendberg for the idea of putting them together. Rose Vekony has been wonderful in seeing the book through the press, and I am immensely in the debt of Anne Canright for the sensitive copyediting and understanding reading of so varied a menu of texts.

I am grateful to the artist Paul Werner for applying his calligraphic skills to visualize a signature for Madame Récamier in my essay "The Seat of the Soul." Finally, I want to thank Sean Scully for allowing me to use the painting *Catherine* (1991) on the jacket of this book. Scully and his wife, the artist Catherine Lee, select one painting each year to be designated a "Catherine Painting," to be withdrawn from sale. The Catherine Paintings thus constitute a unique record of the best of Scully's work since the late 1970s. In 1993 the Modern Art Museum of Fort Worth exhibited the series; I refer the reader to my essay "The Aesthetics of Sequence," in the catalog for that exhibition, to see how exactly Scully's work exemplifies art philosophizing.

Introduction

Philosophy and Contemporary Art

IT HAS BECOME CLEAR to me that even during the composition of *The Transfiguration of the Commonplace* (1981), I was possessed with the history of art as a philosophical problem. I mean by this something stronger than the consideration that artworks themselves have a certain historical identity, where the problem is how the knowledge of this affects how we interpret and respond to those works. The question instead is why works of art in fact form a kind of history themselves, beyond the mere circumstance of their being made in a specific temporal sequence. From that perspective, two books must have exerted a far greater influence upon me than I was altogether conscious of at the time: Ernst Gombrich's *Art and Illusion* (1960) and Thomas Kuhn's *The Structure of Scientific Revolutions* (1962). Gombrich's problem can be given an almost Kantian formulation: How is a history of art *possible?* The horizons of Gombrich's agenda as an art historian, together with the boundaries of his taste in art, meant that he transformed his powerful question into a restricted version of itself, namely: How is a history of *representationalist* art possible? And to this he gave an answer which owed a great deal to his philosophical peer, Karl Popper, who thought of the history of science as constituted by certain creative leaps disciplined by the criterion of falsification. Gombrich saw the history of art as similarly

constituted of creative leaps from form to form of representation, disciplined by the criterion of matching representations against the appearances of the visual world. Gombrich was able to deduce a dictum of Heinrich Wölfflin as a consequence of his theory, in that he could explain why everything was not possible at every time. Because representation has a history, an artist early in the history of increasingly adequate schematisms of representation simply would not have had available the representational powers of a later time. Each of us learns through experience, and the history of art realizes that very dynamic through the growth of representational adequacy, almost as if Art were some superordinate being who learns, through the centuries, how to represent the world.

Although Popper was an immeasurably greater philosophical thinker than Gombrich, he very largely lacked, as most of the positivists did, any especially vivid sense of historical change. His focus was on the philosophy of scientific method, and he polemicized tirelessly against the view that induction—the inference from sample to population, or to a universal generalization from a finite set of observations—was the way science arrived at its best hypotheses. He was interested in the formation of scientific hypotheses, irrespective of the historical circumstances in which this occurs, but failed to ask the question parallel to Gombrich's of how it is possible for science to have a history in the first place. That would have required him to explain how scientific representations evolve from less to more adequate, other than through the modifications made in response to the efforts to falsify them. Like most methodologists, he was interested in what is everywhere and always the case. He and Kuhn were in essential agreement that hypotheses are arrived at by acts of creative imagination, rather than by what President Clinton not long ago referred to as "bean counting."

At one point, Kuhn argued that the history of art had been held up as a demonstration that there genuinely is progress in human affairs, and although Gombrich had shown that the progress in question was not linear and smooth, but punctuated by leaps (in a manner very like evolu-

tion itself, understood on the model of "punctuational equilibrium"), he would have had little doubt that there was genuine progress in the history of art from the relatively primitive representational schematisms of the early Renaissance to those of the nineteenth century: from Cimebue, say, to Constable. It would be progress only if those later in the sequence were able to perform more effectively the same tasks as those earlier in the sequence; otherwise there would merely be a change of agenda (which would in effect have been Panofsky's view of history, in which one set of symbolic forms gives way to another without this in any sense constituting a progress).

Had modernism not occurred, there would have been little to fault in Gombrich's analysis; but the operations of "making and matching" do not easily capture the shift from the impressionists to the postimpressionists, or from Cézanne to the cubists and the fauves. They do not easily capture the shift from representational to abstract art. They do not in any sense account for whatever it was Duchamp thought he was doing after his declaration that painting was finished. The dynamisms Gombrich worked out in such detail and with such ingenuity seem to have little to do with the directions art began to take after the mid-1960s. Indeed, what Gombrich accounted for was a history of representational art which Vasari would have been able to accept without changing in any particular the concept of art with which he worked. It would have been a predictable response, for someone wed to a theory that accounted for the art he was also by temperament attached to, that Gombrich would disparage an artist who, like Duchamp, is perhaps the most influential artist of the last third of the century. Gombrich did, to be sure, work out an interesting theory of ornament in *The Sense of Order* (1979). But Duchamp was neither representational in the ordinary sense, nor in any sense whatever an ornamentalist. So how is one within Gombrich's framework to deal with an artist like Duchamp without simply refusing to take him seriously?

A thinker whom I have come to admire greatly for the scope and originality of his thought was the American critic Clement Greenberg. It was

greatly to his credit that Greenberg worked out an entirely novel theory of modernism, according to which that movement arose when art became conscious of itself as a problem, and undertook a quasi-Kantian investigation into its own foundations. It was Greenberg's thesis that with modernism, art became the subject of art, which undertook to create foundations for itself by seeking that which was unique to each of the arts. In the case of painting—to which it is, he felt, central that a flat surface be in some degree covered with color—flatness became the defining character, and the canvases of the first modernist painters—Manet in particular, but Cézanne as well—incorporated this discovery, which inevitably made them appear distorted. Flatness differentiates painting from sculpture, which possesses a true third dimension. This means that illusion disappears as a *beau idéal* for painting, which instead aspires to abstraction as a final state. With Manet, the history of art took a critical turn, away from the appearances of the phenomenal world to the reality of art itself conceived of in material terms—that is, so far as painting goes, as flat panels of defined shapes, covered with pigment. Greenberg's credibility as a thinker was enhanced by the authority of his famous discoveries, particularly of the genius of Jackson Pollock. But no more than Gombrich was Greenberg able to deal with art *after* modernism, and certainly not with pop, to which he was by temperament antipathetic, and which he dismissed as mere novelty for novelty's sake. I heard him lecture in 1992, when he said that the history of art had never moved so slowly as in the past thirty years. For thirty years, he contended, *nothing had happened at all!*

I of course was obsessed with pop, and felt that the most important task a philosopher of art could discharge would be to account for it, as I sought to do in *The Transfiguration of the Commonplace*. Gombrich addressed art as a historian, Greenberg primarily as a critic. I approached it as a philosopher, feeling that there was a philosophical problem with pop in that it raised acutely the philosophical question of why an object like Warhol's *Brillo Box* of 1964 was art when the countless Brillo cartons of the supermarket world were merely cartons for shipping soap pads.

How could it be art when things that resembled it to any significant degree were what I termed "mere real things"? I began to notice that the form of the question was one with the form of a whole class of philosophical questions, for example the question, obsessive for epistemologists, of distinguishing dream from waking experience when there is no internal criterion for doing so. It seemed to me that pop, however unlikely it may have appeared to those unsympathetic with it (to most of my friends who were artists, for example) had finally discovered the true form of the philosophical question about art. Pop had made it possible for philosophers to address art philosophically! Instead of attempting to define art as such, the problem, far more tractable, was to distinguish philosophically between reality and art when they resembled one another perceptually.

My effort, in *Transfiguration*, was to begin the task of framing a definition of art, and the book lays out a few conditions for such a definition which aim to be universal, addressing art as art, whatever its provenance or situation. Still, I was haunted by the question of what, in the history of art, made it possible for art to be addressed philosophically, with no fear that anything that was to come in the future would limit my analysis in the way in which modernism limited Gombrich's, and pop and what came after limited Greenberg's. If there were to be no future counterinstances, then, it seemed to me, this history of art had in some important way ended. It had, if I may put it somewhat obliquely, ended with the disclosure, with the coming to consciousness, of its philosophical structure. It was as if art had, through its own resources and certainly with no help from philosophy, arrived at a philosophical understanding of its nature. It was up to philosophers now to lay out the structure of this concept—and it was up to art to do whatever artists now cared to do. Art had entered the posthistorical phase in which everything was permitted—at least artistically. Naturally, like any human endeavor, it was externally constrained by moral impermissibilities. Internally, however, it had opened into an end state of total pluralism. And the mark of this pluralism was the fact that purity almost immediately stopped being the

goal of the arts. Puritanism and modernism really did go together. Greenberg had that right. But with the end of modernism, art could be as impure or non-pure as artists cared for it to be. It was only when this was perceived, primarily by artists themselves, that an adequate philosophy of art could properly begin. And I shall take the license this introduction offers to explain why this is so.

The chief mark of *contemporary* art—contemporary not simply in the sense of the art being made at the present moment but in the further sense that "contemporary" names an overall *style*, which the characteristic art of our times exemplifies—is its extreme and total diversity and openness. It is a style unlike that of any previous period in that no criteria can be offered for it, and hence no way of telling whether something is "contemporary" through recognitional capacities of the kind called upon by such stylistic terms as "baroque" or "classical" or "mannerist." This is because it is open to contemporary artists to use historical styles to whatever ends they may have, making those styles the subject of their art. So a contemporary work could look quite like something done centuries ago and in another culture. In no previous period of the history of art can this have been true, and only under this total disjunctiveness would it have been entertained as a serious possibility that *anything* can be an artwork, which became a not infrequent claim in the 1970s.

Since we are aware that some things are *not* works of art, the philosophical problem for contemporary aesthetics is to explain what makes the difference. This problem becomes acute when we consider works of art that resemble, in all relevant particulars, some object that is not a work of art, such as Warhol's *Brillo Box*. In this case it would be unreasonable to argue that such material differences as may exist between the artwork and the soap-pad packaging suffice to explain why the one is a work of art while its utilitarian look-alikes are not.

When the diversity in art first came to general awareness, there was an understandable tendency to say that objects are works of art when the artworld decrees them to be. This is the gist of the so-called institutional theory of art. But in view of the philosophical problem of why one of an

indiscernible pair of things is art while the other is not, the act of conferring the status of art on one and not the other must seem as arbitrary as the bestowal of grace according to Calvinist theology. It is a foundation of moral theory that equals must be treated as equals; in this sense, two persons or actions cannot be said to differ merely in that one is good and the other is not (the way in which one thing can be *red* and something else not, even if the two should be alike in every other way). The Calvinist God cannot, consistently with his omnipotence, be thought of as limited in this way, which means that of two individuals, alike in every relevant particular, one may receive grace and not the other. It would hardly be suitable to view the artworld, as a status-conferring institution, in these inscrutable terms. So, as in moral judgment, the designation of something as art must be justified, through a discourse of reasons, and cannot, without becoming unacceptably arbitrary, consist simply in declarations. Even the most powerful critics are not, after all, gods.

The upshot is that the diversity of contemporary art is not equivalent to the idea that anything goes. That assertion must at first appear inconsistent, so it is a next task for the philosophy of art to dissolve this impression. The diversity is due to the fact that there are no a priori limits on what *can* be a work of art. Down the centuries there have always been such limits—whether photography was art was a border controversy from the moment of its invention until well into the twentieth century. These internal boundaries have disappeared from the concept, however, leaving only the boundary that divides art from everything else—a fact hidden from aestheticians throughout the previous history of art. It is this lack of internal boundaries that opens the concept up for works of art of radically different sorts. The concept of art is *not* like the concept, say, of cat, where the class of cats do pretty largely resemble one another, and can be recognized as cats by more or less the same criteria. In precontemporary periods, the class of artworks was much like the class of cats. But with modernism it became less and less easy to identify something as art, simply because of the discrepancy between modernist and premodernist works, which is why, in part, responses to the former so often,

and so characteristically, held that some outrageous canvas was not art at all, but a hoax or a symptom of madness. The great modernist critics had to evolve a theory of art that would accommodate these unaccommodating objects, without at the same time disqualifying what had previously been acknowledged as art. They did this, often, by defining art in formalist terms, which applied indifferently to a still life by Cézanne or a crucifixion by Giotto. But a work such as *Brillo Box* cannot obviously be distinguished, on formalist grounds, from the ordinary object it resembles: a photograph of Warhol among his boxes looks just like a photograph of a stock boy among the cartons in the stockroom. A pile of felt scraps by Robert Morris need look no different from a pile of felt scraps in some mill or workshop, where no claim whatever is made to the status of art. If there is to be a definition of art that fits contemporary art as well as all previous art, it has to be consistent not only with the fact that there are no limits on what can be art but also with the possibility that artworks and mere objects can resemble one another to any degree whatever. For better or worse, that helps show that the concept of art is different from the concept of moral goodness, where such a possibility cannot arise. And it helps show how the concept of art differs in its logic from the concept of cats—or of any so-called "natural kind."

These considerations demonstrate that we cannot define art in terms of how things look. But they in no sense entail that we cannot define art. We can, but we must do so in full recognition of the problems generated by contemporary art. In my 1995 Mellon Lectures, published as *After the End of Art: Contemporary Art and the Pale of History* (1997), I argued for two criteria: an artwork must have content, that is, it must possess *aboutness*; and it must *embody* that content. So what *Brillo Box* is about is an important first question to ask, and whatever answer one comes up with, it will have to differ from what *Brillo* cartons are about—in case we recognize that the shipping carton is, after all, a piece of commercial art. The design of the box proclaims the virtues of its *literal* contents, namely soap pads. But one may be certain that this is not what *Brillo Box* is about. Similar questions arise for piles of felt scraps, whether presented as art

or merely left over after the sheets of felt are shaped in the cutting room. These issues belong in what I term the "discourse of justification," and while the definition will doubtless need to be carried further, these two conditions explain how two things may look alike but one of them not be art. To be art is to be internally connected with an interpretation, which means precisely identifying content and mode of presentation. These are first steps in art criticism as well, whatever further needs to be said. However, it is one thing to connect the definition of art with the practice of art criticism, another to define art in terms of what critics happen to say. Critics, after all, are often locked up in earlier moments of art history, with formalism, for example, which applies with such difficulty to contemporary art. It is this difficulty, indeed, which makes contemporary art itself seem, well, *difficult.*

The two criteria, however primitive, help validate the idea of a parallel philosophical structure between persons and artworks. Persons embody representational states, as artworks embody their contents. There is more to the two categories than this, but the overlap between the philosophy of mind and the philosophy of art at the very least connects this volume of essays with its companion volume, *The Body/Body Problem.* It justifies, I hope, my own philosophical agenda of developing the philosophy of these two domains in parallel ways. The main thought, so far as the present volume is concerned, is that contemporary art meets the philosophy of art halfway, so that one can speak of the *art itself* philosophizing. This is especially perspicuous in the work of Warhol, whom I treat here as if a philosopher in "The Philosopher as Andy Warhol." It is interesting to contrast that essay with the one on Robert Motherwell, who, for all his generosity of spirit, found very little good to say about Warhol. My assertion at one point that Warhol was closest to a philosophical genius of any twentieth-century artist very nearly cost me Robert's friendship, and he pointed out to me that Warhol rarely said more in front of a painting than "Wow." But that of course is just my point: the philosophy was in and through the *work,* and not in what was said in front of the work. There is in my view a great deal in Hegel's

belief that art and philosophy are deeply affined—that they are, in his heavy idiom, two moments of Absolute Spirit. The wonder of Warhol is that he did philosophy as art, in the sense that he defined false boundaries by crossing them. Since no philosopher of art in 1964 recognized the kinds of problems Warhol raised, he could not have had a philosophical language in which to explain it. So, perhaps, "Wow."

Motherwell, however, had worked toward an advanced degree in philosophy, and took it upon himself to articulate the philosophy of the great school of painting to which he belonged (and which he named the "New York School"). His writings have a philosophical richness we would not expect to find equaled in Warhol's verbal remnants. But his work nonetheless philosophizes, in that there were internal philosophical reasons he could find for why the paintings came out as they did. So the volume begins with his philosophical search, his effort to understand his practice. And one might join to the essays on Warhol and Motherwell the one on illustrating a philosophical text (the formulation is Mel Bochner's), which means to find images *equivalent* to philosophical theses and then use these to illustrate the text which asserts them. It was fascinating to work through the ways in which Bochner's drawings for Wittgenstein's text *On Certainty* seek to make the kind of point Wittgenstein himself makes, graphically rather than verbally. In some sense, Louis Kahn's architectural creations can be seen as illustrations of a philosophical text—or a group of such texts—very close to Platonism. His own writing expresses the philosophy his buildings illustrate, and explains why the buildings went one way rather than another. Which came first is difficult to say, but Kahn clearly had the philosophy he needed when he entered the period of his greatness with the art museum he designed for Yale University.

The expression "philosophizing art" is deliberately ambiguous as to whether the art does the philosophizing or is the object of philosophizing, and the essays here can be loosely partitioned along such lines. "Moving Pictures" attempts to elicit at least a fragment of the medium's philosophy by proceeding as Warhol did, imagining films which he

showed to be possible but which, for perhaps obvious reasons, never were made. The principle of imagination, however, is in every instance that of conceptual discovery, and my sense of the philosophy of film is seriously different from what is accepted as film theory in the academy today. Something like this is true also for the curious essay "Gettysburg," which considers ways in which one can think of battlefields as works of art, for which Civil War memorial statuary holds the key. The essay on chairs brings to consciousness what must be true for pieces of furniture to be works of art, and does so by considering chairs *in* art as a guide to how to think of chairs *as* art. Each of the essays "philosophizes art" from somewhat different angles. My great hope is that by conjoining discussions of works with a relevant piece of philosophy, the art in question is opened up for critical analysis, precisely in the terms specified above. One looks for the content, and then the mode of presentation. And then one sees where one is.

The essays gathered here are from very diverse and often quite obscure sources, read by quite different audiences, very few of whom could be counted on to know the other venues in which my essays appeared. Unlike the critical essays that appear with some regularity in the *Nation*, of which I publish collections from time to time, these would languish in the back files of such publications as the *Print Collector's Newsletter* or the *Quarterly Review of Film Studies* or *Grand Street*, or as catalog essays for certain exhibitions, such as the inaugural exhibition of the Andy Warhol Museum or a wonderful exhibition of Motherwell's works on paper, organized by David Rosand for the Wallach Art Gallery at Columbia University in early 1997. In these essays, the relationships between philosophy and art are made more explicit, and carried further over a wider array, than I have been able to achieve in any other place, and this justifies bringing them together. My great hope is that their readers will get a more vivid sense of philosophizing criticism than my regular critical pieces make possible.

One last word. I have sometimes been interpreted as saying that the history of art ends when art turns into philosophy. That is not my view.

The history of art ends when it becomes possible to think philosophically about art without having one's philosophy held hostage to the future. Art ends when one is positioned to ask, as could not have been done at earlier moments, the proper philosophical questions about it. Only in rare cases, Warhol's being exemplary, is the art itself philosophy, doing what philosophers do but in the medium of art.

Very little of contemporary art is especially philosophical in this way. Still, it was through the deep pluralism of contemporary art that an adequate philosophy of art—a philosophy of art compatible with everything everywhere that is art—became possible. So there is after all a connection between contemporary art and the philosophy of art, which leaves it open to art to philosophize or not. That is the realm of freedom the artworld exhibits, even if pressures to do or not to do certain things remain. We are human beings, after all.

The "Original Creative Principle"

Motherwell and Psychic Automatism

THE CIRCUMSTANCE OF HAVING had advanced training in philos-
ophy before going on to become a painter, and indeed a great painter, is
almost certainly unique to Robert Motherwell. But he carried his philo-
sophical knowledge so casually that other than in the autobiographical
mode that came easily to him in later years, when he was the subject of
frequent interviews, or in the occasional title of a painting like *In Plato's
Cave*—which in any case is so commonplace a cultural allusion that no
inference from its use by someone to any special degree of philosophi-
cal education would be licit—one might have had no sense of him as ever
having had a philosophical background or any great interest in the sub-
ject. In our numerous conversations, from 1985, when we met, until the
year of his death, philosophy rarely came up in a way that made me feel
that he brought with him from his graduate years any special grasp of the
world that an exposure to philosophical discipline might explain. He
loved talking about the surrealists and their circle, and in the two public
conversations we had nothing seemed of greater interest to him than the
memory of that extraordinary group of artistic intellectuals whom it fell

Reprinted from *Robert Motherwell on Paper*, exhibition catalog, ed. David Rosand
(New York: Harry N. Abrams, 1997), 39–58.

to him to guide through the labyrinths of American, or at least Manhattan, life. He returned, again and again, to André Breton and Marcel Duchamp and Max Ernst, on whom he was always fascinating, but very much as if the ideas that drove them were a good deal less interesting and engaging than the personalities that embodied them, and his discourse a glittering stream of anecdotes, episodes, and portraits rather than a reflection on surrealist theories and doctrines. Doubtless this was because those theories and dogmas had no great currency in the late 1980s and early 1990s, but it must also have been, it has come to me to seem, because Motherwell himself had no special concern for such theories. For someone with a reputation as a thinker and an intellectual this may seem odd, and may suggest that his philosophical studies had not dyed, or at least not deeply dyed, the fabric of his mind. But it has recently begun to come home to me that Motherwell's philosophical spirit must be located elsewhere, in a set of critical attitudes that had an immense impact on his own development as an artist and, through him, on the whole development of American modernism. His was the spirit one might say of critical, rather than of dogmatic, philosophy, to use the distinction through which Immanuel Kant sought to distinguish himself from his contemporaries and predecessors.

Motherwell's philosophical training shows up with particular vividness in the way that, in the 1940s, he saw painting itself as a problem, very much as the great philosophers of the past saw knowledge itself—or understanding, or truth—as a problem, or as, in the twentieth century, philosophers found philosophy itself a problem to which increasingly radical solutions were proposed. In an interview of 1977 with Barbaralee Diamonstein, he speaks of the task of finding a "creative principle" as a problem, and indeed as a crisis, as if painting, and especially American painting, could not go forward if the problem were not solved and the crisis overcome.[1] The solution could not be discovered by simply continuing to paint, but rather by putting painting at a certain distance and determining how it could be done. This has the great sweep and methodological ambition we find in the master philosophers of the seventeenth

and eighteenth centuries, whom Motherwell must have studied at Harvard as a graduate student, all of whom felt philosophy to be confronted by an intellectual crisis of one sort or other that required an ascent to a new level of knowledge, thought, and understanding, where knowledge, thinking, and understanding themselves became their own objects: René Descartes's *Discourse on Method*, Nicolas de Malebranche's *The Search for Truth*, Baruch Spinoza's *The Improvement of the Understanding*—or, as the climax of the great series of investigations into the foundations and limits of the human intellect, Kant's tremendous *Critique of Pure Reason*. "I know of no enquiries which are more important for exploring the faculty which we entitle understanding, and for determining the rules and limits of its employment, than those which I have instituted," Kant wrote in his preface, responding, as his predecessors did, to a sense of crisis in the old methods, and a sense of mission in finding a new method for leading philosophy out of "chaos and night [and] that ill-applied industry which has rendered them thus dark, confused, and unserviceable."[2] No painter—one is tempted to say, no "mere painter"—could, like Motherwell, have conceived of painting as something that demanded a wholesale reconstructive methodological solution. It was this posture of philosophical address that set him apart from his peers. What is unique about him as thinker and artist is that he really did find the principle he sought, and then applied it in the great sequence of drawings, prints, collages, and paintings that stands as his life's work. The parallel with Descartes is intriguing, for Descartes not only hit upon the "Method of Rightly Conducting the Reason,"[3] but put it into application in a sequence of works on geometry, physics, optics, physiology, cosmology, and the like, which, in his view, vindicated the validity of his method.

The creative principle—what we might call the "Method of Rightly Conducting the Brush"—was of course what the surrealists called "psychic automatism," which, "in the case of painting . . . usually begins as 'doodling' or scribbling."[4] Before discussing this, however, I want to say a few words more on the philosophical nature of Motherwell's early investigations into the foundations of modernist art.

Kant distinguishes sharply between his own critical project and what he terms "dogmatism," which is "a procedure of pure reason *without previous criticism of its own powers.*" He speaks with a certain irony of "the celebrated Wolff, the greatest of all the dogmatic philosophers," who was "peculiarly well-suited to raise metaphysics to the dignity of a science, if only it occurred to him to prepare the ground beforehand by a critique of the organ, that is, of pure reason itself."[5] The surrealists, and to an exaggerated degree Breton himself, were dogmatists through and through, not simply in the sense of being utterly convinced and, well, dogmatic in the articulation of their beliefs, but in the rather more strict Kantian sense of attempting to lay down deep metaphysical truths without first investigating the adequacy of their methods to do so. Motherwell, so far as I was ever able to tell, had no interesting theses to which he was committed about the nature of reality or of the mind: he was not a "dogmatist" at all. He was a pure painter in the Kantian sense of being interested purely in the act of painting, without specific commitment to content.[6] The surrealists thought to use "psychic automatism" in order to reveal the underlying structure and contents of the unconscious mind, something in which, as a modern, Motherwell had a certain interest, but which did not, so far as I know, particularly motivate his appropriation of psychic automatism. Certain others in the abstract expressionist movement were, in the manner of Breton, dogmatists (and indeed dogmatism affects the artworld to this day, whether as part of the surrealist heritage or not I cannot say), and spoke of the Sublime, of the *Ding-an-sich*, and of Jungian archetypes with the assurance of "the celebrated Wolff." But Motherwell, in everything perhaps except the matter of the creative principle, was an exceedingly open person—pragmatic, flexible, diffident. I always thought in fact that his *Open* series was a monument to an openness that might easily have been a principle of his—as it almost had to be (as we shall see), given that psychic automatism leaves open just what is to emerge when one embarks upon it.[7]

We can, of course, press parallels too far, but the distinction between the critical and the dogmatic is a piece of philosophical structure, one to

which a person who studied philosophy would have been alive in a way in which someone who came to philosophy from the outside, as a reader, might not. Barnett Newman was a dogmatist, Ad Reinhardt was a dogmatist, Mark Rothko and even Jackson Pollock were dogmatists, while Breton was a dogmatist raised to a higher power. But Motherwell was a criticalist in method and a pragmatist in everything else, a combination to which his employment of psychic automatism was perfectly suited.

Actions are considered "automatic" when they take place without their agents being conscious—or fully conscious—of their taking place. The term "action" excludes mere reflex motor responses, in the sense that a great many automatic actions begin as conscious actions to which the agents become habituated through repetition, whereas reflex responses have no history of explanation through consciousness at all, so that their causes are entirely mechanical or physical. Driving a car or riding a bicycle becomes "automatic" in the sense that we perform the various subactions involved in them without thinking about them and without their ever breaking through to consciousness. In much the same way, the various subactions of playing a musical instrument get to be "second nature" to us in that we do not have to think of where, for example, we are to put our fingers. Playing a piece can get to be as automatic as moving one's fingers, especially when the piece has been completely learned and one plays it, like a theater musician, over and over again, without having to think, or think very much. And perhaps playing a role in a theatrical performance gets to be automatic in this sense, to the point, even, where one's effectiveness would be hindered if one in fact became overly conscious of what one was doing.[8] In the nineteenth century there was a feverish interest in behavior that was automatic, with consciousness and premeditation playing no particular role, but that was not in any obvious way rote or routinized. So-called automatic writing would be a case in point. "In a typical but simple case," Baldwin's 1901 *Dictionary of Philosophy and Psychology* says, "a pencil placed in the hands of the automatist will begin to write apparently of its own accord; the automatic character of the result being indicated by the fact that the writing proceeds the more

successfully the more the subject is distracted from the action . . . and frequently too by the content and character of the writing."[9] Creative writing is easily thought of as automatic in the sense that the poem or novel seems to write itself—a process more picturesquely characterized as dictation by the Muse. But automatic writing, as it is classified here, would rather rarely have much literary interest, and even more rarely a sustained literary interest: it would be marked by the fact that the writing seemed almost *physically* to have taken place without the intervention, or even against the will, of the agent—as if the pencil were driven by some source other than the one whose hand held it. And, with the high interest in "psychic" phenomena in the nineteenth century, automatic writing would most obviously have been explained with reference to some "spirit" communicating through the "medium" of a writer's hand. Needless to say, one's interest in what got written would almost certainly not have been literary, but would focus on the information transmitted through automatism from the Beyond—that "I am happy and I love you," for instance. (Motherwell's celebrated inscription "Je t'aime" has an uncanny affinity to a spiritualist's communication from an Absent Beloved; it would have been precisely the kind of message one would have wished to see formed "automatically" during a seance, validating the "medium's" powers.) Spiritualism was animated, if that term be allowed, by the thirst for evidence of immortality, and not simply by the "intimations of immortality" with which the Romantics were content. The Romantics were defined by their disdain for science, whereas spiritualists were defined by their fear that science might have cut the ground out from under hope in the Higher World and the Afterlife.

It is striking how the very phenomena that excited spiritualist hopes—dreams, visions, and of course automatic writing—were naturalized in the nineteenth century through the complication of our picture of the mind. It is very much as if spiritualism was the obverse of positivism, the position that natural science and natural science alone is in a position to explain whatever takes place in the world. The corollary of positivism was a kind of materialism, according to which body and mind together are

explainable through natural causes and covered by natural laws. Positivism meant that there was no "higher" revelation; materialism was taken to mean that the mind dies with the body; and spiritualism was an effort to find evidence that refuted the latter and enfranchised the former. "I hold it truth," Tennyson wrote in *In Memoriam*, "that men may rise on stepping stone / Of their dead selves to higher things." The postulation of what Baldwin's *Dictionary* designates "a subconscious personality, which has become dissociated from the main conscious stream of thought, a secondary personality split off from the main personality, and accessible only by psychological means like hypnotism or automatic writing which reveals as 'out of gear' the usual co-ordinating relationships of the highest cerebral center" replaces Tennyson's "higher thing" with a natural mechanism.[10] And with the complication of our theories of the mind, through writers such as William James and Pierre Janet, and of course Freud, the explanation of automatic writing has come to be believed altogether endogenous. And with this, automatic behavior of whatever sort was transformed from a conduit to the supernatural into a diagnostic device for revealing inner mental structures themselves inaccessible to introspection, as of course the unconscious, or the "Ucs. System," in Freud necessarily was. The behavior was transferred from the psychic's parlor to the clinic, where Breton, who after all was a student of medicine—he worked at the Charcot clinic, where Freud had come to study the phenomenon of hysteria—discovered it and turned it to artistic ends. But those ends were, in important ways, tinctured with the psychological associations Breton learned about from psychoanalytical theory and practice. For him the unconscious was an exciting hidden world, to which automatism gave access.[11] Still, it was with a poet, Philippe Soupault, that he practiced automatic writing in 1919, and he clearly considered it literature rather than clinical notation, since it was published as *Les champs magnétiques* the following year.

In his first *Surrealist Manifesto* of 1924, Breton defined surrealism methodologically. It was "pure psychic automatism by which one intends to express verbally, in writing or by other method, the real functioning

of the mind. Dictation by thought, in the absence of any control exercised by reason, and beyond any aesthetic or moral preoccupation."[12] It is important to stress that Breton saw the unconscious from an epistemological perspective: it was like a cognitive organ that disclosed a world with which we have lost contact, a marvelous world that appears to us in dreams and to which automatic writing and drawing give us access. That is, automatism takes us not simply to the unconscious mind, but through that mind to the world with which it is in contact, past the real to the sur-real. That world, through the mediation of the unconscious, speaks through the medium of automatic writing. To practice automatism means to disengage reason, calculation, and indeed everything component in "the highest cerebral center," to use Baldwin's expression. And since Breton found it imperative to identify automatism with art, the art he favored was an unpremeditated and uncontrolled pouring forth of language, without guidance or censorship—a kind of "speaking in tongues" that was, for the spiritualist, the mouthpiece, the persona, of the Holy Spirit. It is little wonder that the early abstract expressionists, who were profoundly affected by the tone of surrealist thought, if not its substance, should have seen themselves as shamans through whom objective forces poured forth. Breton's marvelous world and his belief in the primitive mind are distantly present in the famous letter to the *New York Times* of 1943, written by Adolph Gottlieb and Mark Rothko, in which they say, "To us art is an adventure into an unknown world, which can be explored only by those willing to take risks."[13] And it could be conjectured that "pouring" itself should become among the means available to the true artist, as it did in Pollock at least, whose Jungian searchings into the archetypes of the unconscious made him an edgy heeder of surrealist doctrine.

There is in truth very little "pouring forth" in the typical surrealist canvases of the 1940s. They tended on the whole to use illusionistic pictorial space, and indeed, deep illusional space—with sharp, explicit perspective, as in the paintings of Salvador Dalí—became graphic shorthand for the space of dreams.[14] And Dalí, again, sought to convey the

feeling of dreams by situating finely delineated objects in those spaces, exhibiting properties never encountered in ordinary experiences—like the celebrated limp watches—or juxtaposing objects in ways so incongruent with the conceptual schemata of ordinary life as to evoke uncanniness in the viewer's mind. Dalí, to be sure, deliberately exploited what he termed the "critical-paranoic" method, but this was a method of conjoining images whose facture was far from the uncontrolled gush and rush Breton evidently advocated. Breton had in mind words that spill from the mouth or the fingertips, rather than images built up with glazes and cunningly shaded to elicit the sense of dramatic illuminations. But even the loosest of the surrealist painters were more fixed on a kind of dream content than on a specific method of painting that was itself "automatic"—in the received sense of transpiring without being monitored by consciousness or directed by the representational capacities of the rational mind. With Breton, one dares to say, content and mode of utterance alike referred to the subrational mind. But with the surrealist painters, it was content alone that was surrealist: the method of painting remained traditional and even, in Dalí and in Yves Tanguy, academic. What Motherwell's automatism accomplished was to make the method itself congruent with Breton's way of writing, so that in effect painting could even be treated as a mode of writing. The result was either to eliminate recognizable content or to treat content so abstractly that one could dash a figure or face across the space of canvas with the same unstudied urgency that splashing paint entailed. The success of this change in the production of art has had the consequence—one among many in the subsequent history of art—of bumping the surrealist painters onto a sidetrack of modernism.

It was precisely the illusionism of surrealist treatments of space—not to mention, since it does not function in his criticism, the disjunction between writing, which does, and painting, which does not, lend itself to automaticity—that Clement Greenberg found incompatible with the very concept of modernist painting, whose essential principle required the exclusion from painting of everything alien to the medium. But, so

Greenberg argued, illusional, three-dimensional space is proper to sculpture rather than to painting, which demands flatness. And the dominance of Greenberg's view has tended to keep surrealist art very much on its sidetrack, much like that celebrated surrealist photograph of an abandoned steam engine covered with vines. It is possible that, with the waning of Greenberg's influence, surrealism will make a comeback; indeed, at least according to some writers, such as Hal Foster, it *has* made a comeback, even "with a vengeance, the subject of many exhibitions, symposia, books, and articles." Nevertheless, Foster goes on to say, "surrealism is still often folded into discourses of iconography and style."[15] And the symbols on which iconographical analysis is expended have cloyed over the years, while the hopeful belief that tapping into the unconscious, as if into an immense source of creative energy, has, along with the fourth dimension, lost its charm.

Stylistically speaking, the painter Matta has little to recommend him to someone who finds surrealism wanting as a modernist paradigm. But he felt himself sufficiently apart from the governing body of surrealism as a movement in the early 1940s to want to create what Motherwell described as a "palace revolution" in the movement, and it is possible that the crux of the revolution was precisely that change I have identified as Motherwell's. Motherwell did not admire Matta greatly as a painter—"For me [his paintings] were theatrical and glossy, too illusionistic for my taste"—but thought highly of his colored pencil drawings: "His painting never compared to his drawings."[16] And drawing lends itself to "doodling" rather more readily than painting does; or painting has to be reinvented, so to speak, in order to make room for painterly doodles. (Dalí could make a splendid painting of a doodle, but it is difficult to picture him doodling as such.) "The fundamental principle that he [Matta] and I continually discussed, for his palace revolution, and for my search for an *original creative principle,*" Motherwell said in a letter to Edward Henning in 1978 (a little later than his public interview with Diamonstein), "was what the surrealists called psychic automatism, what a Freudian would call free-association, in the specific form of doodling."[17]

The "original creative principle," Motherwell said more than once, was "the thing lacking in American Modernism."[18] It was to be something which, once discovered, would enable American artists to produce original modernist works, by contrast with what was the practice at the time of attempting to be modernist by emulating European works that were by definition modernist. And it was in formulating this that Motherwell's philosophical training and sensibility come through. *"The American problem,"* he emphasized in his discussion with Diamonstein, "was to find a *creative principle* that was not a style, not stylistic, not an imposed aesthetic." On at least two occasions he formulated this as a problem with the painter Arshile Gorky specifically in mind:

> The enormously gifted Gorky had gone through a Cézannesque period and was, for the 1940s, in a *passé* Picasso period, whereas much lesser European talents were more in their own "voice," so to speak, because they were closer to the living roots of international modernism (in fact, it was through the Surrealists and, above all, personal contacts with Matta that Gorky shortly after would take off like a rocket . . .).[19]

Matta "shifted Gorky from copying *cahiers d'art* to a full-blown development of his own," Motherwell told Henning. So Gorky was the model of what the original creative principle could do. "With such a creative principle, modernist American artists could cease to be mannerists." It transformed Gorky from a mannerist of modernist idioms to the original artist he became, allowing him to realize his native gifts through its means. Psychic automatism was an almost magical device for enabling each person to be at once artistically authentic to his or her true self and at the same time modern. "And what was 'American' would take care of itself, as it did soon enough."[20]

Motherwell does speak of "the preconscious," but he sees this in a far different light than did Breton or, for that matter, Freud. For Motherwell it consists in that complex of causes, of influences, experiences, and circumstances, which make each of us the person we uniquely are: our

selves. The same methods of automatism lead each of us to this rich and unique personal complex, but that to which we are led "differ[s] for everyone, to the exact degree that each person differs from another."[21] And he observes, in confirmation, not only how different each of the abstract expressionists who resorted to automatism are from one another—just as the surrealists who resorted to it differ each from each—but also how practitioners of the two movements differed generally from one another: "How different, in ultimate thrust, are each of these two movements." Motherwell, in personal conversation as well as in the interviews he granted, loved to describe the experiences that were peculiar to him, and that explained this or that feature of his paintings.

The first time we met, after having exchanged several letters, he took me to a restaurant he liked in Banksville, New York, where we spent some hours talking, not about philosophy or about art, but about our lives, about women, marriage, money, and children. He was immensely relieved, he told me afterward; he had had a kind of nightmare the night before about meeting me, and I think he must have feared that I was going to hold his feet to the fire of unremitting abstract discussion. Motherwell had reached a stage in his life where he was not anxious to talk abstractly about abstract ideas, having attained, as it were, to a philosophy of painting that served him admirably, as an artist of course, but also as someone who found himself increasingly called upon to talk about his art and the history in which he had played a role. There was little reason for him to go back, so to speak, to the philosophical drawing board. Our conversations were always personal and delicious, about what both of us, given our francophilia, would designate *les choses de la vie.* The difference was that in talking about himself he was talking about his art, for his art really was himself: "As for my lifelong interest in blue, it should be remembered that invariably I spend summers beside the sea."[22] "In some ways all an artist's past years remain intact, but particularly, as everybody knows, childhood impressions. [Dore Ashton] is the only one who has ever remarked how crucial was the fact that I grew up in pre-war California. . . . (The hills of California are ochre half the year)."[23]

Motherwell was singularly conscious of the contents of his preconscious. And his preconscious seems more to have been the scene of hills and oceans than that dank forest of surrealist monsters and irrational fears, though he had plenty of his own private demons to deal with as well. It is the psychic compost of the daily experiences that forms our characters and our work, and what automatism yields is continuous with our most common experiences. Matta evidently found this puzzling. In an essay for an exhibition of Matta's work at the Rose Art Museum at Brandeis University, Nancy K. Miller wrote that "the Americans Matta was intimate with . . . had never been completely comfortable with an art of images containing metaphorical ramifications."[24] The emphasis here should be on the word *images*. For Matta's method was evidently close to a kind of game, consisting in making marks and then seeing what sort of image one could find in the mark, rather in the manner Leonardo describes in a famous and influential passage regarding the use of a mottled wall as an aid to invention. Matta is characteristically impish in describing what Leonardo did:

> Leonardo da Vinci, as against the academic stillness that disturbed him in the work of Raphael and the classics, invented a new approach. He said that it was very boring to start with a white piece of paper and put a line on it, because all you are doing is putting what you know in the paper. He said you should start from a spot on the wall, humidity. If you look at a spot for a while, he said, something will start appearing by a funny process called hallucination. He would see whatever came in the hallucination, like we may see a horse in clouds. He said follow that image. When it comes to seeing things in the spot on the wall, you will be doing things you don't know—you will be discovering and inventing things. And you'll have more fun. That is my technique. If I see in the spot on the wall something I know, I erase it and wait until something else comes along. And then I see something which to me is fascinating because I don't know what it is. . . . I get amused. I get surprised. That's what I told the School of New York—I said "start like that and be very amusing."

Being bored and having fun are hardly motivations we dare ascribe to Leonardo. Nor can we altogether imagine the serious young Americans as in the least driven by the desire to be amusing. Matta continued:

> They made spots themselves—Pollock's spots, Motherwell's spots, etc. But then I told them to go the next step which is to get into the hallucination. I asked them to see things in the spot, because what they would see comes from our being, our social and emotional being. But they stopped there and didn't go into the next step.[25]

"Matta," Miller writes, "attributes the direction of Americans away from the poetic and philosophical toward an emphasis on the process of making pictures to American pragmatism." As though it were practical considerations and concerns alone that made the Americans stop short with abstraction and not go on into "hallucination." But in fact this refusal was the entire crux of the "original creative principle." Motherwell, Miller goes on to say, "took his separate course in 1944 with a replacement definition for 'psychic automatism.' . . . He stated, 'Plastic automatism, as employed by modern masters like Masson, Miró, and Picasso, is actually very little a question of the unconscious. It is much more a plastic weapon with which to invent new forms.' "[26] But as we have seen, "new forms" was less the issue than not repeating, manneristically, old ways of being modern, was less an issue than enabling American artists to be modern, without being sham Europeans. The new forms could come from whatever formed their spirits.

Abstraction was in some way internally connected with this. But abstraction, too, was something one could acquire, as an artist, and still be a mannerist. There was something infectious in Joan Miró, for example, and although Miró adamantly refused the label of abstract painter, the biomorphic blobs floating in thin space like amoebas under a cover glass lent themselves to abstract painting in America, as much so as did circles and triangles and squares. The "doodle" was neutral within what one might call the vocabulary of accepted abstract forms, but what was important about it, it seems to me, was the fact that it could be—perhaps

had to be—done without being controlled by conscious mental process. But to have an identity of any kind, as a representation, would require conscious direction of the pen or brush. It would perhaps be unthinkable that someone could produce, say, the Ghent Altarpiece by doodling.[27] Even to draw the human torso requires some degree of conscious attention. So one has to disengage from the hand and let it find its way across the surface.

In recollecting the meetings that took place between himself and the scarcely younger Americans—Pollock, Peter Busa, William Baziotes, Gerome Kamrowski, and Motherwell—Matta reported that he felt it important, if it was to be a group, that its members agree on a direction, find a vocabulary: "I remember that some of the first things we used to do were things like that—images of man. I felt we had to keep a degree of reference to reality. It couldn't be all explosion, you know." And Matta spoke of going through a phase of "explosion," of "chaotic circles of drippings," which was "an expression of my anger in terms of the war," and then, afterward, his return to "anthropomorphic things," which "created a very definite divorce with the Americans, and especially with Motherwell. When he came to visit me, he would say, you are coming back to the figure." And Busa, in that same interview, added that Motherwell "had an abhorrence of the figure as I remember. As soon as we painted the figure it was as though it wasn't art."[28] It was as though the return to the figure meant a falling away from the universal creative principle. Memories differ. "Around 1943," Motherwell remembered in his letter to Edward Henning, "Matta abandoned us, as is his wont."[29] "I became sort of the fellow who wasn't accepted," Matta remembered in his conversation with Sidney Simon: "They were happy as long as my work expressed cosmic violence and whirlpools. I think it was a pity we didn't see more of each other. Because *action* is not necessarily the *hands*." But doodling, in Motherwell's sense, really was what the hands did, acting on their own. "It was a fratricidal situation in many ways," Busa recalled.[30]

Motherwell gave every evidence of believing himself to have discovered what he set out to find, and in the retrospective mood more or less

imposed upon him by the format of the increasingly frequent interview or historical inquiry of the 1970s and 1980s he treated the "original creative principle" as a fait accompli. In his letter to Henning, he lays out the chief attributes of his discovery, very much as if he were describing a theorem that had been proved or a chemical breakthrough made. The letter is in numbered paragraphs, but paragraph 7, which treats the original creative principle, is further broken down into lettered subsections. Rereading his letter, Motherwell expressed particular satisfaction with paragraph 7 as "worth the effort."

Here are the itemized attributes of psychic automatism from the letter to Henning, which I shall lay out serially and comment upon one by one:

A. Psychic automatism "cuts through any a priori influences—*it is not a style.*" Because the psychic automatism of an artist A is not a style, one cannot speak of, or logically even think it sensible to look for, the influence of artist B on A. Hence in making art automatistically, it is logically not possible for an artist to be a "mannerist." In case what A does looks like what B has done, this is, if the former is automatistic, a strict coincidence. Hence, finally, in making use of psychic automatism, artists indemnify themselves against art-historical explanation of their work because their work, strictly, originates with *them.* Styles can be shared, so that it sometimes is difficult to tell which artist within a given style did which work, as in the case of Picasso and Georges Braque at a certain stage of analytic cubism, or Henri Matisse and André Derain at a certain moment in the history of fauvism. With the first generation of abstract expressionists—and this is a confirmation of Motherwell's claim—there is no single style: Pollock, Willem de Kooning, Newman, Clyfford Still, Rothko, Motherwell himself, all look like no one other than themselves. One unquestioned truth is that de Kooning especially was easily mannerized, almost as though he had invented a vocabulary that other artists could use. Motherwell would explain this lapse from originality as due to the fact that those who followed de Kooning stood to him in the same relationship in which Gorky stood to Picasso or Miró: they were "man-

nerists." And the solution to this would have been issued like a prescription: psychic automatism!

B. Psychic automatism is "entirely *personal*." This means that the automatisms of artist A and of artist B are like the personalities of the two. They belong to them as native equipment, so to speak, and not as something acquired, by contrast with a manner or a style, or even a language. What emerges through automatism, since not acquired, cannot have been learned or taught: an art school can give someone an opportunity to do things automatically, but cannot instruct anyone in what to do. Should the automatisms of two artists resemble each other, this again would be entirely accidental.

C. Psychic automatism "is by definition *original*, that is to say, that which originates in one's own being." This means that what one does automatistically stands in a very special kind of relationship to the artist who does it. Call this relationship "originary." Philosophers at one point sought to distinguish two kinds of causation, what they termed *immanent* from what they termed *transeunt* causation. The classic case of one billiard ball causing another to move by striking it would exemplify transeunt causation. The way in which an agent raises an arm voluntarily would exemplify immanent causation: no event stands to the arm raising in the relationship of cause to effect. The agent *simply* raises it.[31] One raises one's arm the way God creates the world, as an act of absolute beginning. This is what "originating" means in its deep metaphysical sense. Because there is no causal gap involved in immanent or originary causation, it is possible to say that the distinction between being and doing is overcome. One *is* what one *does*.

D. "It can be modified stylistically and in subject matter *at any point during the painting process:* for example the *same original primitive doodle* in the hands of, say, Paul Klee, Tanguy, Miró, Baziotes, Masson, and Pollock can end up as a Paul Klee, Tanguy, Miró, Baziotes, Masson, and Pollock, according to the aesthetic, ethic, and cultural values of each individual artist."

I must pause at this point, since I find this thought somewhat difficult to grasp: the modification of automatism, presumably, is not itself a further piece of automatism. This seems to imply that the modification of a doodle is not itself a doodle, and accordingly, that the higher cerebral processes—consciousness itself—must come in at this point. This may have been what Motherwell meant by "plastic" automatism, but since it involves the possibility of "stylistic" modification, it cannot itself be automatistic because automatism is not a style. Moreover, the very fact that the "same original primitive doodle" can be made by all the artists enumerated suggests that their differences cannot be in automatism but rather in the modifications. I feel that this is where Motherwell should have borne down a little harder on his point. It suggests that the differences are not "original" but have to do with "aesthetic, ethic, and cultural values"—and these cannot be "personal," in a sense, at least, that excludes their being shared. It sounds, in any case, as if the "modification" of the doodle is more important than the doodle itself.

E. Motherwell here expresses his belief that psychic automatism is "the most powerful creative principle—unless collage is—consciously developed in twentieth century art." He notes that collage, too, "is also partly free association," and it is instructive to recognize, through this bracketing together of collage and psychic automatism, that the word *principle* means in Motherwell's vocabulary "way of art-making." Both ways involve the conscious abandonment of consciousness, but then, at a certain point in the process, they both bring in conscious process, working consciously, as in the "modification" Motherwell brings in under D. It is the abandonment of consciousness in doodling and in tearing paper that is of most interest to him. My sense is that subsequent modification is not the originary upsurge of art that interested him. On the other hand, it may help explain why automatism led to the making of great art, whereas it did not lead, in the hands of the surrealist poets, to the making of great literature—at least to the degree that it was inconsistent with stream-of-conscious free association to rewrite, impose structure, control the final product. It is often observed that the way

words relate to words in *Finnegans Wake*, as in the stream-of-conscious-ness passages of *Ulysses*, exemplifies to perfection what the surrealists as-pired to. But neither *Finnegans Wake* nor *Ulysses* was a verbal doodle. Joyce controlled and shaped. And so, of course, did Motherwell. The only painter who at least on the surface seemed through and through au-tomatist was Pollock in his drip phase, which raised the doodle to a tran-scendent power.

It is worth observing, after this, the degree to which Motherwell's au-tomatism satisfies the conditions he lays down. There is an India ink drawing on tracing paper of 1978 that is untitled—a fact that fits, after all, with its status as a doodle (fig. 1). This work, when published as plate 129 in Arnason's *Robert Motherwell* (2d ed.), elicited the following obser-vation from the artist:

> I have been known as a proponent of "psychic automatism" in the
> form of what I used to call doodling, but following a recent book on
> children's art, I now prefer the usage "artful scribbling." But I am
> even better known for the imagery of my *Elegy to the Spanish Republic*
> series. It is still surprising to me that most persons have failed to see
> the connection between "artful scribbling" and the *Spanish Elegy*
> motif. The seeming contradiction disappears if one knows that nearly
> all the *Spanish Elegies* begin with "artful scribbling."[32]

The untitled 1978 drawing has the feel of Japanese "grass-style" cal-ligraphy, rapid and cursive, elegant and wiry. It traces the movement of the hand that inscribes it, the way we can imagine a line in the ice records the arabesque of a figure skater improvising a movement. At almost dead center of the paper the line goes left, pivots and turns down, and then curves right and, making two subcurves as it ascends, reaches a point on the same level at which it began—whereupon it performs a small loop, curves slowly up, pivots, and then trails gracefully off as it descends. That is the main figure. To the left, it is touched by a sort of bell shape. There are two diagonals, one broken, with a line at about thirty degrees to the unbroken one. The artist has violated the grace of the basic figures by

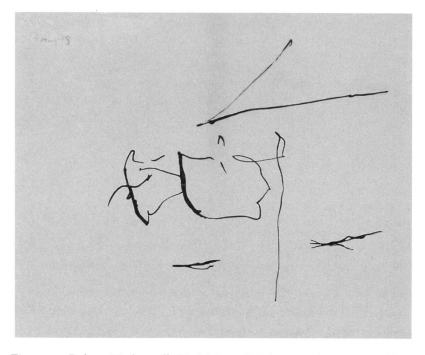

Figure 1. Robert Motherwell, *Untitled*, 1978. Ink on tracing paper, 13½ × 16¾". © Dedalus Foundation/Licensed by VAGA, New York, N.Y.

thickening the left sides of both main figures. It is very simple. One could count the strokes. There is nothing referential, but it is masterly and it could not easily be thought of as done by anyone but Motherwell. It is an abstract autograph of which the artist must have thought enough that he kept it and allowed it to be collected. It is about as basic an illustration as one might find of the "original creative principle" realizing itself through an artful scribble by a hand that conveys delicacy, sensitivity, and strength. One can see in it the history of unconscious decisions and reversals. It is also unsigned, as if the signature would introduce another element the drawing is too fragile to sustain.

This drawing has three verticals: the two left-hand curves, which the artist has drawn over to give them strength, and then the right-hand ver-

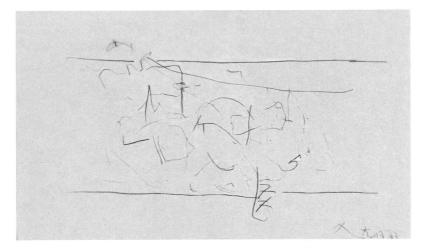

Figure 2. Robert Motherwell, *Untitled*, 1977. Pencil on mylar, 13½ × 23".
© Dedalus Foundation/Licensed by VAGA, New York, N.Y.

tical. The two left-hand curves form a pair, and in an attenuated way one
can see a nascent *Spanish Elegy* taking form. In his published comment
on this sheet, Motherwell pointed to three drawings that build toward
an *Elegy*, as if stages in a single emerging work. The first (fig. 2), pencil
on mylar, has two continuous horizontal elements, as if the edges of a
table. Between the edges—hence on top of the table—are some hesitant
curves, suggesting the beginning of a still life: were the drawing identi-
fied as by Cézanne, an array of apples and dishes perhaps. There is a
dance of stronger verticals, like accents—five or six in all, depending on
how one is counting. These seem less *Elegy*-like than the nesting curves
in our previous example. But in the lithographic *Altamira Elegy* (fig. 3),
where the grass-style fibrillations have been exchanged for something
heavy, as if deposited by a charged brush, there could be four shawled
figures or four brooding trees, and there is a tense rhythm left and right
and left. What gives it the elegiac feel is the heaviness, the downward-
ness of the forms, as if sorrow refused to let them rise. But perhaps one
reads too much into it, knowing that the word *elegy* appears in the title.

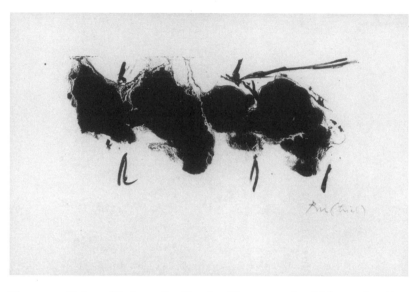

Figure 3. Robert Motherwell, *Altamira Elegy*, 1979–80. Lithograph, 9⅜ × 11⅞″. © Dedalus Foundation/Licensed by VAGA, New York, N.Y.

The four heavy forms could be bunches of grapes, or fruits on a table, as in a famous painting of persimmons by the thirteenth-century Japanese artist Mokkei. And one wonders if the elegiac feeling of the great *Spanish Elegies* is not in part a function of scale. The third study in this sequence (fig. 4) is elegant black sweeps of acrylic paint on canvas board, and it is too lyrical to be elegiac: the figures could be dancing within the space of a stage. I make these critical observations to suggest that more than artful scribbling is involved in transforming an artful scribble into an elegy. One has to achieve that feeling, and it is here, doubtless, that the values Motherwell brought in under his letter D do their work in finding a visual equivalent to the feeling with which the artist wished to infuse his drawings. If we subtract from an *Elegy* an artful scribble, the remainder is filled with what makes the difference between art and great art, depending on what Motherwell concedes are "the limitations of one's own beingness."³³

In order to see what Motherwell refers to as "unadulterated automa-

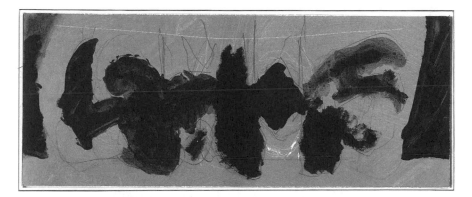

Figure 4. Robert Motherwell, *Elegy Study*, 1976. Acrylic and pencil on canvas board, 10 × 25″. © Dedalus Foundation/Licensed by VAGA, New York, N.Y.

tism," one must turn to the *Lyric Suite* of 1965. These are unrevised paintings with watercolor brush on rice-paper sheets of a uniform size (11″ by 9″). One is here especially conscious of the physical properties of the paper to absorb the ink, and of the ink to spread "like a spot of oil on a smooth surface."[34] The medium allowed no revision, really, and although the paintings differ one from another in terms of the original impulse each reveals, of blots and splatters, dashes and drips, the feeling is not particularly of something human *in* the space—no mourning figures, no architecture, no dance—but at most of something outside the human range altogether, like microscopic encounters and engulfments by minuscule creatures of one another, or of perturbations in a cloud chamber. The items in the *Lyric Suite* are cosmological notations, but what we are put in mind of is the action of making them, rather than what they mean. They represent their own making and are, I suppose, exemplifications of the theory that explains them. And they express a determination to be no more than that, as if Motherwell had decided once and for all to see how far automatism could take him. They enable *us* to see how crucial the factors Motherwell implies in D are: Nothing else, after all, is "unadulterated automatism." Automatism is necessary to the great art he achieved, but not, as philosophers say, altogether suf-

ficient. He tells us he had finished about six hundred when the death of David Smith brought the series to an end. One cannot help but feel that death, friendship, loss reminded him that there was more to art than art.

NOTES

1. Barbaralee Diamonstein, "An Interview with Robert Motherwell," in *Robert Motherwell*, ed. H. H. Arnason, 2d ed., new and revised (New York: Harry N. Abrams, 1982), esp. 228.

2. Preface to Immanuel Kant, *Critique of Pure Reason*, trans. Norman Kemp Smith, 2d ed. (London: Macmillan, 1963), 11.

3. *Discours de la méthode pour bien conduire la raison et chercher la vérité dans les sciences* is the full title of Descartes's text of 1637, which was published together with *La dioptrique, les météores et la géométrie*, characterized by Descartes as "des essais de cette méthode."

4. Diamonstein, "Interview," 228. I find it endearing that Motherwell should have used the word *doodling* where a surrealist would have sought out some immeasurably more portentous term. Doodles, after all, are in their nature ephemeral and rarely of any consequence, though they have a possible diagnostic value. In Frank Capra's film *Mr. Deeds Goes to Town* (1937), a witness in a trial scene uses the word *doodle*, which is not understood by the court. The implication is that it is part of the patois of the bumpkin community from which Mr. Deeds comes, and my inference is that it entered American English through that scene. The scene would not have been funny if the term were part of a viewer's language in 1937.

5. Kant, *Critique of Pure Reason*, 32, 33.

6. And possibly, or at times, he was also interested in the act of pure painting, which of course is a different matter.

7. Arnason, *Motherwell*, 80, 162, reprints the definitions of "open" from the *Random House Dictionary of the English Language*. It encompasses eighty-one entries, plus (as number eighty-two) "the open." As to which of these Motherwell had in mind, he would answer, "I'm open."

8. I once heard Rudolf Arnheim deliver a lecture called, I believe, "The Toad and the Centipede," in which the toad, admiring the grace of the cen-

tipede in its dancing, asks merely what the centipede does with the thirty-seventh leg on the left side when it lifts the seventeenth leg on the right. As the centipede tries to find out, it loses the power of dance. Presumably, it learned to dance by learning to place its legs in prescribed positions, but the action became automatic in a sense of the term in which something can be at once automatic and inspired.

9. James M. Baldwin, ed., *Dictionary of Philosophy and Psychology* (New York: Macmillan, 1901), 1:55–56.

10. Ibid., 56.

11. As it was for his disciple, the painter Gordon Onslow-Ford, who wrote Breton from Mexico that "whether I want it or not, the depths of my imagination are stronger than I am, and it's there that I live" (quoted in Martica Sawin, *Surrealism in Exile and the Beginning of the New York School* [Cambridge, Mass.: MIT Press, 1995], 260).

12. André Breton, *Manifestoes of Surrealism*, trans. Richard Seaver and Helen R. Lane (Ann Arbor: University of Michigan Press, 1972).

13. Quoted in Dore Ashton, *The New York School: A Cultural Reckoning* (New York: Viking Press, 1972), 128.

14. Or in the paintings of Gordon Onslow-Ford. Writes Sawin (*Surrealism in Exile*, 261): "Onslow-Ford was still following a practice of keeping notebooks at his bedside and attempting to draw his dreams while in a semiawake state, so that in its genesis his work was spontaneous and automatist. Yet a large work like *The Luminous Land* was months in the making, its light-dark contrasts carefully worked out."

15. Hal Foster, *Compulsive Beauty* (Cambridge, Mass.: MIT Press, 1993), xii–xiii.

16. Robert Motherwell, "Interview with Sidney Simon: Concerning the Beginnings of the New York School, 1939–1943," in *The Collected Writings of Robert Motherwell*, ed. Stephanie Terenzio (New York: Oxford University Press, 1992), 160.

17. Motherwell to Edward Henning, October 18, 1978, in *Collected Writings*, 230.

18. Ibid.

19. Diamonstein, "Interview," 228.

20. Motherwell to Henning, October 18, 1979, in *Collected Writings*, 229. Motherwell's point, obviously enough, was that Americans do not need to do

something in particular to be American artists. They in particular would not need to paint the American landscape, the folk, or to illustrate American songs. He certainly always thought of himself as American *von Haus aus*, as the Germans say. It is interesting that American English lacks a comparable expression. We have only similes like "As American as apple pie."

21. Ibid.

22. Arnason, *Motherwell*, 172.

23. Diamonstein, "Interview," 229.

24. Nancy K. Miller, *Matta: The First Decade* (Waltham, Mass.: Rose Art Museum, Brandeis University, 1982), 31.

25. Quoted in ibid., 13.

26. Ibid., 31.

27. It would be a marvelous topic for a Saul Steinberg drawing to have the Ghent Altarpiece take form beneath the doodler's pen.

28. Sidney Simon, "Concerning the Beginnings of the New York Art School, 1939–1940: An Interview with Peter Busa and Matta," *Art International* 11 (summer 1967): 18, 19.

29. Motherwell to Henning, October 18, 1978, in *Collected Writings*, 230.

30. Quoted in Simon, "Concerning the Beginnings," 19.

31. I have designated such events "basic action" and have worked out in considerable detail the theory of such actions and the kinds of causation they involve in my *Analytical Philosophy of Action* (Cambridge: Cambridge University Press, 1973).

32. Quoted in Arnason, *Motherwell*, 116.

33. Diamonstein, "Interview," 230.

34. Quoted in Arnason, *Motherwell*, 154.

Art-in-Response

ROBERT IRWIN'S *Tilted Planes* (1978) and Richard Serra's *Tilted Arc* (1981) seem a natural pair for forced comparison, not just because the word *tilted* in both titles implies a shared aesthetic, but because both were intended as exemplars of public art. They were public in the specific sense that each defined a public space the primary users of which were not members of the artworld and so would not have entered the space in question specifically in order to respond to the work as art—though, given the considerable reputation of each artist, there would doubtless have been pilgrims to either site (had Serra's work not been removed and Irwin's not aborted in the planning stage) whose primary interest *would* have been in the art, in particular in the way each work related to its site. *Tilted Arc* and *Tilted Planes*, albeit each in its own markedly different way, referred respectively to Javits Plaza in downtown Manhattan and to the Oval Mall of Ohio State University in Columbus. The primary users of the former space would have been employees and clients of a government building to which the plaza architecturally belonged, and, of the latter, students and teachers entering and leaving the classroom buildings that

Reprinted from *Robert Irwin*, exhibition catalog, ed. Russell Ferguson (Los Angeles: Museum of Contemporary Art; New York: Rizzoli, 1993), 129–51.

ringed the space's perimeter, crisscrossing the somewhat eccentric system of paths that connected entryway with entryway. Each space had a secondary use as a recreational area—a welcome outdoor patch for office workers to take their lunch breaks, and a kind of academic grove in which students grouped on lawns in fine weather, or played frisbee, or, in periods of political effervescence, held demonstrations.

The parallels and similarities of the two works do not extend greatly beyond this point; in fact, they begin here quite radically to diverge. It will serve the purposes of an essay on Irwin's conception of public art to make these divergences explicit, a strategy that will have the incidental effect of underscoring the heterogeneity of the designation and the meaning of the term *public art*. For as public artists, Irwin and Serra could not be more different.

In the first place, *Tilted Arc* dominated the space for which it was conceived to the point where it subverted the basic functions of the space, treating it virtually as if its sole role were to be a kind of extended base for Serra's sculpture. Workers and clients were obliged to find their way round the work in order to enter or leave the building, and it partitioned the plaza as effectively as the Wall cut Germany into distinct geopolitical realities. Never especially hospitable—windy, often wet, shadowed by sullen office structures—Javits Plaza became even less so after it was invaded by Art. Office workers, not educated to the aesthetics of rust, nor in the exquisite placement of works of sculpture, found the work ugly, confrontational, domineering, and alien to the fundamental human purposes the space had heretofore served. Inevitably they protested its presence, making way for a contest between art experts on the one side, whose vision of public art was predominantly aesthetic and for whom it sufficed that Serra's work had unquestioned artistic merit, and, on the other side, the ordinary men and women who may not have seen eye to eye with the experts on matters of what constitutes art but who knew they had been deprived of an amenity rendered suddenly poignant by its loss.

By marked contrast with *Tilted Arc*, *Tilted Planes* would have been all but invisible; indeed, had it been executed as Irwin intended, there would

have been nothing separate and identifiable as *Tilted Planes* that could be seen as such. It would have stood to its site in roughly the relationship in which spirit stands to matter or mind to body; and its near-invisibility would be metaphysically of a piece with the invisibility of each of the left-hand members of these pairs. A photograph of the Oval Mall would ipso facto have been a photograph of *Tilted Planes*, but there would have been no way one could have made a photograph of just *Tilted Planes*, the way one could of *Tilted Arc* by whiting out Javits Plaza. There would have been no difference between figure and ground in Irwin's work, as there is in a photograph that shows *Tilted Arc* with its urban background: in Irwin's work, figure and ground would be *one*. Wittgenstein says, in the *Philosophical Investigations*, that the human body is the best picture there can be of the human mind. In this sense, the Oval Mall would have been the best picture there could have been of *Tilted Planes*. The work would have been everywhere and nowhere. Of course, there would have been some just-discernible differences in the Oval Mall after *Tilted Planes* was made: certain shadows visible from an aerial perspective and, to someone who walked across the space, a certain felt difference—a certain easy change in gradients and some gentle drops. But it would have been altogether possible to traverse the space without recognizing that anything had happened, or that one was walking on a work of art. The Ohio State dean who blocked the project with the wholly understandable query "Where's the sculpture?" asked exactly the right question.

Usually, it is logically implied by the concept of sculpture that there is a "where," a space marked for the placement of the sculpture, which itself has fixed boundaries, *dis*placing a portion of the atmosphere. But this is to assimilate the concept of sculpture to the concept of the *statue*— a movable, detachable piece of worked material such as bronze, aluminum, stone, or steel. In the present case, the boundaries of *Tilted Planes* would have been coincident with the boundaries of the site (which invited an image, under the statue concept of sculpture, of paving the entire space with steel!). But Irwin in fact uses the concept of sculpture in so non- or even so antistatuary a sense that in his view, the Oval Mall

was *already* a work of sculpture, whatever might have been the fate of *Tilted Planes*. As he explained to Lawrence Weschler, "To me, it was already a piece of sculpture. It had all the dimensions and all the properties of a piece of sculpture: physical divisions, both organic and geometric, participation of people, the kinetics of movement. It was already operative in that way." He immediately concedes that "no one but someone like myself who was preoccupied with it would even recognize that idea. Not too many people pay attention to that sort of thing."[1] So *Tilted Planes* would have involved the transformation of one piece of sculpture into a momentously but hardly noticeably different piece of sculpture.

By Irwin's criterion, Javits Plaza too was already a piece of sculpture, but, clearly, an artist like Richard Serra, with his largely statuary concept of sculpture, would hardly have seen it that way at all. His view of the plaza was of an aesthetically undistinguished open space, a pure spatial potentiality awaiting artistic actualization through the placement in it of a work of art. The dean at Ohio State might not have been prepared to accommodate so abstract a presence as *Tilted Arc* to his vision of art, but he hardly could have wondered *where* the sculpture was, supposing it were acknowledged by him as sculpture. This work proclaimed its whereness in its scale, its opacity, its conspicuous fabricatedness. (After its removal, I once suggested a sort of memorial scar, an arc of bronze set flush with the pavement to memorialize where it had been, commemorating the battle in which the public reclaimed its aesthetic rights from the experts.) At the time of the controversy, it was often argued that *Tilted Arc* could not be moved, mainly because its identity as a work was coimplicated with its placement: it was repeatedly insisted that the work was *site-specific*. Irwin characterizes *his* work as *site-generated* instead. Since what I regard as Irwin's most interesting and challenging work is site-generated rather than site-specific, it will be of some value to distinguish the different relationships to site these expressions imply. Irwin himself is at some pains to explain them in his extremely helpful text, *Being and Circumstance*, but it is worth going over this not altogether

familiar ground once again, all the more so in that the dominant impulse of his oeuvre since 1977 is site-generation.

The site-specific work refers to and defines the space into which it is set; and part of its meaning must be specified with regard to these relationships, formal and at times semantical. Thus the curve of *Tilted Arc* may be said in some way to emblematize the shape of the general space for which it was designed; and the assumption is that a quite different work might have been designed had that space been different. Its site-specificity means in effect that the work together with the site form a kind of aesthetic whole: the site is emblematically present in the work, which in turn is a kind of icon for the space to which it inherently belongs. There is certainly a strong distinction between work so conceived and the kind of public art exemplified by what is sometimes disparaged as the "corporate bauble"—a Henry Moore statue placed in front of corporate headquarters, say, proclaiming the commitment to artistic values of the highest sort on the part of the corporation, which enhances its image by association with the recognizable style of a renowned master. Budgets may not always allow, of course, for the purchase or commission of a Moore—or a Calder or a Smith—but then the kind of art displayed will in any case transmit, in the rhetoric of cultural signs, the kinds of values with which the corporation means to identify itself. These works can, often in consequence of their value, be transferred to museums without losing much if anything of their meaning: Michelangelo's *David*, Rodin's *Balzac*, are cases in point, in which an ornamental and symbolic function was overridden by the artistic value of the works, which finally transcended their original sites. They were promoted to the inventory of the world's works of art and placed in protective custody.

In large measure, the same could have happened with *Tilted Arc.* Space was set aside for it, for example, in the Storm King sculpture garden, north of New York, where it might have led a life of pure aesthetic placement forever. Serra resisted this, perhaps rightly, on the grounds

that the work was specific to the site and had no identity apart from it, and he clearly had the courage of his convictions: the work now sits disassembled in storage, perhaps awaiting a Napoleonic return. Now, without question there may have been features of the site without reference to which the work could not have been appreciated in its full meaning. But there are a good many steel arcs by Serra that are every bit as freestanding as the *David*. The work does not wear, so to speak, its site-specificity on its sleeve. And it is not difficult to argue that the main relationship between the steel arc and its place is very largely external and designatory. Its "meaning," that is, does not penetrate its form to any significant extent. The mere fact that it should have occurred naturally to the directors of Storm King that the work could be translocated there is evidence that even in the curatorial mind the work is perceived as having an independent and detachable being. A sign, say a sign that consists in an arrow, is clearly site-specific, in that if it is removed from that to which it was constructed to point, its meaning will have been lost: it becomes an abstract deictic shape. Still, someone could place it in the Museum of Signs. It exists as an object. Even in its present dismantled state, *Tilted Arc* remains an object—so many units of Cor-Ten steel, weighing so much and having thus and such dimensions.

Nothing remotely like this could have been true of *Tilted Planes*. Its being is so indissolubly mingled with the being of its site that it can have no detached and separate existence. It is, as the philosopher Bishop Berkeley once said in regard to minds or spirits, incapable of being an object. Had it been realized as a work and afterward objected to for whatever reason to the point where its removal was mandated, there would really be nothing left over when it was taken away. Or nothing for which a separate site, like that at Storm King, could be imagined. It would revert to mere materials—some truckloads of dirt and a few retaining walls of Cor-Ten steel—and to its previous status as a plan, a project, an idea—which is its present state of being. Its being is merely on paper now, but even had it achieved what philosophers once called "formal reality," in space and time and external to its various represen-

tations in the mind of the artist or in his drawings, it would not have existed as a separable object. It is precisely nonobjective art in the meaning of that term which I hope is now quite clear: it is art that has no separate material existence as an object.

We are now, I think, in a position to say what in that site "generated" *Tilted Planes*, and what in general are the salient features of nonobjective site-generated art as practiced, perhaps uniquely, by Robert Irwin. *Tilted Planes* was among the earliest of Irwin's exercises in what he terms "art-in-response," which means that in contrast with the kind of artist who creates, so to speak, out of his or her own substance a body of works done "on spec," which are then shown, bought, sold, collected, exchanged, Irwin generates art only in response to the invitation to do so, and then in specific response to whatever it was that occasioned the invitation. "I am no longer concerned with the art world context," he confessed to Weschler in 1979. "I'll use any materials, any techniques (I don't care if somebody else is using them or seems to have them earmarked; I don't care if they're thought of as art or non-art), *anything that references against the specific conditions of the site*. Whether it works is my only criterion."[2] No one can really know whether or not *Tilted Planes* works, of course, but Irwin has said on more than one occasion that it is among his most successful pieces to date, which I take as my justification for so protracted a discussion of it as a paradigm of his artistic agenda. As with so many of his projects, this was part of a competition, in this instance sponsored by the University Art Gallery of Ohio State. Strikingly, Richard Serra was in the initial roster of those invited to compete, and though every creative artist is creative in his or her own way, it is not unreasonable to surmise what sort of work he would have submitted. Irwin's proposal was by contrast entirely unpredictable. He approaches a site with nothing specific in mind by way of the art he will propose, letting the work, whatever it is to be, emerge out of the objective conditions of the site as he perceives them. Serra at that time was placing monumental steel sculptures at various sites; Tony Smith—an earlier artist on the short list—would have been placing his signature black metal pieces. These would

be identifiably sculptures in readily identified styles. Irwin, in that sense, has no style, only a philosophy of openness and response, and in truth his proposal on this occasion resembles nothing that had been done before. *Tilted Planes* emerges from his acknowledgment that the Oval Mall was the symbolic and in certain ways the functional center of the institution. His project was finally a response to the question of how to transform into considered art what made the Oval Mall the crucial, indispensable site it was.

This meant a kind of underlining of its most palpable features, which were the various paths that crossed and recrossed the space in a not quite regular pattern of diagonals (fig. 5). The irregularity was due to the fact that the lines reflected paths spontaneously taken by students heading from one building to another, which then were paved after the pattern had been established. It is a kind of monument to the natural being of a given society to trace the patterns of its being onto the surface of the world: a sort of natural script. This characterization, however, treats the paths as figure to the Oval's ground: the grass intersected by the paths is almost read as a blank sheet on which the script unfurled itself. What Irwin did was to reverse the figure-ground relationship, emphasizing the paths by emphasizing the spaces between the paths, which became the "planes" of the title. He did this by literally tilting some of them, transforming them, as it were, into grassed facets of a figure that seemed to conform to a certain fractal formula. The Oval became a sort of three-dimensional entity, and the planes mark the edges and vertices of the now salient planes (fig. 6).

Not all the planes tilt, but the somewhat subliminal difference between those that do and those that don't immediately defines the two distinct kinds of areas that at present intermingle: areas where students engage in strenuous campus recreations (like frisbee throwing) and those where groups sit on the lawns to discuss things or individuals study out-of-doors. This quite geometrical division of function—so different, after all, from planting signs that interdict certain activities and so encourage the possibility of resistance to authority—is typical of Irwin's solution to

Figures 5 and 6. Robert Irwin, *Tilted Planes*, proposed 1978, Oval Mall, Ohio State University, Columbus: project drawing (*above*), inverted to show relation to project model (*left*).

human problems. He is an astute psychologist, and the shapes of his designs reflect, or at least take into consideration, the ways in which the minds of users will characteristically respond: the more strenuous activities find, as it were, their natural sites on the flat planes. But the gradients are sufficiently gentle not to discourage sitting in circles. A further and ingenious feature of *Tilted Planes* is that the edges that are at the highest points above the paths—from eighteen to perhaps thirty inches— constitute what one might designate "natural benches": comfortable, grass-upholstered ledges where pedestrians can sit and let their legs dangle. The edges themselves are neatly formed by bands of Cor-Ten, which, with their natural rusting surfaces, look like sod. So the planes turn insidiously into benches without the need for what Irwin calls "the addition of cumbersome street furniture."[3]

Perhaps a word of criticism might be ventured at this point. One cannot help but wonder to what degree the idea of a grassy natural bench is not an expression of a climatic Southern California optimism, or perhaps of the artist having been somewhat taken in by the idyllic images of students lounging on lawns, beneath the trees, that universities use in their publicity to encourage a certain arcadian vision. Midwestern winters would tend to make "natural furniture" unusable through the many months of the year when "street furniture" would still make possible the taking of the sun of a winter afternoon without getting one's bottom soaked through!

Be this as it may, *Tilted Planes* can hardly be bettered as a teaching example for Irwin's aesthetic and his methodology as public artist. His best response-driven work will be site-generated, will be nonobjective, and will use the natural psychological dispositions of users of the site to provide the ideal amenities of which the site is capable. And of course the work will be unforeseeable: it will require the actual response of the artist to the actual site, at which point his intuitions as to what the site "wants" will be mobilized. There is a certain conceptual precedent for this, perhaps in Michelangelo's famous idea that as a sculptor he sought to discover, literally uncover, the figure already present in the stone, so

that sculpting for him, at least as he saw it, was a procedure for removing matter from form, liberating the figure from the imprisoning stone. Michelangelo would certainly not have thought of himself as imposing his will-to-form on passive matter. Nor does Irwin think this way either. His task as an artist is to give the site, understood essentially in human terms, what the site "wants" for itself, in terms of how it is to be used and what its meaning is to be relative to that use. He has often said in my presence that there may very well be occasions on which the cannon-on-the-lawn is the ideal solution to the kind of problem that defines his art. It might be worth dwelling on this radical and surprising formulation for what it tells us about the way he thinks as an artist.

The cannon-on-the-lawn formulation tells us at the very least that we are not to thematize the tilted triangles and polygons of *Tilted Planes* as evidence of a certain resolute drop-dead minimalism on the artist's part. It is true that his early work bounded on minimalism, though its motivations were almost always different from those that drove the official minimalists of the East Coast. It just happened that the ideal solution for *this* problem called for geometrical shapes. But Irwin was no more wedded to the rhetoric of geometry than he was to certain materials that had become virtual signature materials for him: scrim, as a notable example, or glass or plastic. The materials for *Tilted Planes* are enumerated as "Cor-Ten steel, concrete footings, and re-sod grass." He had already used floral motifs in his work, which the more doctrinaire minimalist would have impugned as "decorative." Such motifs suggested themselves naturally in his 1979 *Filigreed Line* project for Wellesley College, and somewhat less naturally in the *Two Ceremonial Gates, Asian Pacific Basin* (1983), designed for the San Francisco International Airport. He there employs without embarrassment what looks like wisteria blossoms alongside a flowing stream. He really meant it when he emphasized his readiness to "use anything that references against the specific conditions of the site." So why not a cannon, if that should "reference" against the specific conditions of a site? You cannot tell in advance of the invitation what may be called for.

As a philosopher of art, I have often used examples consisting of pairs of objects that are all but indiscernible—that look virtually alike—but where one is a work of art and the other not. My best case was the *Brillo Box* by Andy Warhol, a 1964 sculpture whose photograph would look indistinguishable from the ordinary corrugated cartons in which Brillo pads were routinely packed and which were found in the storerooms of supermarkets. My strategy was in part to emphasize that you cannot define visual art in visual terms alone, since no interesting visual differences exist between *Brillo Box* (for example) and the Brillo boxes. Or, if there are differences, surely the distinction between art and reality hardly can be accounted for in terms of them! The artworld has been exceedingly fertile in such examples: there is no interesting visual difference between the photograph of a sharecropper woman by Walker Evans and its rephotographing by Sherrie Levine. Both, to be sure, are works of art, but they have deeply different meanings and certainly different semantics. Evans's is of a person, Levine's is of a photograph, and a very famous one at that. The difference has less to do with looking than with knowing the history and theory of the two images. After all, the differences between the Oval Mall before and after *Tilted Planes* is minimal and yet in some ways monumental. The patterns would be indiscernible, but the meanings would diverge greatly, in part because *Tilted Planes* would be about the Oval Mall.

So it would be an interesting exercise to try to imagine a site Irwin would respond to by the placement of a cannon and, let us suppose, a neat pile of cannon balls, in contrast with the rather banal sites with cannons and piled cannon balls found in hamlets and villages throughout the nation, from wherever men went off to fight in wars. Our imagined site would resemble these to whatever degree one wishes, and the differences need not be visual at all. It is not for me to construct the scenario in which Irwin's generated response to a site would consist in the cannon. But cannons are symbols drenched in certain generic meanings—of memorialization, of stifled violence, of military narrative, or young persons lost, of the rhetoric of military glory and defeat. The very

presence of cannons must activate a cluster of associations. A critic seeing such work might correctly and at the same time irrelevantly say that "it had all been done before." It would be essential to its meaning that it had been done before. But it would be equally essential to its meaning that it had not been done before at all, for those other cannons would not have been placed there because "it had all been done before"! This cannon would be site-generated and perhaps make reference to all those sites. I can even imagine Irwin designing a cannon and having it fabricated to his specifications. Some of his works look as though they incorporate elements that had been salvaged or found in junkyards, when in truth Irwin designed them, did the drawings, and oversaw their fabrication. He just happened to need something that looked as if it belonged to an earlier era.

The federal eagle, done in a sort of art deco manner, that is a component of *Sentinel Plaza* in Pasadena, California, is a case in point. It is archly styled, faces in the four directions of a compass as a sentinel eagle should, and its wings are drawn up like the closed petals of a lotus flower, but poised for flight. It surmounts a column of cast granite, and is in turn surmounted by a blue-violet lamp that proclaims the identity of the building behind it as in fact a police station. The whole lamp—ornament, column, light—has the air of having been rescued from a site from the WPA years. It and the whole remainder of *Sentinel Plaza* have a kind of cannon-on-the-lawn dimension: the piece looks as though at least parts of it had been there for centuries. There is, for example, a sort of basin with a trough, made of fitted stones and planted about with echeveria—drought-tolerant succulents which emphasize the thin course of water that runs along the trough. In style, it fits the postmodern police building designed by Robert Stern, heavy as it is with Spanish colonial baroque references, such as the heavy volutes above the portico. The basin-with-trough in fact is a kind of fountain, the thin stream of which celebrates the preciousness of water (by contrast with the boisterous fountains of Rome, which celebrate water's plenitude). The desert plants convey the same message. And so does the double-trunked sycamore

tree, by Irwin's reckoning the centerpiece of the work and its most expensive single component. The sycamore, too, has the appearance of having stood there for centuries, casting its sparse shadow over the place, and indeed nothing visual will mark the difference between the tree-as-art and a mere tree that is merely a tree. In fact, the sycamore belongs to a system of symbols already, which is why Irwin chose it. It connotes water: the Indians used to make their kayaks from the trunk. It binds everything in the plaza—the fountain, the plantings, even the riverbed gravel that composes the surface—into a complex of meanings. There is behind this complex a painted wall that has begun to undergo a beautiful patination, insinuating use and wear and age. Someone, hearing that Irwin had executed a commission in Pasadena, might, knowing that he once did minimalist paintings, see the wall as the art, so compelling is the domination by painting of our concept of art. But in fact the wall is no more the art than the tree is or the gravel. The art is one with the place. Work and site are seamlessly a unity.

Close of kin with *Sentinel Plaza* is the unexecuted City Front Plaza, which was to have been in downtown Chicago, in front of the insurance company that commissioned it but filed for bankruptcy before work could begin. It would precisely have illustrated the cannon-on-the-lawn principle, inasmuch as there would have been nothing especially contemporary about the two sixty-foot towers in which the site was principally to have consisted. One of them, indeed, looks as though it might have antedated the Eiffel Tower in its ornamental cast-iron verticality and airy elegance, and the drawings for this tower look as though they were executed by a nineteenth-century draftsman. One might think Irwin would sell these drawings, somewhat in the manner in which Christo markets drawings and prints to finance his various projects.

Irwin refers to these images somewhat disparagingly as "postcards," but his refusal to treat his own drawings as art in their own right goes some distance toward marking the internal difference between public art as he conceives of it and as Christo does, though there are certainly outward similarities between the two artists. For Christo, the political

processes leading up to the execution of the work are, however frustrating, as important as the work, in that the entire community will have been brought into the discussion. For Irwin, all this is external, a matter of obstacles to be gotten round, and often destructive of the work: he told me that of the twenty-five competitions he had won, only one actually achieved completion. And for each of the twenty-four unfulfilled projects, there is a tale of politics, resistance, bureaucracy, suspicion, or, as with the tower complex for Chicago, sheer bad luck: a company fails, a patron dies, the person in authority retires. Christo, again in contrast with Irwin, very much imposes his artistic will on a preexisting site, skirting islands with pink plastic, dotting a landscape with umbrellas, wrapping structures in plastic, piling oildrums up in the shape of a *mastaba*. His work is site-dominant, to use Irwin's vocabulary, rather than site-generated. And because of the notoriety of certain of his works, Christo will often be invited to "wrap something," which a community may perceive as an event with a certain newsworthiness and visibility. Christo interacts with the community, there is an active dialogue, whereas Irwin, while not opposed to education, tries to enlist the psychology of users to achieve the goals of a work, as with the differential gradients of *Tilted Planes*. And then Irwin pretty much depends on his inviters to find the money, whereas Christo makes a point of his work costing the community nothing, of covering all his expenses through the sale of drawings, film rights, publications, and the like. But Irwin's nonobjective conception of art rules out selling what social critics sometimes speak of as commodified art. I don't think Irwin is especially ideological on this point; he is merely consistent with his agenda. So, marvelous as the drawings are, even to the point of exquisiteness, it would be a subversion of their function to treat them as objects-of-art: that is not the way an artist-in-response *works*.

The two towers refer to the surrounding towers of downtown Chicago, to which landscape, of course, they belong. But their reference is far wider than that. Tower One refers to the industrial history of Chicago, set as it is on a base in the form of a gear, soaring upward in a surge of

rotarian confidence to where a flame is lit, of the sort one sees in oil refineries burning off impurities, and serving here as a flambeau of progress. There was to have been a concealed tank so that water could mist down, which would, in winter, freeze along the internal cables. The iced-iron filigree would have been underlit by a blue spot in the base. Thus the complex symbolism of industry and progress would be fused with an Aristotelian symbolism of fire and water (fig. 7). That would leave the elements of earth and air in Tower Two, which, in Irwin's description, is "a stalk-like aluminum shaft that turns into a faceted glass top light." In fact, Tower Two has a certain affinity with the quadruple eagle of *Sentinel Plaza*, inasmuch as it looks like a poised rocket as conceived by a 1930s designer, someone influenced, say, by Raymond Loewy. The rocket form inevitably unites earth and air, poised as it is for flight (fig. 8).

Had the two towers been erected, it is difficult to believe, for all that they refer to and emblematize their towered ambience, that they could be considered altogether nonobjective. One could imagine a time when they might have been removed to some museumlike site, to be sure at a certain loss of meaning, given that the drama of their presence is underwritten by their intended original location. But that danger would not be faced by Irwin's proposal for the expansion of Miami International Airport, which is immeasurably more complex than *Tilted Planes*, but which would have been—which *is*, as concept—no less successful than it. I think it fair to designate the Miami Airport project Irwin's masterpiece (fig. 9). He put several years into developing it and learned a lot from the process. Had the project gone through, it would almost certainly have revolutionized airport design. Miami International Airport would have been a brilliant fusion of function and amenity that would, at the same time, hardly have been noticed as such by its users, even though nearly every move they made in approaching, in waiting, and in leaving the airport would have been subtly directed in Irwin's astonishingly detailed plan. I shall conclude this essay by discussing this extraordinary conception, in which all the components of Irwin's artistic philosophy are brought together and raised to their highest level to date.

Irwin's approach to the airport was characteristically novel, but it was in fact more deeply novel than could be inferred on the basis of his previous response-oriented art, even though the Miami project carries over into the new schematism a great many of the values and strategies inherent in its predecessors. It has become commonplace for airports, like any number of public agencies, to commission a piece of art, but usually this will be by way of adjunction: an artwork is adjoined to an existing complex, and serves as an ornament that does not penetrate the larger meaning of the site. To be sure, artists may make the effort to represent the function of the place in one or another way. The Miami airport had at one point a mural by James Rosenquist, which contained an oblique reference to flight in its iconography. But for the most part, airport public art is typically of the bauble category, a spot of aesthetic afterthought calculated to grace a site whose essential business of moving people off the ground into the air and vice versa goes on perfectly adequately without benefit of the art. Needless to say, this would never have been Irwin's way if he could help it, and he basically reinvented the relationship in which art and the airport experience were to stand to one another. It is a tribute to his considerable powers of persuasion that he actually convinced the airport administration of the viability, indeed of the necessity, of this radical arrangement.

Of course, one could not begin completely from scratch; Miami's was a preexisting structure. Even so, Irwin's idea was that he should participate fully in the planning of the airport, that there should at every stage be decisions in which the input of artists would materially enhance the final result. Irwin devoted himself to establishing the relationship between art and design engineering at crucial points in the passengers' movement through the airport. His project assumes that the airport, the first and last part of the city a traveler experiences, should in some way emblematize the city, rather than serve some impersonal outskirt function, architecturally everywhere and nowhere. This involved him in the design of approach roads, parking, rental car return sites, and of the roads back to the metropolitan center. What is emblematic of Miami is

Figure 7. Robert Irwin, Tower One, proposed 1989, for unrealized City Front Plaza, Chicago: drawing and model.

Figure 8. Robert Irwin, Tower Two, proposed 1989, for
unrealized City Front Plaza, Chicago: drawing and model.

Figure 9. Robert Irwin, Arts Enrichment Master Plan, proposed 1986, for Miami International Airport: airport plan.

the abundance of water (as water is emblematic of Pasadena by its scarcity). The road from airport to city and back again should traverse typical Dade County waterscape, planted with palmettos and reeds. But there should be no scenic distraction at the point of approach, where drivers must find their way to departure, arrival, and parking sites. Irwin designed a cool corridor through which one headed to these various destinations, and the pattern of the driver's experience was an alternation of shade and light. And he designed a marvelous "central park," filled with plant and even bird life, an amenity for spiritual restoration as needed by travelers, leave-takers, and greeters (fig. 10). Artists would enhance the way windows worked, and would collaborate on the placement of Florida-like installations in the various approaches to the gates. In the end, the entire airport would be art, and, of course, it would at the same time be nothing but what it is, a busy international gateway, the users of

Figure 10. Robert Irwin, Arts Enrichment Master Plan, proposed 1986, for Miami International Airport: central park plan view.

which need hardly be mindful of the marvelous way art has been used to ease their passage. One of the goals of art in such projects is, Irwin states in a sort of flowchart, to "heighten awareness." Not to heighten awareness of art as art, but of the dimensions and features of life that art raises to the highest powers of enhancement while remaining invisible, directing the viewer's sensibilities with a kind of aesthetic Hidden Hand.

The great constructivist visionary Alexander Rodchenko invented the slogan "Art into Life!" He meant that artists were not to make the traditional sorts of things—paintings and sculptures—that hang in frames or stand on pedestals in prosperous salons. Characteristically, he and his followers transformed objects of use with fine bold designs: clothing, book covers, stage sets, posters. Irwin has, as with *Tilted Planes*, added a third dimension to this formulation. Anything can be art without having to look like art at all. The task he has set himself, as he says explicitly in the epilogue of his text *Being and Circumstance*, is "to enable us to experience beauty in everything." Art is the means to that end, rather than its object.

NOTES

1. Lawrence Weschler, *Seeing Is Forgetting the Name of the Thing One Sees: A Life of Contemporary Artist Robert Irwin* (Berkeley: University of California Press, 1982), 198–99.

2. Ibid., 193.

3. Robert Irwin, *Being and Circumstance: Notes toward a Conditional Art* (Larkspur Landing, Calif.: Lapis Press, 1985), 43.

The Philosopher as Andy Warhol

"Warhol," Victoria said pompously, "the early Warhol, before
he was shot—"

"Where would America be without Andy Warhol?" I said.
"He put his stamp on American culture. . . . He invented
superstars and all of that shit. It didn't quit with the Tomato
Soup Can. Andy Warhol was a genius. He—what he had, was
this great radio antenna. Picked up on all of the cosmic
vibrations. He just did it, I don't think he knew the half of it.
He was one of those idiot savants, I'm thinking. Your paintings
are too goddamn vague, Vick. I can't get a reading on them."

Thom Jones, "The Pugilist at Rest"

THERE IS A PENETRATING PASSAGE in Virginia Woolf's *To the Lighthouse,* in which the philosopher, Mr. Ramsay, contemplates with a melancholy complacency the power and the limits of his mind. Construing thought as if it were organized in some order of profundity and labeled with the letters of the alphabet, Mr. Ramsay reflects this way:

His splendid mind had no sort of difficulty in running over those letters one by one, firmly and accurately, until it had reached, say, the letter Q. He reached Q. Very few people in the whole of England ever reach Q. . . . But after Q? What comes next? After Q there are a number of letters the last of which is scarcely visible to mortal eyes, but glimmers red in the distance. Z is only reached once by one man in a generation. Still, if he could reach R it would

be something. Here at least was Q. He dug his heels in at Q. Q he was sure of. Q he could demonstrate. . . .

He heard people saying—he was a failure—that R was beyond him. He would never reach R.

It is difficult to repress the speculation that Andy Warhol was alluding to this passage (he was, Barbara Rose once told me, a far more literate man than he cared to let on) in the title of his 1975 publication, *The Philosophy of Andy Warhol (From A to B and Back Again)*. A philosopher who makes it from A to B and has to begin all over again is scarcely a philosopher at all, one might think (though the founder of phenomenology, Edmund Husserl, characterized himself as a perpetual beginner). "From A to B and back again" fits the image of a kind of fool which Warhol sought to project as one aspect of his persona—the image of one of those "pin-headed gum-chewers," as a critic unsympathetic to pop called that generation of artists who had recently invaded gallery precincts in New York, heretofore dominated by the metaphysical heavyweights of abstract expressionism. But to put himself forward in the first instance as having a philosophy at all must have been intended to sound a note of comic incongruity with an artistic corpus that consisted in comic-strip heads, soup cans, Brillo cartons, and like images from what cultural critics were disposed to take as typifying the mindless, tasteless, thoughtless inanities of American popular culture, too sunk in banality to rise even to the level of kitsch. For kitsch at least has ambitions that its audience misconstrues as classiness and artistic seriousness. In the scale of images, Warhol's remain at A: B must have seemed as much beyond his grasp as R was to Mr. Ramsay's "splendid mind."

Since at least Warhol's exhibition of Brillo (and other) cartons at the Stable Gallery on East 74th Street in Manhattan in the spring of 1964, I have felt him to possess a philosophical intelligence of an intoxicatingly high order. He could not touch anything without at the same time touching the very boundaries of thought, at the very least thought about art. The 1975 text, as well as its pendant volume, *POPism: The Warhol '60s*, sparkles with conceptual observations and wit, put forth in the most

piquant aphoristic language ("So full of thorns and secret spices, that you made me sneeze and laugh," Nietzsche says of his "written and painted thoughts" in *Beyond Good and Evil*). I refer, however, to the very art that Warhol's critics saw as mindless and meritricious. Indeed, I believe it was among Warhol's chief contributions to the history of art that he brought artistic practice to a level of philosophical self-consciousness never before attained. Hegel had proposed that art and philosophy are two "moments," as he put it, of Absolute Spirit. (Religion was the third.) In a certain sense, if he is right, there must be a basic identity between the two, and Hegel believed that art fulfills its historical and spiritual destiny when its practice is disclosed as a kind of philosophy in action. That someone as astute as Warhol should have chosen to disguise his depth by what passed as motley in the 1960s has, in its own right, a certain allegorical appropriateness. In any case, I shall, in the essay that follows, endeavor to reveal some fragments of the philosophical structure of Warhol's art. Along the way I shall try to relate it to certain of its art-historical as well as its cultural circumstances. But my essay differs from the standard art-historical exercise in that I seek to identify the importance of the art I discuss not in terms of the art it influenced (or which it was influenced by) but in terms of the thought it brought to our awareness. Whatever he did, "He did it as a philosopher might," wrote Edmund White in a memorial tribute. He violated every condition thought neccessary to something being an artwork, but in so doing he disclosed the essence of art. And, as White goes on to say, all this was "performed under the guise of humor and self-advancing cynicism, as though a chemist were to conduct the most delicate experiments at the target end of a shooting gallery."[1]

I want to illustrate my claims with an initial example drawn from Warhol's films, which, whatever their standing in the history of cinema may prove to be, have an unparalleled contribution to make in our philosophical understanding of the concept of film. I have in mind his *Empire* of 1964, which someone might just wander into under the misapprehension that its title promises one of those sagas of colonization or business,

in which a nation, or a mogul, builds up an empire. It is indeed of epic length, but it is marked by a total absence of incident, and its title is a pun on the Empire State Building, which is its only actor, doing what it always does, namely, nothing. Imagine that someone, inspired by Warhol, were to make a film titled *Either/Or*, "based," as the title promises, on the masterpiece of the celebrated Danish philosopher Søren Kierkegaard. Let the film be just as long as *Empire* (or longer, if you wish) and consist of nothing but the title page of the book. There might, the producer thinks, be an internal joke here for someone who was familiar with Kierkegaard's sly aphorisms, which allow us to ponder the ambiguity in the concept of books, which exist both as physical objects, of a certain color and size and weight, and as objects of meaning, which have a certain content and are in a certain language and are capable, as makes no sense with physical objects, of translation. That ambiguity immediately gets transferred to the concept of being *based on*. Here is one of the aphorisms: "What the philosophers have to say about reality is often as disappointing as a sign you see in a shop window that reads Pressing Done Here. If you brought your clothes in to be pressed, you would be fooled: for the sign is just for sale." The two modes of being of a sign, as one might portentously say, are as a rectangle of plywood with paint and ink on its surface, which costs so many kroner at the store where they make and sell signs; and as an emblem that gives information to potential customers—for example, that they can get their clothes pressed in the place where the sign by convention means that that is what the place where the sign is does as its business. These are also the two modes of being of a book—as something that gets sold by the pound, so to speak, and as something dense with wisdom.

It is this ambiguity that makes the film *Either/Or* a kind of joke, or, for the matter, that makes *Empire* a kind of joke. The same ambiguity in fact generates certain of Warhol's paradigmatic works of art—such as, for signal example, the Brillo boxes, which as works of art have all sorts of rights and privileges mere cartons of Brillo systematically lack, not being art. Here might be two Kierkegaardian/Warholian jokes:

A man sees what looks like an ordinary soap-pad carton in a shop window and, needing to ship some books, asks the shopkeeper if he can have it. The shop turns out to be an art gallery and the shopkeeper a dealer who says: "That is a work of art, just now worth thirty thousand dollars."

A man sees what looks like Warhol's Brillo box in what looks like an art gallery, and asks the dealer, who turns out to be a shopkeeper, how much it is. The latter says the man can have it, he was going to throw it away anyway, it got placed in the window temporarily after it was unpacked.

Perhaps half the visitors to the Stable Gallery were angry that something could be put forward as art which so verged on reality that no interesting perceptual difference distinguished them. And perhaps the other half were exultant that something could be put forward as art which so verged on reality that the two were undistinguished by any interesting perceptual difference. In the early 1960s it was universally assumed that art must be something exalted and arcane, which put one in touch with a reality no less arcane and exalted. The reality on which Warhol's art verged was neither arcane nor exalted: it was banal. And this was perceived as intoxicating or degrading depending on where one stood on a number of issues having to do with American commercial reality, the values and virtues of the commonplace, the role and calling of the Artist, the point and purpose of art. For me, the interesting feature of *Brillo Box* was that it appropriated the philosophical question of the relationship between art and reality and incorporated it into the Brillo box, in effect asking why, if *it* is art, the boxes of Brillo in the supermarket, which differ from it in no interesting perceptual way, are not. At the very least *Brillo Box* made plain that one cannot any longer think of distinguishing art from reality on perceptual grounds, for those grounds have been cut away.

I shall return to this in a moment, but I want first to explain what makes *Empire* finally so philosophical a film. Philosophers from ancient

times down have been concerned to frame definitions—definitions of justice, of truth, of knowledge, of art. This means in effect identifying the essential conditions for something to be an *instance* of art, of knowledge, of truth, of justice. The first thing that might occur to anyone as obvious, in framing a definition of moving as opposed to still pictures, is that the former do and the latter do not show things in motion. A still picture (let us restrict ourselves to photography) can show us things we know must be moving, as in the famous image by Cartier-Bresson of a man leaping over a puddle, but it cannot show them in motion. A motion picture of the same scene would show the trajectory the leaping man describes. And with this the hopeful philosopher of film might suppose something had been nailed down. What *Empire* demonstrates, however, is that something can be a moving picture and *not* show movement. Nothing in the film relevantly changes at all, in fact, although, since the film was taken over an eight-hour stretch, something could have changed irrelevantly: a light in a window might have gone on or off, a plane could have passed, the dusk in fact fell. But none of this is essential to the thought that the entire film could have been made with nothing whatever changing or moving. At once it must become clear that only moving pictures can show stillness, as well as motion. A photograph by Ansel Adams of the Rockies, paradigmatically immobile to the point of being natural symbols for eternity, is a still picture of a still object. Even so, the photograph, we now realize, no more shows the stillness than Cartier-Bresson's shows the motion. Still pictures show neither stillness nor motion. Think, for comparison, of the difference between black-and-white photography and color photography. A black-and-white photograph may be taken of a black-and-white object—a zebra, say. But it does not show the blackness and the whiteness of that object, it merely shows the difference. For all we can tell from a black-and-white photograph, what registers as black *could* be red and what registers as white *could* be pink. A *color* photograph of a black-and-white object actually shows the black and the white of the object. Hence black-and-white

photography, like still photography, is essentially more abstract than its counterpart.

Warhol subtracted everything from the moving picture that might be mistaken for an essential property of film. So what was left was pure film. What we learn is that in a moving picture it is the film itself that moves, not necessarily its object, which may remain still. Warhol's art, in film and elsewhere, goes immediately to the defining boundaries of the medium and brings these boundaries to conceptual awareness. What makes him an artist, however, is that he actually makes the art and is not content with imagining it, after the manner of my *Either/Or.* To sit through an entire seance of *Empire*, all eight or so hours of it, in which nothing happens but nothing, may have the collateral effect of making the experience of time palpable, almost as if in a sensory deprivation experiment. We do not become aware of time in ordinary cinema because too much takes place in time for time itself to become the object of consciousness. Time ordinarily lies outside the experiences with which, as we say, we kill time, seeking distraction. Time is not killed but restored to awareness in *Empire*. And usually, in the ordinary moving picture, the time in the film is a kind of narrative time, so that a century may pass in the course of watching a two-hour film. In *Empire*, narrative time and real time are one. The time in and the time of the film are the same. There is, as with *Brillo Box* and the cartons of Brillo, no interesting perceptual difference between the two.

Finally, with *Empire* we become aware of the material properties of film, of the scratches, the grain, the accidental luminosities, and above all the passing before our eyes of the monotonous band. I think Warhol had an almost mystical attitude toward the world: everything in it had equal weight, it was all equally interesting. Perhaps, in the same vein, it says something about the human mind that under conditions of sensory deprivation it will find interest in the most marginal and unpromising differences. The film is made with the barest equipment, zero degree of intervention, and null degree of editing. It was concerned, rather, with

meaning, material, and, finally, mystery. That it, like *Brillo Box* itself—like almost everything to which Warhol put his hand—should have the form of a philosophical joke bears out a conjecture of Wittgenstein's that it is conceivable that a philosophical work could be composed that consisted solely of jokes. They have to be the right kinds of jokes, of course. There is an astronomical distance between Warholian jokes and the one-liners Richard Prince, for example, incorporates into his paintings.

For one thing, Warhol's jokes aren't funny. There was, in my recollection, a spirit of play in the Stable Gallery nearly thirty years ago. But the boxes on display where not made in the spirit of play. Nor do I think Warhol was capable of play. His seriousness seems almost otherworldly. There is a widely repeated story of a scolding given him at a Long Island party by Willem de Kooning. "You're a killer of art, you're a killer of beauty," de Kooning said, and it is clear that he hated Warhol for taking away from art everything that made art fun. So it is easy to understand why his indictment continued: "and you're even a killer of laughter." Who goes to the movies for philosophical instruction? Someday a gifted person should write a book about styles of artistic wit, comparing along the way de Kooning's and Warhol's. An incidental by-product of such an inquiry would be to illuminate the deep difference between de Kooning's "Woman" series and Warhol's Marilyns. The act of painting and the act of love were near affines for de Kooning. Warhol, a far less primordial person, found the essence of women to consist of the images of women that form the common consciousness of sex. The art and the wit of these two men are determined by this difference.

I want to pursue somewhat further the deep philosophical bearing of Warhol's central achievement as part of the classical phase of pop art in the early 1960s. There are a great many questions that must be answered before we have a full historical understanding of this extraordinary movement, and in particular of what it meant that imagery was appropriated from all across the face of commercial and mass culture. It was often suggested, even by some of the pop artists themselves at the time, that their

intention was to blur if not obliterate the boundaries between high and low art, challenging, with commercial logos or with panels from comic strips or advertisements from newspapers and magazines, distinctions taken for granted in and reinforced by the institutions of the artworld— the gallery, with its decor and the affected styles of its personnel; the collection; the carved-and-gilded frame; the romanticized myth of the artist.

Despite this overall commonality, differences among the pop artists must be made. In 1962, for example, Roy Lichtenstein painted a work that looked like a monumentalized composition book of the most familiar kind, with black-and-white mottling on the cover and a label that says "Composition." Iconographically, it looks very much as if it goes with the soup cans and the like that Warhol made, but in fact it has a different meaning altogether. The word *Composition* is something of a pun, for it of course refers to the way artists arrange forms in pictorial space. And the black-and-white mottling looks like the all-over composition for which Jackson Pollock had earned high critical praise. The whole work makes a number of sly artworld allusions, and is in every sense a piece of "art about art," as such work came to be known. It is like Lichtenstein's painting of large brush strokes in which he lampooned the veneration of the heavy looped swirl of paint that emblematized abstract expressionism. Mockery is one of the armaments of civilized aggression, and Lichtenstein's work is filled with internal artworld barbs.

I tend to think Warhol's jokes were of another order altogether, and had little to do with insider attacks on the pretensions of the artworld. Rather, he was asking where the distinction is to be sited between art, high or low, on the one side, and reality on the other. This in a way was a question that had driven philosophy from Plato onward, and while it would be preposterous to pretend that Warhol generated the kind of systematic metaphysics that seeks to define the place of art in the totality of things, he did, in a way that I think had never been achieved, demonstrate what the *form* of the philosophical question must be. And in doing this he invalidated some two millennia of misdirected investigation. I want to propose that the imagery of pop enabled him to do this.

There is a famous section of Wittgenstein's *Philosophical Investigations* in which the author seeks to call into question the idea of philosophical definitions, asking whether they can be achieved and whether there is any point in achieving them. Wittgenstein uses the example of games, and asks us to try to imagine what a definition of "game" would look like. He asks us to "look and see," and then, when we have complied, we will see that there are no overarching properties shared by all the games and only games. Rather, games form a kind of "family," the members of which share some but by no means all properties. And yet, Wittgenstein says, we all know what a game is and have no difficulty recognizing something as one without benefit of a definition. So what's the point of pursuing it? His followers not long afterward applied this strategy to art, where similar reasoning suggested that artworks form a family rather than a homogenous class, that there are thus no properties common and peculiar to works of art, and anyway we all know which are the works of art without benefit of such a definition. The upshot, these philosophers argued, is that the long search for definitions was misguided.

It is against this background that Warhol's Brillo boxes seemed to me to have something significant to say. A photograph of Warhol among his boxes looks indiscernible from a photograph of a stockroom clerk among the boxes in the supermarket. With what license can we pretend to tell the work of art from the mere utilitarian object? One is made of plywood, the other of corrugated cardboard, but can the difference between art and reality rest on a difference that could have gone the other way? In the end, there seems to be a "family resemblance" far more marked between *Brillo Box* and the Brillo boxes than between the former and, say, any paradigmatic work of art you choose—*The Night Watch*, say, which in fact seems to have exactly as many resemblances to the Brillo cartons as to *Brillo Box*. After all, experts in the artworld at the time were quite ready to consign Warhol's Brillo boxes to some less exalted category than sculpture, making them subject to customs taxes when a gallery sought to import them into Canada. The point is that the difference between art and reality is not like the difference between Bactrian

camels and dromedaries, where we can count humps. Something cannot be a Bactrian camel that looks just like a dromedary, but something can be an artwork which looks just like a real thing. What makes the one art may be something quite invisible, perhaps the way it arrived in the world and what someone intended it to be.

Brillo Box does for art what *Empire* does for film. It forces reflection on what makes it art, when this will not be something that meets the eye, just as the film demonstrates how little is required for something to be a film. To see *Empire* as film is to shelve as inessential a lot of what theorists have supposed to be central to film, all of which Warhol unerringly subtracted. Edmund White puts it perfectly:

> Andy took every conceivable definition of the word *art* and chal-
> lenged it. Art reveals the trace of the artist's hand: Andy resorted to
> silk-screening. A work of art is a unique object: Andy came up with
> multiples. A painter paints: Andy made movies. Art is divorced from
> the commercial and the utilitarian: Andy specialized in Campbell's
> Soup Cans and Dollar Bills. Painting can be defined in contrast to
> photography: Andy recycles snapshots. A work of art is what an
> artist signs, proof of his creative choice, his intentions: for a small
> fee, Andy signed any object whatever.[2]

This list could be protracted indefinitely. To be sure, Warhol's way was clearly a *via negativa*. He did not tell us what art was. But he opened the way for those whose business it is to provide positive philosophical theories to at last address the subject. It is difficult to pretend that Warhol's intention was to clear the underbrush and make room for a finally adequate theory of art. In some ways it is perhaps impossible to say what his intentions ever were. White, perhaps for effect, called him "a brilliant dumbbell." The speaker in Thom Jones's story says, "I don't think he knew the half of it." Warhol's name is associated with frivolity, glamor, publicity, and making it big. The awesomeness of his achievement is that under the guise of the simple son of the fairy tale, seemingly no match for his daunting siblings, Warhol made the most profound conceptual

discoveries, and produced examples of pure art that appear uncannily to look like examples of pure reality.

The question inevitably arises of the extent of Warhol's originality in this matter, inasmuch as the precedent of Marcel Duchamp casts a certain shadow over all subsequent efforts to draw the boundaries of art. In writing about Warhol, one cannot evade the question of the relationship between what he did with *Brillo Box* and what was achieved with the readymades of Duchamp. "Aesthetic delectation is the enemy to be defeated," Duchamp had said in connection with this genre of work, and the readymades, according to him, were selected precisely for their lack of visual interest. And for the most part, Duchamp did not endeavor to exhibit the readymades (with of course one notorious exception). Thus one snowy night he walked into the Arensbergs' apartment in New York carrying a snow shovel, which was the work *In Advance of the Broken Arm*, and my sense is that this was a relatively private performance for a small and extremely sophisticated group whose members appreciated and perhaps venerated Duchamp as a novel kind of artist and thinker. The "notorious exception," of course, is *Fountain*, which Duchamp endeavored to exhibit in 1917 with the Society of Independent Artists at Grand Central Palace. That show was to have been a kind of *salon des indépendants*, hence was to have no jury and award no prizes. It was nonetheless rejected by the hanging committee on the grounds that, while any work of art was acceptable, this was not a work of art. And the "work" was hustled out and taken to Stieglitz's gallery 291, where it was photographed by the master (with what appears to be an exhibition entry card wired to one of the bolt-holes). Stieglitz was particularly sensitive to the issue of something not being art, inasmuch as one of his main struggles was to get *photography* accepted as art. It is certainly true that Duchamp was pressing against the Independents' conception of art, but my sense remains that this, too, was a precocious performance, inasmuch as *Fountain* itself disappeared when 291 closed the month it was photographed. Evidently nobody came to pick it up, and in my imagined scenario, the

workmen threw it out as so much detached plumbing. Its point had been made (and got underlined with the issue of Duchamp's ephemeral magazine, *The Blind Man*, devoted to "The case of R. Mutt," that being the name with which Duchamp signed it). Maybe Duchamp thought he could pick up another urinal at need, which proved false: that particular line of urinal disappeared, and not even the Museum of Modern Art, with all its resources, was able to find an exact duplicate for its High and Low show of 1990.

Duchamp perhaps felt that, except for the specific occasion of the Independents' exhibition, exhibiting the readymades would be inconsistent with his anti-aesthetic agenda. Not even the Arensberg group was indifferent to aesthetic considerations, and tended to think that what Duchamp was bent on was defamiliarizing the urinal, revealing its inherent aesthetic merits and even its formal parallels with the sculpture of Brancusi which they so admired. Oddly, this may not have been altogether remote from Warhol's intention, just because of his propensity to find not so much beauty *in* the banal as to find the banal *as* beautiful. There is a sense in which Warhol really was moved by the everydayness of everyday things, and this is central to his artistic projects. Whereas Duchamp, so far as one can rely on anything he wrote for *The Blind Man*, claimed only that R. Mutt was seeking only to put in place "a new piece of thought" for the object. Perhaps among other things he was using the banal as a kind of battering ram against the fortified concept of art which the Independents thought they were democratizing by waiving admissions criteria, it never occurring to them that "work of art" was now as elastic a concept as Duchamp demonstrated it to be. Still, he did not raise the question in its vivid Warholian form. Perhaps he made the point that a urinal can be a work of art, anticipating the dictum ascribed to Warhol that "anything can be a work of art." He did not, however, raise the other part of the question, namely: Why were all other urinals not works of art? But that was Warhol's marvelous question: Why was *Brillo Box* a work of art when the ordinary boxes of Brillo were merely boxes of Brillo? (As an ironic footnote, I must point out that the actual Brillo box was

designed by Steve Harvey, a second-generation abstract expressionist who had turned his hand to commercial design.)

Moreover, the urinal is a highly charged object, associated with some of the most heavily defended boundaries in modern society, namely the differences between the sexes, the segregation of the processes of elimination from the rest of life, and a whole host of associations having to do with privacy, sanitation, and the like. *Brillo Box* by contrast has no such traffic with the forbidden and the imperative. It is public, bland, obvious, and uninteresting. It was part of Warhol's personality (and not merely as an artist) to find the uninteresting interesting and the ordinary extraordinary. "Isn't this a wonderful world?" was something Roy Lichtenstein told me Andy used to say. What he liked about the world was the way it was, exactly in the form in which aesthetes might have found it offensive. Philosophy, Wittgenstein once said, leaves the world exactly as it found it. Warhol, in his uninflected way, did slightly more than leave the world alone: he celebrated the way it was. "The Pop Artist did images that anyone walking down Broadway could recognize in a second—comics, picnic tables, men's trousers, celebrities, shower curtains, refrigerators, Coke bottles—all the great modern things the Abstract Expressionists tried so hard not to notice at all." Elsewhere he once said, "Pop art is a way of liking things."[3] So it was not just the ordinariness of ordinary things that came to constitute his subject matter. His art was an effort to change people's attitudes toward their world. It might almost be said, paraphrasing Milton, that he sought to reconcile the ways of commerce to those who lived the world it created. It just happened that in so doing, he made a philosophical breakthrough of almost unparalleled dimension in the history of reflection on the essence of art. In fact, as I have said, he could not have made this breakthrough had he not been as involved as he was with just those objects the "Abstract Expressionists tried so hard not to notice."

This raises a further point. Only when someone thinks enough of the most ordinary objects—objects "despised and rejected" by anyone with taste, anyone interested in "higher things," anyone interested in art as

high culture—when someone thinks in fact that they are wonderful, equal to any artwork in existence, only then could that person put these things forward as art. Still, however greatly one is moved by the ordinary objects Warhol so clearly was moved by, the thought could not have been available that they might be turned into art until that had become an actualizable possibility within the history of art. He had to have been *able* to do this. "Not everything is possible at every time" is the great empowering thought of Heinrich Wölfflin. We must then ask what it was that made *Brillo Box* possible in 1964, when it was actually made and exhibited. It was always possible for such an object to exist. The question is, what did it take to make it possible for that object to be *art*?

I begin by considering the negative dimension of pop: what the movement was *against*. The immediate target was the pretensions of what in New York had taken upon itself the mantle of high art, namely abstract expressionism, with its celebration of the self, of the inner states that painting allegedly made objective, and of paint itself as the medium par excellence through which these inner states were externally transcribed. In a certain sense, abstract expressionist painting was a kind of private pictorial language, a turning away from the public and the political in the interest of producing an art that was, in the words of Robert Motherwell, "plastic, mysterious, and sublime." Motherwell, whose sympathies were inherently European, felt that in achieving this the New York School (the label was his) had gone well beyond whatever had been attained by the School of Paris, not one of whose painters, wrote Adolph Gottlieb and Mark Rothko in a famous letter (published in the *New York Times* on June 7, 1943), "is a sublime painter, nor a monumental one, not even Miró." They went on: "To us, art is an adventure into an unknown world. . . . The world of the imagination is fancy-free and violently opposed to common sense." The "unknown world" was of course the sphere of the Unconscious, which artists then sought access to through one or another device of automatism. Dore Ashton, in her authoritative 1972 text on the New York School, articulates superbly the canonical

artistic mentality of those years; she discusses a passage from Jung, whose ideas had had a considerable impact on the reflections of the New York painters, preeminently, of course, Jackson Pollock:

> Recoiling from the unsatisfactory present, the yearning of the artist reaches out to that primordial image in the unconscious which is best suited to compensate the insufficiency and one-sidedness of the spirit of the age. The artist seizes the image and in the work of raising it from the deepest unconscious he brings it into relation with conscious values, thereby transforming its shape until it can be accepted by his contemporaries according to their powers.[4]

Gottlieb and Rothko wrote: "Only that subject-matter is valid which is tragic and timeless. That is why we profess spiritual kinship with primitives and archaic art." The New York painter, in brief, sought to escape the "insufficiency and one-sidedness of the spirit of the age" and to help his contemporaries do so as well. This was to be achieved by connecting them to the powerful contents of the unconscious mind, where they would touch something universal and "tragic." These artists were readers of Freud and Jung, and of the anthropologists; and their reading lists were given them by the surrealists, who had fled a continent at war to form an encapsulated community in New York. So powerful was the impact of surrealism on the small circle of original painters in New York that Motherwell, at one point, proposed naming their collective style "abstract surrealism."

In turning against abstract expressionism's self-proclaimed heroism almost with a sense of revulsion in the early 1960s, artists along a wide spectrum, which included pop, minimalism, and Fluxus among its sectors, were not simply opposing a formal agenda having to do with the way to paint and the meaning of the painterly gesture. They were taking a stand against a certain philosophy of the artist, a certain philosophy of mind, a certain view of society, and in many cases they found themselves not uncomfortable in "the unsatisfactory present" that the New York School members felt to be so altogether alien. Abstract

expressionism, if we accept the formulation of Gottlieb and Rothko, was in fact a form of cultural criticism; in particular, it was an indictment of the values of a commercialized, "capitalist" society in favor of one more primitive and more true to human nature understood as embodied in the symbolic contents of the unconscious mind. The expressionists sought to live amid the "great modern things" much in the way the surrealists lived in American society, not even bothering to learn the language. To the degree that they paid attention at all to the culture of the world they turned their back to, it was to dismiss it as "kitsch," to use the word Greenberg gave currency to in his great essay of 1939, "Avant-Garde and Kitsch."[5] And while minimalism and Fluxus went their own somewhat different reductionist ways, pop, and with pop, Warhol particularly, affirmed everything for which the older movement stood: the ordinary world as against the "unknown world"; the objects everyone knew and recognized in "a split second," as opposed to objects pulled out from the dark depths of the unconscious, which can be made present only in strange and distorted forms; the comic as opposed to the tragic; and the actual world as opposed to something timeless, primordial, and universal. And this meant that pop affirmed the reliable symbols of everyday life as against the magical, the shamanistic, and the arcane. The pop artists cherished the things the abstract expressionists found crass beyond endurance.

Since we are speaking of "the spirit of the age," it is perhaps of some value to pause and reflect on some parallels between what Warhol was doing and what some of the advanced philosophers of the time were doing. The latter, largely under the influence of the late philosophy of Wittgenstein, were making a certain return to ordinary language the center of their thought: precisely, the language of the marketplace, the nursery, and the street, the language everybody knows how to use in the commonplace situations that define the common life. This requires some explanation.

In the period up to and following World War II, philosophical attitudes toward common sense and common speech were by and large

contemptuous—neither of them was deemed adequate for the exalted purposes of philosophy. Common sense gave no adequate reading of the way the world really is, as we know it through the discoveries of science. Science, especially modern physics, tells us things inconsistent with common sense, which must, accordingly, be false. But ordinary language, as modern logic revealed, is prone to paradox and hence inadequate to serve the descriptive purposes of science. (Even Freud credited himself, through his discovery of the unconscious, with having dealt a blow to common sense.) The task of philosophy was to construct an impeccable ideal language suited to house the truths of science, and mathematical logic offered a magnificent tool for this rational reconstruction. Wittgenstein's early masterpiece, the *Tractatus Logico-Philosophicus*, was precisely an effort at designing an ideal language in which whatever was legitimately sayable could be said.

All this changed abruptly in the 1950s, in a shift as dramatic and as climactic as the shift later in that decade from abstract expressionism to pop, and as unimaginable in its way as it would have been to suppose that serious artists would one day paint uninflected pictures of Donald Duck or Mickey Mouse. There was nothing internal to either art or philosophy that explains the shift—it seems to have come from outside, from exactly "the spirit of the times." All at once the project of an ideal language seemed as preposterous as the claims of the New York School seemed pretentious. Here is a pertinent observation by one of the leaders of the so-called "ordinary language" movement, the Oxford University professor J. L. Austin:

> Our common stock of words embodies all the distinctions men have
> found worth drawing, and the connexions they have found worth
> making, in the lifetimes of many generations: these surely are likely
> to be more numerous, more sound, since they have stood up to the
> long test of the survival of the fittest, and more subtle, at least in all
> ordinary and reasonably practical matters, than any that you or I are
> likely to think up in our arm-chairs of an afternoon.[6]

One might substitute "psychoanalyst's couch" for "armchair" and come up with a formulation of the pop artist's position as against the abstract expressionist. The abstract expressionists, of course, insisted that their paintings were not without content, but in fact had the deepest possible content. But as David Hockney somewhere remarked, the surface is deep enough. Nothing could be deeper or more meaningful than the objects that surround us, which are "more numerous, more sound, and more subtle" than all the portentous symbols dredged up in sessions of Jungian analysis, about which ordinary people know nothing and regarding which artists may be deluding themselves in supposing they know more.

The terms of the discussion have of course changed, in philosophy no less than in art, since the late 1950s and early 1960s. Today the controversy in philosophy has to do with whether our ordinary explanations of human conduct—what is derogatorily termed "folk psychology"—does not constitute a leaky theoretical vessel for deep understanding of ourselves, and whether it must not be replaced with the language of neuro-computationalism. The transformations in the terms of artworld controversy are no less striking. As the 1960s wore on, the world that Warhol rhapsodized in his flat descriptive way, like the form of society it embodied, came under various forms of intense cultural criticism. There was a resurgence of left-wing radicalism stimulated by the Vietnam War, and then a search for alternative lifestyles remote indeed from the refrigerators, shining sinks, warm yummy soups, and pantries stocked with ketchup and canned goods of high pop. Warhol was shot in 1968, by which time his own aesthetic had undergone a certain evolution. "The early Warhol, before he was shot . . . ," was the transfigurationist of the commonplace. As the 1970s wore on he became a different kind of artist, more obsessed with glamor, nightlife, and the darker dimensions of gay culture.

But I am ahead of my story. I had intended to give some explanation of how the exaltation of the ordinary helped raise art to a consciousness of its philosophical nature. The abstract expressionists certainly regarded

themselves as metaphysicians in paint, and believed their art to connect with an array of meanings to which they had access through the unconscious. They used with flourish the language of philosophy, and spoke with familiarity of the self, the noumenon, the *Ding an sich*. The ordinary world was, as in a great tradition beginning at least with Plato, misprised as inferior, as mere, as alien in relationship to the reality they believed themselves in touch with. The relationship between art and reality could not be framed in the structures they allowed themselves. It could only be framed when it became possible to accept the ordinary and to see that something could be art and yet look as much like an ordinary object as one ordinary object looks like another—the way *Brillo Box* resembles Brillo boxes as much as they resemble one another. Once that was seen as possible, it became instantly clear that art was not the way abstract expressionist theory required it to be, and could not be philosophically grasped as long as it was conceived that way. Philosophical understanding begins when it is appreciated that no observable properties need distinguish reality from art at all. And this was something Warhol at last demonstrated.

I have often found myself struck by the irony that someone so outwardly unlikely as Warhol, who seemed to the artworld so little possessed of intellectual gifts and powers, so cool, so caught up in low culture—in kitsch!—should in fact have displayed philosophical intuitions quite beyond those of his peers who read Kant and spouted existentialism and cited Kierkegaard and used the heaviest, most highfalutin vocabularies. When I claimed, in an essay I published at the time of his posthumous retrospective exhibition at the Museum of Modern Art, that he was the nearest to a philosophical genius that twentieth-century art had brought forth, I was looked on with some incredulity by a good many of my friends, who held him in very low intellectual esteem. It is true that one of Warhol's contributions to culture was a certain look—that of the leather-clad, pale, lank night-child, monosyllabic and cool, unmoved by "art, beauty, and laughter," to cite de Kooning's trinity. But that persona was itself one of his works—a certain embodiment of "the

artist of modern times." He achieved something antipodal to the paint-smeared proletarian persona of the Cedar Bar: he became what he did. In an interview published in the month of her death, Eva Hesse expressed her unqualified admiration for Warhol because his art and his life were one.[7] That was the way to be, she felt, and she aspired to that unity herself. It is in any case not necessary, in order to display the utmost philosophical acuity, to wear tweeds and elbow patches and peer out at the work through pipe smoke.

His work and his life were one because he transformed his life into the image of an artist's life, and was able to join the images that composed the substance of art. Unlike Duchamp, Warhol sought to set up a resonance not so much between art and real objects as between art and images, it having been his insight, as my aphorism from Kierkegaard implies, that our signs and images are our reality. We live in an atmosphere of images, and these define the reality of our existences. Whoever and whatever Marilyn Monroe actually was is hardly as important as her images are in defining a certain female essence, which, when it was vital, condensed mens' attitudes toward women and womens' attitudes toward themselves. She *was* her images, on screens and in magazines, and it was in this form that she entered common life. She became part of our own being because she occupied the shared consciousness of modern men and women the world around. Nothing could be hauled up out of the depths of the unconscious that could possibly have the magic and power of Marilyn.

Warhol's art gave objectivity to the common cultural mind. To participate in that mind is to know, immediately, the meaning and identity of certain images: to know, without having to ask, who are Marilyn and Elvis, Liz and Jackie, Campbell's soup and Brillo, or today, after Warhol's death, Madonna and Bart Simpson. To have to ask who these images belong to is to declare one's distance from the culture. This made Warhol an utterly public artist, at one with the culture he made objective. There are connected with this two forms of death—the cessation of life and the obsolescence of one's images. When no one recognizes who

a photograph is of, only then is the subject of that photograph irrecoverably dead. True fame in the modern world is to have one image recognized by persons who never knew anything but the image. True immortality is to achieve an image that outlasts oneself, and that continues to be part of the common mind indefinitely—like Charlie Chaplin, or JFK, or Warhol himself. His self-portraits are portraits of his image, and hence as much and as little him as his portraits of Marilyn are "really" her.

To have one's image make it into the common culture is to be a star, in Warhol's system of the world: a movie star, a rock star, a political star, a star of the supermarket shelf, or, fairly rare, an art star. Jackson Pollock became an art star, perhaps the first one in America, through the *Life* magazine article devoted to him in 1949. Everyone stored Pollock's glowering face, but more important, everyone, everywhere, could recognize, instantly, *a* Pollock. De Kooning, far more highly regarded in some critical circles than Pollock, never became a star. Picasso's great face made him a sort of star, but Braque, far more handsome, never became one. There are no art stars among our contemporaries, no one everyone knows, except perhaps Cindy Sherman. In Greenberg's celebrated taxonomy, stars are kitsch because their place of being is the common mind. This makes art stars kitsch, even if their art is avant-garde. This mixing of categories doubtless contributed to Warhol's being held in suspicion if not disdain in high critical circles in America, which found it hard to accept that making kitsch avant-garde was any kind of contribution at all.

Warhol invented a form of portraiture that henceforward specified the way stars would appear. Everyone he portrayed became instantly glamorous through being tranformed into the unmistakable Warholesque image: Liza Minnelli, Barbra Streisand, Albert Einstein, Mick Jagger, Leo Castelli. The art dealer Holly Solomon commissioned her portrait and exclaimed over the way Warhol turned her into "this Hollywood starlet." But in an odd way there was a certain equality in the subjects: just as the Coke drunk by Liz Taylor is no better than the one

drunk by the bum on the corner, so Chairman Mao is no more a star than Bianca Jagger, and the black and Latino transvestites of the print series "Ladies and Gentlemen" are no less—or more—glamorous than Truman Capote or Lana Turner . . . or the Death Star is no different from the human skull. This is how one looks in one's own fifteen minutes of world fame. "If you want to know all about Andy Warhol," he said in an interview in 1967, "just look at the surface."

There is more to it than that. He turned the world we share into art, and turned himself into part of that world, and because we *are* the images we hold in common with everyone else, he became part of us. So he might have said: if you want to know who Andy Warhol is, look within. Or, for that matter, look without. You, I, the world we share are all of a piece.

NOTES

1. Quoted in *Andy Warhol: A Retrospective*, ed. Kyneston McShine (New York: Museum of Modern Art, 1989), 441.

2. Ibid.

3. Quoted in ibid., 416, 441.

4. Dore Ashton, *The New York School: A Cultural Reckoning* (New York: Viking Press, 1972), 124.

5. Clement Greenberg, *Perceptions and Judgments, 1939–1944*, vol. 1 of *The Collected Essays and Criticism*, ed. John O'Brian (Chicago: University of Chicago Press, 1986), 5–23.

6. J. L. Austin, "A Plea for Excuses," in *Philosophical Papers*, ed. J. O. Urmson and G. J. Warnack (Oxford: Clarendon Press, 1961), 130.

7. Cindy Nemser, "An Interview with Eva Hesse," *Art Forum* 7 (May 1970): 59–63.

Illustrating a Philosophical Text

Mel Bochner's Wittgenstein Drawings

MODERN LINGUISTIC THEORY HAS TAKEN as its central theoretical concept that of *competence in a language*. A speaker, when competent, is able to produce infinitely many novel sentences in his or her language and to understand the sentences produced by other competent speakers. But none of these sentences will have been learned as such. The sentence I began with, for example, may never have been written down exactly as I wrote it, notwithstanding which, competent readers of English will grasp what it means. Unlike words, which must perhaps be learned one at a time through definitions of various sorts, sentences seem like creative products of competent speakers. A dictionary can be imagined which houses all the words that compose the vocabulary of our language, but there can clearly be no such reference work that contains all the language's sentences! To account for this astonishing yet species-wide capability, linguists have postulated some internal mechanism, through which children are able to formulate theories of the language they grow up using. It is this innate mechanism, whose properties are not of course

Originally published as the Introduction to Ludwig Wittgenstein, *On Certainty*, ed. G. E. M. Anscombe and G. H. von Wright, trans. Denis Paul and G. E. M. Anscombe, with twelve illustrations by Mel Bochner (San Francisco: Arion Press, 1991).

fully understood, that enables any child to learn any natural language as its first language.

There is another kind of competence that cannot be accounted for in quite this way. To understand a language is to be able to say, for any sentence one encounters, under what circumstances that sentence might be appropriately used. Wittgenstein wrote, in *Philosophical Investigations*, 1.19, "To imagine a language means to imagine a form of life." But this means our languages so connect with the lives we lead that we can say, almost always, where, in the course of life, one would have occasion to use any sentence we understand. We can imagine little scenarios in which, for example, a sentence like "Roses are red" would be the appropriate thing to say and be taken as appropriate by those who share our form of life. From this perspective, to understand a sentence is to know how to use it, virtually as an instrument for the facilitation of the form of life to which it belongs: its meaning would be its *use*. Wittgenstein is recorded as having said to one of his disciples, Norman Malcolm, a professor of philosophy at Cornell University as well as one of Wittgenstein's first biographers, that "an expression has meaning only in the stream of life." And part of Wittgenstein's method as a philosopher consists in reminding us of the facts of usage, of getting us to imagine having to explain to a child, or to a foreigner, under exactly what circumstances of life a given expression has a natural and obvious use. If, on the other hand, we cannot imagine this, cannot think of how to put the expression to work, then the suspicion is unavoidable that, in having no use, the expression has no meaning. To be nonsense is the same as having no recognizable function.

So far as he offers an explanation of this sort of competence, Wittgenstein appears to suppose that it derives from the fact that our beliefs form a kind of system: "When we first begin to *believe* anything, what we believe is not a single proposition, it is a whole system of propositions (Light dawns gradually over the whole)" (*On Certainty*, §141). Each sentence has, one may suppose, a place in the system, and the whole is activated with each of its applications. That is why imagining a use for a

sentence, in effect, is constructing a sort of scenario, or what he some-
times refers to as a language-game: the sentence goes with other sen-
tences and actions in such a way that the other sentences implied by any
given one seem to fall naturally into place. Whatever language-game a
speaker might inaugurate in saying "Roses are red," I participate in that
game by saying, perhaps, "But violets are blue," or perhaps, "And yet
some are yellow," or even, "They are my favorite flowers." Or I could
say, "Yes and no." But if the speaker just looks blank when I say these
things, fitting a context of words around his words, I must begin to take
seriously the possibility that he meant nothing by what he said, that he
was perhaps a sort of human parrot, deficient in the rules of utterance,
perhaps an idiot who had learned to make just that sound.

The presumption of meaninglessness for the isolated sentence or
expression is conveyed in a wonderful metaphor Wittgenstein used in the
Investigations: "A wheel that can be turned though nothing else moves
with it, is not part of the mechanism" (§271). And this means expressions
get their meaning through the other sentences or expressions they
engage when they are used. It was Wittgenstein's rather special view of
language as *philosophers* seek to use it that it is composed of wheels uncon-
nected with life, and hence which turn nothing else when they are rotated:
"Philosophical problems arise when *language goes on holiday*" (*Philosophi-
cal Investigations*, §38). And part of his strategy for dismantling the pre-
tensions of philosophy consisted in showing that, as no scenarios can
spontaneously be constructed for philosophy's utterances, they lack
meaning as they lack use. However deep and full of portent philosophi-
cal language appears to be, in the end it is nonsense through its incapac-
ity to do the work language does. In the *Tractatus Logico-Philosophicus*,
Wittgenstein had written (at 4.003): "Most propositions and questions,
that have been written about philosophical matters, are not false, but
senseless." Their senselessness, he then thought, results "from the fact
that we do not understand the logic of our language." Though Wittgen-
stein abandoned the view of the "logic of our language" elaborated in the

Tractatus, he remained throughout his life convinced that philosophy was some form of linguistic pathology.

Part of Wittgenstein's originality as a thinker lay in his working out of his seminal ideas of use, of language-game, of form of life, and of nonsense. But this meant "the propositions and questions" of philosophy were never very far from the center of his preoccupations. He worked, accordingly, in what we might term the *space* between philosophy and life, taking sentences from the former and endeavoring to see what might happen when we inserted them into "the stream of life." Both aspects of his program are advanced in *On Certainty*, which occupied him for much of the last eighteen months of his life. As a text, it gives us some of the most piquant of his formulations on the nature of language, and some of the most perspicuous. But it is characteristic that these should emerge through a sustained investigation of a special set of philosophical sentences which might not even be recognized *as* philosophical until we try to fit them into life, try to imagine how we might use them, or how we would respond were someone else to. The sentences in fact come from a pair of justly famous papers by the Cambridge philosopher George Edward Moore—usually known as G. E. Moore. Moore is not likely to be well known to the common reader, so I shall try to give some account of him here.

Moore's thought and his personality made an immense impact on two groups of intellectuals. The first was that remarkable group of writers, artists, and thinkers who formed a sort of planetary system around Virginia Woolf, referred to as the Bloomsbury set, some of whom, like Woolf's brother, had in fact studied under Moore at Cambridge. The second were those philosophers who identify themselves as analytical philosophers and for whom Moore's startlingly limpid prose and meticulous and ingenious arguments have served as models for philosophical practice. The economist John Maynard Keynes, who in a way belonged to both groups, once wrote that Moore brought ordinary English to a level of clarity and exactitude found elsewhere only in mathematics. But

Moore, as a person, evidently embodied the virtues of his language and his style, and he was regarded, without embarrassment by the Bloomsbury wits, as a sage rivaled at best by Socrates. There is an engaging portrait of Moore by the Cambridge philosopher C. D. Broad in the latter's preface to Moore's *Philosophical Papers*, which helps explain, I think, the unmistakably affectionate tone with which Wittgenstein refers to him in *On Certainty:*

> It is doubtful whether any philosopher known to history has excelled or even equalled Moore in sheer power of analyzing problems, detecting and exposing fallacies and ambiguities, and working out alternative possibilities. . . . Apart from his immense analytical power Moore's most noticeable characteristic was his single-minded desire to discover truth and avoid error and confusion. Fundamentally he was a man of simple tastes and character, absolutely devoid of all affectation, pose, and flummery. He thoroughly enjoyed the simple human pleasures. . . . It is because ordinary unpretending Englishmen are so often muddle-headed, and intellectuals so often cracked and conceited, that Moore, who combined the virtues of both and had the vices of neither, was so exceptional and lovable a personality.

Moore's ordinariness was his extraordinariness. If he raised ordinary language to the level of mathematical precision, he raised the defining beliefs about the world of the most ordinary of ordinary men and women to the level of a metaphysical system. It was as though, in his view, *common sense*—the precritical, pretheoretical beliefs of everyone under the sun about themselves, about the world, and about their connection to the world and the connections within the world of things to things and persons—was so much more compelling than anything a philosopher might propose as incompatible with it, and more certain than any reservations that might appear to put it in doubt; as though these most basic and most commonplace beliefs, so taken for granted as scarcely to become matters for conscious consideration except when they are put into question by contrary philosophical arguments, when taken together

and regarded as a system, must furnish us with as unshakable a metaphysics as the human mind might produce.

This may, of course, sound perverse, especially when we reflect on how many "commonsense" beliefs have been shown wrong through the progress of scientific knowledge. In his *General Introduction to Psychoanalysis*, Freud spoke of his own discovery of the unconscious as the third of the "great outrages" which "humanity has had to endure from the hands of science." The first was the discovery that Earth was after all not the center of the universe, but "only a tiny speck in a world system of a magnitude hardly conceivable." The second was the discovery that we are after all descended from animals through the mechanisms of evolution, rather than created, all at once, in the image of our creator. If commonsense beliefs include the belief that the sun rises and sets, or that we are of an order of being altogether different from animals, or, against the Freudian discoveries, that we are rational through and through, then surely there is a conflict between science and common sense in light of which it is very difficult to see how anyone can insist that common sense must be right. From this perspective, one might say that common sense has been battered and bruised by science on so wide a range of matters, from the age of Earth to the indeterministic character of the most basic physical forces, that it is exceedingly incautious to imagine that any commonsense belief is immune against further scientific understanding. But Moore's commonsense beliefs are not really of a sort to be challenged by science. At best, challenges to them have come primarily from philosophy, insisting on such things as that, for all we know, the world might be an illusion, so that nothing at all is real; or that everything is mental; or that outside the mind nothing exists at all. Unlike scientific knowledge, these claims do not rest so much on evidence as on arguments that in fact call into question the very possibility of evidence, just because they entail the radical untrustworthiness of our senses. It is as though the senses constitute an inherently defective system, giving rise to paradoxes and absurdities, the only escape from which must be a structure of thought grounded in reason and indemnified against the kinds of doubts to which

the senses inevitably give rise. The world is far indeed from what the senses lead us to believe it is.

The reigning philosophy in England in Moore's early years was a form of idealism, attributed to Hegel ultimately but argued forcefully by the leading philosophers of the day. And idealism, if true, entailed as false the commonsense view of the world Moore found himself increasingly driven to defend against it—that there really is an Earth, with real trees and hills and rivers, populated by animals and human beings, like ourselves, under real skies in which true stars shine. Bertrand Russell has written of the great excitement he felt when, mainly in consequence of Moore's arguments, he was able to accept, against the philosophy taught in the lecture halls of Cambridge and of Oxford, that there are things outside us, and that the dear world, the dear "commonsense" world, really is as we spontaneously take it to be and *not* something we are required to believe exists merely in the mind. Russell gave Moore full credit for showing the way to the real. In 1903, Moore published "The Refutation of Idealism" in the journal *Mind*, an article in which he undertakes to rebut the view that the universe is spiritual and hence "(1) that the universe is very different indeed from what it seems and (2) that it has quite a large number of properties which it does not seem to have." As to the properties in question, "chairs and tables and mountains" are not different in kind from *thoughts* about chairs, tables, and mountains. It would be such claims as these that Moore felt were offensive to common sense and—it is here that his originality is to be found—*hence* false if common sense is true. That imposed upon Moore the task of defending the truth of common sense. Behind his arguments, always, stood the shadow of idealism, which threatened to rob us of our world. Admittedly, idealism came less and less to be a plausible philosophy, and Moore's motives, accordingly, came to seem less and less transparent.

The two papers that Wittgenstein considers in *On Certainty* are in effect elaborations on the theme and polemic of the 1903 essay: "A Defense of Common Sense," published in 1925; and "Proof of an External World," which appeared in 1939. In the first of these, Moore sets

down a number of propositions that he terms *truisms*, for each of which he claims, "I know [it], with certainty, to be true." The "certainty" of which *On Certainty* treats is the "certainty" claimed here, in connection with the kind of knowledge Moore insists he possesses of these truisms. In part the question is what "with certainty" adds, if anything, to "I know," and what, if anything, it might refer to beyond what "I know" refers to, if indeed it refers. Wittgenstein's investigation is into the use of "I know" and "with certainty," as well as into the status of Moore's truisms. The following extended passage from "A Defense of Common Sense" gives the flavor of Moore's writing, and samples of the kinds of things Moore is certain that he knows:

> There exists at present a living human body, which is *my* body. This body was born at a certain time in the past, and has existed continuously ever since, though not without undergoing changes; it was, for instance, much smaller when it was born, and for some time afterwards, than it is now. Ever since it was born, it has been either in contact with or not far from the surface of the earth; and, at every moment since it was born, there have also existed many other things, having shape and size in three dimensions (in the same familiar sense in which it has), from which it has been *at various distances* (in the familiar sense in which it is now at a distance both from that mantelpiece and from that bookcase, and at a greater distance from the bookcase than it is from the mantelpiece); also there have (very often, at all events) existed some other things of this kind with which it was *in contact* (in the familiar sense in which it is now in contact with the pen I am holding in my right hand and with some of the clothes I am wearing). Among the things which have, in this sense, formed part of its environment (i.e. have been either in contact with it, or at *some* distance from it, however *great*) there have, at every moment since its birth, been large numbers of other living human bodies, each of which has, like it, (a) at some time been born, (b) continued to exist from some time after birth, (c) been, at every moment of its life after birth, either in contact with or not far from the surface of the earth; and many of these bodies have already died

and ceased to exist. But the earth had existed also for many years before my body was born; and for many of these years, also, large numbers of human bodies had, at every moment, been alive upon it; and many of these bodies had died and ceased to exist before it was born. Finally (to come to a different class of propositions), I am a human being, and I have, at different times since my body was born, had many different experiences, of each of many different kinds: e.g. I have often perceived both my own body and other things which formed part of its environment, including other human bodies; I have not only perceived things of this kind, but have also observed facts about them, such as, for instance, the fact which I am now observing, that that mantelpiece is at present nearer to my body than that bookcase; I have been aware of other facts, which I was not at the time observing, such as, for instance, the fact, of which I am now aware, that my body existed yesterday and was then also for some time nearer to that mantelpiece than to that bookcase; I have had expectations with regard to the future, and many beliefs of other kinds, both true and false; I have thought of imaginary things and persons and incidents, in the reality of which I did not believe; I have had dreams; and I have had feelings of many different kinds. And, just as my body has been the body of a human being, namely myself, who has, during his lifetime, had many experiences of each of these (and other) different kinds; so, in the case of very many of the other human bodies which have lived upon the earth, each has been the body of a different human being, who has, during the lifetime of that body, had many different experiences of each of these (and other) different kinds.

It is a philosophical truism that if someone knows that P, then P must be true. It thus follows from the fact that Moore knows all these propositions that all of them are true. If they are true, whatever is incompatible with them must then be false. But since each of the truisms would be denied by idealism, idealism must itself be false. This is Moore's argument.

In "Proof of an External World," the strategy is somewhat different. Moore begins with a citation from Kant:

It still remains a scandal to philosophy . . . that the existence of
things outside of us . . . must be accepted merely on *faith*, and that,
if anyone thinks good to doubt their existence, we are unable to
counter his doubts by any satisfactory proof.

If by "things outside of us" Kant means what we would ordinarily mean
by a material object, such as things made of bone and flesh are, such as
our hands, then, Moore claims, it is not that difficult after all to produce
as good a proof as anyone could wish that there are material objects and
hence that there exist things outside of us. The proof consists in hold-
ing up one's hands—as Moore evidently did:

And saying, as I make a certain gesture with my right hand, "Here is
one hand," and adding, as I make a certain gesture with the left,
"And here is another." And if, by doing this, I have proved *ipso facto*
the existence of external things, you will see that I can do it now in
numbers of other ways: there is no need to multiply examples.

The balance of Moore's essay is a defense of the claim that this is a *proof*,
in the course of which Moore makes the astute observation that if other
proof were wanted, it would be difficult to see what premises it might
use that were more certain than the conclusion itself already is, viz., that
there are two hands. Certainly no other proof could confer a greater cer-
tainty than we already possess.

One might suppose that Wittgenstein would sympathize with an
effort such as Moore's, to use common sense, to use "what everyone
already knows," as a dialectical weapon for the dissolution of meta-
physics. But in fact these two philosophers could hardly stand further
apart. Moore still speaks of "proofs," of "refutations," of "defenses," as
if the propositions brought under attack were demonstrably false, since
propositions contrary to them are demonstrably true. But this accords a
cognitive dignity to philosophical propositions it was Wittgenstein's
ingrained disposition to believe not false but *nonsense*. It is nonsense dis-
guised as sense, of course, but the task then is to penetrate the disguise

and reveal the nonsense for what it is. But—and this seems tacit in Wittgenstein's procedure—the contrary of a nonsense proposition must itself be nonsense. If idealism is nonsense, so too, in a way, must Moore's truisms be. And so the burden of *On Certainty* consists in showing how truly strange and special Moore's truisms finally are. Plain as Moore's propositions appear, undeniable in a way as they seem to be, there is something quite curious about them, just because their denials would themselves be transparently nonsensical. And that cannot but raise the question of what kind of sense the truisms themselves have.

Wittgenstein's method, as always, is to endeavor to insert language into the stream of life. So where, in the stream of life, might I or anyone have occasion to *use* a sentence such as "Here is one hand"? One may call upon that kind of competence in which those who live a form of life know under what conditions any sentence of the language which goes with that form of life might be used. We can imagine grisly scenarios, like gathering body parts after an explosion. I say, "Here is one hand," and you might say, "And here is another." Of course, these would not be the speakers' hands. To imagine them being the speakers' hands, one would have to imagine something like discovering one's lost hand and pointing to it, perhaps with a vigorous nod of the head, saying, "Here is one hand." Or, using an example I think was invented by Norman Malcolm, at whose urging Wittgenstein considered Moore's truisms, one could have had a dream, terrifying and utterly compelling, in which one's hands fell off. And then one might, upon awakening, realize that it had been a dream only and, holding up one hand say, with an implied "O Joy!" "Here is one hand," and then, "And here is another." It would be like Scrooge awakening to discover that he after all had not died, and that he could still celebrate Christmas with Tiny Tim. But where, outside the philosophy classroom, and in the stream of life, might one say, a propos of nothing, "Here is one hand," and then, "And here is another"? In teaching the meaning of *hand* to a foreigner? In showing a Martian what Earthling anatomy is like? But in these cases I am explaining how an expression is used, where a challenge, should we imagine one, would be

more a challenge to my authority than a denial of the truth of what I say. And in any case, it would be less a truth about hands—and hence material objects—than about the word *hand* and what it means. So what have we got with propositions that, though it cannot easily be seen how they can be denied, cannot easily be imagined usable in any straightforward way in the stream of life? Moore's propositions in fact seem useless.

Kant distinguished two orders of propositions, those he termed "synthetic," whose denials are false when the propositions are true; and those he termed "analytical," whose denials are necessarily false because contradictory. Kant's distinction has been much contested, and it is now much less clear and obvious than he believed it was, but the difference between propositions whose truth can be settled by observing the world and those whose truth is to be settled by virtue of their meaning is probably defensible. One can determine whether bachelors are unhappy only through interviews with bachelors. But the dictionary suffices to tell us whether bachelors are married: they *cannot* be, or it is inconsistent that a bachelor should be married, in the somewhat obscure sense of "inconsistent" to which Kant appealed as his criterion for analytical truths. What is striking about Moore's truisms is that they seem synthetic, by Kant's criterion, and yet their denials are nonsense by Wittgenstein's. Perhaps we can think, for a parallel, of a famous phrase of Descartes's, "I exist." Each of us would be hard-pressed to deny that we exist. Yet the proposition is not analytical. Its denial is less contradictory than unintelligible. It is, rather, as philosophers sometimes say, "self-stultifying." Its falsehood is inconsistent with stating it. "I don't exist" seems to die in the mouth. "This is not a hand" is not quite self-stultifying in the way "I don't exist" is. But there is something strange or curious about it, as might be seen were we to imagine a painting by Magritte that shows a hand, with the phrase underneath *Ceci n'est pas une main*. What on earth could anyone mean by holding a hand up and saying, "This is not a hand"? So what on earth could anyone mean who just held a hand up and said, "Here is a hand"? The latter cannot sensibly be denied, but can it sensibly be affirmed? Since all Moore's propositions appear to be like

this, Moore seems to have made some sort of discovery. But has he discovered truths that can be *known with certainty?*

Wittgenstein, certainly in the *Tractatus* but implicitly throughout his writing and teaching, disavowed a view of philosophy that saw as its task the provision of certain general theses about the world, or about thought, or even about language. "Philosophy is not a theory but an activity," he wrote (*Tractatus*, 4.112). "Philosophy," he said just before that, "is the logical clarification of thoughts." And again, "A philosophical work consists essentially of elucidations." This appears on the face of it somewhat incoherent with the spirit of the *Tractatus*, which seems, as it seemed to its early readers, to be at the very least a metaphysics of language and indeed of the world if the world is to be represented in language, as the text construes it. The book is thick with some of the most thrilling utterances in the whole of philosophy about the self, about the meaning of life, and even about God. Still, the text was sufficiently clear about its purposes to self-destruct—to say that if it was itself a set of philosophical propositions, it too was nonsense and should be discarded.

Nevertheless, when we think of Wittgenstein as a philosopher, we think of him as engaged in a kind of activity he practices nowhere more compellingly than in *On Certainty*. It is an activity of linguistic imagination, of the creation of little scenarios in which someone, perhaps the writer himself, responds to the effort of inserting a proposition we are trying to understand into the stream of life as we live it and on which we are accordingly authoritative. To read *On Certainty* is to live through a certain number of these scenarios, tiny semantical psychodramas of everyday discourse seeking to assimilate, and finally having to reject, an invader from some alien discourse, and perhaps some form of life alien to the one we live. It is almost as if our language formed a kind of immune system, with all manner of defenses against invaders that, were they to succeed in getting past these defenses, would mean the destruction of our form of life.

And yet, out of this complex play, certain theses emerge of the most striking philosophical power. They present themselves almost as sudden

kills, after the shuffle of scenarios, after the tireless testings, after the imaginative questions and probes. Number 144 is a case in point:

> The child learns to believe a host of things. I.e., it learns to act according to these beliefs. Bit by bit there forms a system of what is believed, and in that system some things stand unshakably fast and some are more or less liable to shift. What stands fast does so, not because it is intrinsically obvious or convincing; it is rather held fast by what lies around it.

What §144 in effect claims is that beliefs occupy different positions in the system. Some seem more basic than others, not because the rest are supported by them as foundations, but because *they* are held in place by the whole system pressing down, as it were, as with the keystone in an arch. Moore's propositions belong to this class. To imagine them false would be to imagine everything else as incoherent. In Wittgenstein's analogy of the machine, some wheels are involved in the whole system, but there are others that, though part of the machine, turn without turning *everything* else. Perhaps this is what Wittgenstein means when he writes, at §213, "Our 'empirical propositions' do not form a homogenous mass." Without being a foundationalist, Wittgenstein step by step lays bare the foundations of our language. If Moore's propositions form part of that foundation, it is because believing them is a condition for sharing in the form of life they support. A person who failed to share them would have to be demented, relative to the norm (§155). "My *life* consists in my being content to accept many things" (§344).

With these last observations Wittgenstein's investigation intersects with one of the great mainways of modern philosophy, the "quest for certainty" that has obsessed philosophers since it was raised in its most acute form by René Descartes. There, in the meditation with which, we might say, a gap was opened up between ourselves and the world, in the meditation in which Descartes undertakes to see if there are not some basic and unshakable foundational beliefs upon which the entirety of our system of beliefs rests, or if not, whether we must abandon ourselves to

what Bishop Berkeley was later to call "a forlorn skepticism," virtually everything one would ever have thought certain is submitted to the most exacting criteria and found wanting. Descartes finds, for example, that consistent with his experience being just as it is, nothing is really taking place inasmuch as it is thinkable that he could be dreaming. He might merely be dreaming that he has a body—which of course is one of the propositions Moore claims that he knows with certainty to be true, though it is worth mentioning that in a paper precisely titled "Certainty" Moore attempts to deal with the argument that one might be dreaming and finds himself unable to respond to it satisfactorily. A man who believed he had no body, who really was certain that he was bodiless, would no doubt be demented, as Wittgenstein says. But so did Descartes say that, at the beginning of the great meditation: "How could I deny that these hands and this body here belong to me," Descartes asks, as if in rhetorical anticipation of a discussion with G. E. Moore, "unless I were to compare myself with those who are insane, and in whom the brain is so troubled and obfuscated by the black vapors of the bile, that they assure themselves constantly that they are kings when they are very poor. . . . They are madmen, and I should be no less extravagant if I ruled myself by their examples."

And so Descartes assures himself, and those readers who co-meditate with him, that he is not mad, that he does not really believe or doubt extravagantly. Then why call into doubt what we cannot really doubt, one might ask. And Descartes might respond by insisting that he is looking for the justification for what he in any case believes, transforming his beliefs into rational rather than intuitive ones. And Wittgenstein might in turn ask what better grounds can we have than the fact that we cannot help believing certain things. Later on, as the meditations unfold, Descartes offers a kind of criterion: I am certain of whatever proposition(s) I grasp "clearly and distinctly." This is a kind of psychological criterion. In truth he never quite understands with the needed clarity and distinctness the proposition that he has hands and a body. But Wittgenstein in any case dismisses psychological criteria in favor of reminding

us of linguistic practice, and finally his careful argument is that our criteria in any case are social rather than psychological and have to do less with exalted states of mind than with shared forms of life.

It would not be appropriate to press the argument past this point for a text I mean merely to situate. But it is worth mentioning that Descartes finds reason to accept the common practice in his moral beliefs, as if practical conduct is as good as we require for the moral business of life. He might very well consider it a defeat to say the same for our beliefs about the world, but we must ask ourselves, in working through the scenarios of *On Certainty*, whether it is reasonable to ask for more, or rational to imagine there could be more. The things we "accept" are what we are certain of only in the sense that we cannot imagine what life would be were they false, almost because they define the limits of imagination. Were we to attempt to set down these "accepted" propositions, they would be simple, obvious, and useless. They would be all but uninformative. They would be Moore's propositions—propositions we cannot use. In a way it is their uselessness that gives them their power. An edition of *On Certainty* that had as an appendix all the things we accept, say, would contradict the spirit of the text. It is a text in which the truisms must emerge in the course of reading it through. But they are not, as it were, detachable or separately entertainable or assertable, any more than Moore's propositions are.

In this sense, *On Certainty*, as a text, is closer in spirit to Descartes's *Meditations* than to Moore's essays. Moore's are like scientific reports, statements of results, though admittedly it is a strange thing to report that the writer of the paper has two hands. The results of the *Meditations*, by comparison, cannot be detached from the movement of thought the reader must transact in working the text through. They are inseparable from the processes of discovering them for oneself. One must make them one's own. So it is with Wittgenstein's text. It is a kind of philosophical exercise, a way of thinking, an itinerary to be traversed. It cannot or should not be read passively, as if one were being presented with philosophical facts. One is being, rather, strengthened to work one's way

through philosophical questions of whatever sort. One emerges less with a set of propositions than with the understanding of a practice. The relevant beliefs are after all the ones that make possible the practice of discovering what they are.

It may occur to the reader that it is just as well that what we are to be left with is a practice, rather than a group of propositions. For at least one of the beliefs canvassed in the text has been underwritten less by considerations of sense and sanity than by the progress of science: trips to the Moon are expensive, but not unthinkable. Philosophers, touted as visionaries, have been singularly conservative in imagining the conquest of space. At one time, when it was the fashion to equate meaningfulness with verifiability, it was grudgingly allowed that the statement "There are mountains on the other side of the Moon" was meaningful, since verifiable in principle, though no one expected that it would ever be verified in fact. As this was a commonplace when *On Certainty* was written, it is curious that Wittgenstein should find grounds for withholding sense from the belief that there can be travel to the Moon, all the more so since he was a great reader of pulp fiction as well as a trained engineer. Perhaps the answer is that he found it unintelligible that *Moore* should be an astronaut and moonwalker, just because of Moore's comfortable and earthbound personality. It would border on the unimaginable to fancy Moore with his head in a plastic bubble, or his wife, Dorothy, allowing him to undertake so insecure a transit.

In a volume of eleven excerpts from his ongoing thoughts on art, published in Paris in 1971, Mel Bochner wrote, "I do not make art. I do art." This sounds almost like an echo of Wittgenstein's "Philosophy is not a theory but an activity," as if Wittgenstein's philosophy and Bochner's art moved on parallel tracks and consisted in processes and activities, rather than products, to wit, theories and artworks. Of course a book has to be a product, as a drawing or an image must. But Bochner's remark, like Wittgenstein's, helps situate the viewer and the reader in a certain relationship to image and text rather different from the passive one of aes-

thetic appreciation, in the one case, and intellectual appreciation, in the other. In both instances something more strenuous is being asked.

For Wittgenstein's philosophy one must, as it were, read the text as if one were living through the discussions that compose it, living through the perplexities, internalizing the clarifications as they dawn, emerging a transformed being from the one who entered these texts. So far as there is a parallel between Bochner's images and these texts, a degree of participatory engagement is demanded of the viewer, who must enter the work, rediscover the decisions that explain why the work goes the way it goes, and make the work his or her own. But this in a sense requires that the viewer recover the rule the work implies in order to realize itself on the paper.

The images that accompany the Arion Press edition of *On Certainty* involve two sets of components, which stand to one another in relations interestingly parallel to these in which the two sets of beliefs distinguished in §144 do. One set of components is, with a qualified exception to be noted below, invariant from image to image. I shall term this the "matrix," which serves, in effect, as foundation or scaffolding for the drawings, which inscribe, in each image, a different path made possible by the matrix. The matrix is, for the most part, a kind of quincunx, a square that is divided into four subsquares by a cross that runs from the midpoints of its four sides through the center, and that is further divided into triangles by a cross whose arms run from corner to corner, again through the midpoint. If the British flag were square, then the matrix would be a schematized version of it, with the Cross of Saint George and the Cross of Saint Andrew superimposed.

Bochner's matrix has a history it would be fascinating to trace, mainly, I think, back to the latter part of the fifteenth century, where it served a practical as well as symbolic role in architectural design, in the design of figures, and in typography. Through it Bochner's work is connected to that of Da Vinci, Dürer, and Vitruvius. Possessing this history is important to the meanings of the drawings it facilitates, especially when they are viewed as visual parallels to Wittgenstein's thoughts about language.

The basic propositions or beliefs are those most entrenched, the ones that have evolved over time and have made possible the form of life we live. Propositions like "Elvis lived in Graceland," by contrast, are peripheral; little turns when they turn, and they could be false without much else having to be false when they turn out to be that. But propositions about material objects are so central we cannot imagine what it would be for them to be false, or not easily, and though Descartes can think about considering their claims to truth, he cannot really, as a matter of psychological fact, doubt that they are true. Bochner's appropriation is of a matrix whose early users believed must underlie the way human beings and buildings are structured, and which must be assumed in order to represent them convincingly.

The other component is very much more variable. It consists of patterns created by drawing numbers along the various sides and axes of the matrix. The use of numbers, written down sequentially, in cardinal order, is crucial to the viewer, for the direction of counting is the direction in which the drawing moves. Counting plays a considerable role in the explanation, or the exploration, of rules in *On Certainty*, as it does elsewhere in Wittgenstein's writings. And counting is, I suppose, among the basic things we know how to do, so that the knowledge that 4 comes after 3 and before 5 might be a candidate for one of Moore's truisms. Some very simple arithmetic propositions have been put forward by philosophers as possible candidates for bedrock certainty, and it is one of the great insights of *On Certainty* that, despite this tradition, there is little to choose between such propositions and other basic ones: "We learn with the same inexorability that this is a chair as that $2 + 2 = 4$." But counting, as an activity, requires less the knowledge of arithmetical truisms than a grasp of the rules that make arithmetic possible, and Wittgenstein asks, often enough in his writing for Bochner's drawings to make a tacit allusion to it, how we know that someone has grasped such a rule. An obvious test is that the person is able to continue the series.

Consider Bochner's *X-Branch* (fig. 11; the ninth drawing of twelve in the Arion edition). The counting-writing begins in the upper left cor-

Figure 11. Mel Bochner, *Counting Alternatives: X Branch*, from *On Certainty*, by Ludwig Wittgenstein (San Francisco: Arion Press, 1991).

ner with 0, and continues along the diagonal to the midpoint, occupied by the somewhat curious number 17. It is curious because the other endpoint of the diagonal is occupied by the number 30, which would suggest, or perhaps even require, that the midpoint of the diagonal be occupied by 15. But the numbers do not precisely match the geometry, and besides, the inscription of the numbers is rather free. In any case, an important distinction has to be drawn between numbers, as abstract mathematical entities, and numerals, which are physical entities, made of ink, taking up space. When we examine the other diagonal we see that two separate pieces of counting are involved, one that goes upward from the midpoint to the upper right corner, leading to 28, while the other

again begins at the midpoint but goes down to the lower left corner, and leads instead to 29. The X-branch in fact is more like a branching form, a sort of three-tined fork, whose true shape is discerned only by following the direction of counting and seeing where one is taken. It would, for example, be a very different drawing were one to have an X formed by counting straight down one diagonal and then straight up the other.

The drawings themselves constitute a kind of series, in the sense that we might extrapolate a rule, based on drawings 1 through 11, that the numerals will always fall on one or another element of the quincunx, either a side or a diagonal, or one or another arm of the vertical cross. But drawing number 12 changes the rules abruptly (see the frontispiece to this volume). In order to draw a diamond, Bochner has had to use diagonals that run the "wrong way," relative to the rule one might think one had found. These diagonals, which run from midpoint to midpoint of the square's sides, subvert the rule, in fact introduce a radical instability into what we thought was a system—or a "form of life"—which consists in matrix and superscribed numerals. We get an abrupt shock, as if a form of life had been overthrown in some revolutionary act, in which, for all the surface order, everything has become anarchic. It is anarchic because if numeration can go the way it goes in number 12, there is no way in which it *cannot* go. One has lost the structure of the world in which one was at home. Nothing could more vividly illustrate the collapse of a form of life than this. It demonstrates, in pictorial terms, what it would be for a truism to be false. It is a kind of geometrical madness. It is, if one wishes, a pictorial proof of Wittgenstein's deepest point. Beyond that, it seems to me, it offers us a remarkable example of what an illustration to a philosophical text might be—a pictorial thesis, which achieves in terms appropriate to pictures a thesis one might have thought could only be made with words.

Wittgenstein was obsessed with pictures, one might say, throughout his life. In the *Tractatus,* it was his view that propositions in fact are pictures, pictures of facts, pictures that show what must be the case if they are true. And although what sometimes is called the "pictorial seman-

tics" of the *Tractatus* was abandoned in Wittgenstein's later philosophy of language, he often held theses about pictorial equivalents to verbal truths. He believed, for example, as Ray Monk has recently shown, that there might be a pictorial proof of the commutative law of multiplication, that is, that a × b = b × a, namely:

where one can *see* that four rows of five elements is the same as five rows of four elements.

To what further extent Bochner's drawings offer "proofs" of the theses they illustrate, or in what relationship other than equivalence they might stand to these theses, must be left to the readers to work out for themselves. The point is that both must be worked through, and from this perspective pictures and texts constitute parallel disciplines, and yield comparable illuminations.

Giotto and the Stench of Lazarus

AT THE EXTREME RIGHT of the fresco in which Giotto shows us Christ raising Lazarus from his tomb, a bystander is holding her nose, while another, just next to her and standing beside Lazarus himself, still wrapped head to foot in his cerements, has drawn her veil protectively across her mouth and nose—"to remind us," Gombrich writes, "that the corpse was already far gone" (fig. 12).[1] The Gospel of Saint John tells us that by the time Christ arrived in Bethany, where Lazarus's sisters Mary and Martha grieved, their brother had lain in his grave already four days. When Jesus, characteristically peremptory and executive, orders the stone removed from the mouth of the cave that served as Lazarus's burial chamber, Martha, expressing a piece of knowledge sufficiently commonplace and domestic to explain the stone being there in the first place, says, "Lord, by this time he stinketh; for he hath been dead four days." It is, then, a deep fidelity to the text, rather than an impulse to render the telling naturalistic detail, that accounts for the unmistakable gestures of the two fastidious witnesses. The remaining figures are too caught up in amazement at the miracle, too strained from having moved the stone, too

Reprinted from *Antaeus*, no. 54 (spring 1985): 7–20.

overwhelmed with gratitude and heightened devotion, to pay attention even to powerful and obnoxious smells. This is psychologically plausible as well as artistically correct: it would diminish the awesome performative correlative of Christ's awesome claim "I am the resurrection and the life" to show fifteen figures, more or less, each holding its nose. But it would expurgate the spontaneous earthiness of biblical reality if the defining smell of real death went unremarked. Just as a snapshot registers the unintended background details of life, which become visible only when they have vanished, the Bible conveys by such innocent touches an overwhelming conviction of the truth of simple lives.

The fact of this stench must have been regarded as epistemologically important in representations of the miracle, to reassure doubters that Lazarus really had been brought back from death rather than out of a coma or wakened from some exceptionally deep sleep—or to assure them that something had not been staged. Smells like that could not be feigned, and were criterial to men and women not insulated from olfactory truth by the cosmetic interventions of morticians Mary and her sister could in any case not afford, and so who knew how death smells. So it is not surprising that the held nose figures in even very early representations of the raising of Lazarus. A Benedictine painting of 1058 in the church of Saint Angelo in Formia shows only four figures: Christ, Mary or Martha, Lazarus, and a gravedigger, the last holding his nose. A tiny scene in a panel that shows a number of episodes in the life of the Magdalene has the leftmost figure holding his nose, an affecting realism considering that he appears to handle the tomb lid as effortlessly as a surfboard. The Disentombment in the church of Saint Zeno in Verona, from the second half of the thirteenth century, has three nose-holders. Fra Angelico's *Lazarus* shows a woman with her hand across her mouth, a gesture disambiguated by this tradition, since it would be read as a stifled cry of astonishment. Giotto has several nose-holders in his treatment of this subject in the Magdalene Chapel in the church of Saint Francis in Assisi, and Duccio di Buoninsegno even shows *Lazarus* holding his nose! Nose-holders tend to become rare in later depictions,

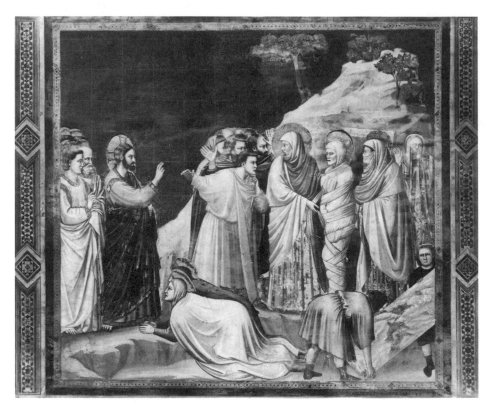

Figure 12. Giotto di Bondone, *The Raising of Lazarus*, fresco, Scrovegni Chapel, Padua, Italy. Foto Marburg/Art Resource, N.Y.

whether because biblical text itself becomes less constraining on artists, or because the episode has become more symbolic than urgently historical, or because artists have gotten interested in other things, which the raising of Lazarus provides them an occasion to explore. There are four or five nose-holders in Tintoretto, but too diluted by the rest of what goes on to be more than vestiges of a faded tradition; there are none to speak of in the astonishing painting of this subject by Sebastiano del Piombo, full of Michelangelesque postures; and Caravaggio depicts the entire company inside the tomb, making a complete departure from the

text, since Lazarus is shown naked in the sarcophagus from which he is being lifted, with rigor mortis having set in. In neither of these last two is there anything relevant to the sense of smell that I can detect. The miraculous has swamped ordinary experience rather than enhanced it, as in the original homely account. It is the naturalism of the Bible that enabled Giotto's naturalism.

In whatever way it is that Giotto earned Vasari's epithet "The Disciple of Nature," it is not by putting in the telling detail; he was not a painter of genre, or a keen observer like the Dutch. In representing gestures that in Dutch painting must have an altogether different meaning, Giotto, instead of being responsive to nature, was extending a tradition he had internalized, and conforming to a narrative text which generated that tradition and specified its iconic components. He is concerned to offer a visual equivalent to that text, enabling his viewers, even if illiterate, to recover the main information that text delivers. Of course, he has to make decisions where the Bible itself is inexplicit. He has to decide how many people to show, for example, where the Gospel speaks only of "the people standing round." But the Gospel tells us that Christ came with his disciples ("Let us go unto him") and that Mary arrived at tombside with weeping comforters, a fact of some narrative importance, since what happens later requires that there have been witnesses, all of whom, incidentally, believed that Christ had performed a miracle, which some saw as a dangerous and disturbing fact. Not even the unquestioned miracle, as perhaps Christ already knew, will have forensic clarity in the instillation of faith. In any case, where with words we can say "several" or "many" or "some," with pictures we have to show some specific number like three or seven, until some device is discovered for showing indefinite quantities, like leaves on trees—a device unavailable to Giotto, who gives us every leaf in the tree a spectator has climbed to get a good view of the entry into Jerusalem.

The stench, however, is explicit in the narrative and crucial to its meaning, and some visual counterpart is demanded in view of the congruity

between a text and any acceptable tableau. When Christ commands, "Take ye away the stone!" and Martha sweetly observes, "Lord, by this time he stinketh; for he hath been dead four days," she is indicating the kind of fact the Son of God—which Martha fervently believes Jesus is— might simply not know about or might be indifferent to. Jesus is bound to the sisters through a complex semiotics of smell: when Mary anoints his feet with a salve of spikenard she wipes with her hair, Jesus observes that "against the day of my burying hath she kept this." Perhaps Mary uses it to demonstrate her faith, now reinforced by miracle, that it will not be needed to mask a stench—though Nicodemus brought "more than a hundredweight" of mixed aloes and myrrh to the sepulcher in which Christ stayed three days to Lazarus's four. So Christ's reproof to the bystander who murmurs at the costliness of Mary's charged action shows that he is enough connected to the world of sense and decay to know how it is with bodies after four days in the Palestinian heat. But to Martha he responds instead from another level of knowledge altogether: "Said I not unto thee that, if thou wouldst believe, thou shouldst see the glory of God?" So, the Gospel tells us, "They took away the stone from the place where the dead was laid."

The persons there assembled, like the readers of the story, were to appreciate that two planes of reality, as symbolized by the two speeches of Martha and of Jesus, were intersecting in this momentous event; that what was really death on one plane, for which sleep was a kind of image, was really sleep on another, from which the dead might be precociously awakened. So it was essential that, on the plane of historical enactment, things should be as they really are, smell for smell. Had Lazarus come forth redolent of aromatic oils, the miracle would have been blunted, the economics of Mary and Martha obscured, since the immense sacrifice in first acquiring and then lavishing the spikenard on Jesus would have been lost if they could have afforded to perfume their brother. When the stench stops being a pictorial necessity, an abyss between words and pictures will have opened. Luckily, it was a terrible smell! Think of the problem of showing the overpowering fragrance of that ointment which

must have filled the home of Mary and Martha like a prefiguring metaphor for heaven!

No one, not even Giotto, can visually represent a stench directly. But when it is imperative, as in biblical illustration, to show in visual terms the fact that something smells a certain way, painters considerably more primitive than Giotto can achieve this much; think of the fairly humble pictures in the church of Saint Angelo in Formia. Usually this is done by picturing something in such a way that the best explanation for its being so is that there is a smell in the neighboring causal precincts. It is widely remarked upon by psychologists of perception that much the same physiology is involved in the visual perception of *pictures* of things as is involved in perceiving those things themselves: the same neural pathways are activated either way, so that it is demonstrable that a child who acquired his vocabulary from objects alone, in a picture-free environment, will spontaneously apply to pictures of things, when finally these are introduced, the very terms learned in connection with objects. No extra piece of learning is required to transfer these skills from object to picture than from object to object of the same kind. "Somewhere in the visual process," Norbert Wiener wrote, "outlines are emphasized and some other aspects of an image are minimized in importance: the eye receives its most intense impression at the boundaries . . . and every visual image in fact has something of the nature of a line drawing." Mimetic skill in the visual artist then consists in producing shapes in some medium which will then be seen, with no inference other than may be involved in seeing things as such, as those very things. But in a guardedly parallel way, we find our way around in pictures as we find our way around in the world, referring to explanations of why things look as they do in reality in accounting for why pictorial representations of them look as they do. Giotto demonstrated his extraordinary manual reflexes in drawing the legendary *O* for the edification of Benedict XI, but a higher because more cognitive power must account for his greatness in executing pictorial equivalents of the narrative realities of Christian history,

since these involve not so much showing but showing *that* something is the case—pictorial propositions, as it were. Of course, the stories themselves were the common culture of his viewers, as the fables of La Fontaine are for the French or our nursery rhymes are for us. But more than common culture had to be drawn on by him in those exceptionally convincing scenes from the life of Jesus: he drew on the knowledge of the real world his viewers must be counted on to have had in order to see not the stench of Lazarus but *the fact* that Lazarus stank. The pictures really are like windows onto the world, but glazed so as to insulate us from all but visual qualia, requiring that we call upon our causal knowledge to render what meets the eye coherent with what we know of the world in its full sensory array.

This is nowhere better seen than when there is no explanation to be drawn from the real world to account for what we see in the paint-world, where another kind of glass keeps us isolated from causes on some other plane which have effects on this one, as in the case of miracles. I can think of no depiction of a miracle that is more miracular than Giotto's showing after all the central fact in the raising of Lazarus: namely, the fact that *Lazarus is raised*. Christ *orders* the stone to be moved, and it is moved, but routinely, by strong men complying with the order and exerting physical force. I suppose a being who did what Jesus did in providing loaves and fishes, or turning water into fine wine at the wedding feast at Cana, possessed the telekinetic capacities to move stones directly, without the mediation of compliant stone-movers. But in the context, it would have been vulgar and more magical than miraculous. Moving stones is something any of us can bring about by one means or another, and moving stones directly, as a basic action, can be philosophically entertained. So even though Christ might have removed the stone in some unusual or abnormal way, still what he achieved directly could have been achieved indirectly by very ordinary beings. It takes a god to bring someone back from real death, however; *we* cannot do that even as a non-basic action. We can resuscitate someone, bring someone back from the gate of death, but that person will have been marginally alive all along:

there will have been no stench. I am always moved by the Gospel when it tells us that Jesus "groaned in the spirit" as he approached the tomb, as though some effort as much outside mortal competence as what lies the other side of Saint Paul's darkly translucent glass is outside our cognitive competence were being summoned. Consider then what happens: Jesus "cried with a loud voice, *Lazarus come forth*. And he that was dead came forth, bound hand and foot with graveclothes."

Almost no artist I know of had the visual courage to show the miracle as the miracle it was: not simply that Lazarus came back from death, but that he came forth, out of his tomb, *bound hand and foot with graveclothes*, as though expelled by some violent chemistry of spiritual forces. Usually Lazarus is depicted as assisted, or being carried. Sometimes he simply sits up in his coffin. The ordinary sequence would be: first remove the fetters, then move. But this is reversed in the biblical account. That is what Giotto shows: Lazarus is too closely bound even to be able to place his palms together in prayer and acknowledgment, as in Fra Angelico. It is a very powerful image, with Lazarus *simply there*, and no explanation forthcoming out of the common knowledge as to how he got there.

Motion, like odor, cannot be directly represented by painters, though movement is something to which we are directly responsive, visually, as we are to outline. Until the advent of the motion picture, pictures could only show the *fact* that something moved, not the movement itself, and so they enlisted cooperative inference on the part of viewers, rather than that in the visual system which detects movement directly. Imagine, then, a moving picture of the raising of Lazarus. There is an actor playing the part of Jesus, reciting the words ("with a loud voice," as the biblical script directs) "*Lazarus come forth*." But the actor who plays Lazarus cannot do what the script requires, cannot imitate what Lazarus does in the way that, without much difficulty, one can imitate Jesus—though of course we cannot strictly imitate raising *by* saying, we can only imitate the saying, so in fact both action and response lie outside the human repertoire either to perform *or* imitate. So some cinematic intervention is required, some special effect, like whatever made it appear that Dorothy was windborne to Oz.

The picture Giotto made is intelligible only against the assumption of a miracle, in the same way in which the correspondent reality would have been had you been there as a witness. In an odd way, only someone with the cognitive resources of the naturalistic artist, such as Giotto was, could really show a contravention of the natural order having taken place. The miracle of Lazarus had been depicted since very early times: it is already part of the visual vocabulary of catacomb art as a natural metaphor for the promised resurrection, just as entering the catacomb must have been a ritual metaphor for death. But until Giotto nobody could have shown the miracle *as* a miracle. He invented a style that finally met the narrative requirements of the sponsoring faith.

I want to distinguish some of the ways in which one solves the problem of showing that certain things exist or certain events take place when their direct representation lies beyond the limits of our medium. One way is through conventional signs. The halo that surrounds Christ's head, or the head of that disciple who supports Lazarus while gazing directly at the Redeemer, is a convention in that there is no direct way of sensing, hence no direct way of picturing, holiness. Holy objects are typically mysterious in that they look indistinguishable from quite ordinary, non-numinous things, as holy water, for example, cannot be told apart from plain water at the level of sense or of molecularity. A fragment from some saintly skeleton bears no special mark that sets it apart from a mere knucklebone. For complex reasons having to do with some essence supposed common to spirituality and to light, the aureole has come to express holiness as a natural metaphor. Yet however natural it may seem, it is a convention that had to be invented and must be specifically learned: we have to inhibit a reading of the circle as a special kind of headpiece. The halo is in the representation, but not in the visual reality, where what the halo designates is invisible to ordinary sight, much as smell is. If Christ's arm were lifted in a gesture of salutation rather than performing the action of raising someone from death, that would be a convention in visual space, noticeable by witnesses who, of course,

are necessarily blind to what halos denote from the plane of conventional depiction. Conventions such as these are broadcast in pictorial cultures such as our own, and their ubiquity is evidence of representational limits having to be overcome, picturing what cannot be shown directly. And this, I think, must be due to pressures put on artists by the imperatives of narration. A purely pictorial or visual artist such as Cézanne is marked as such by a fact that he typically chooses subjects about which there is no story to be told. Or there may be stories to tell without anyone being able to infer this from the paintings. We cannot imagine a Cézanne with a convention in representational space alone, like the halo, for example— granting that it may be of some psychological interest to observe, as Meyer Schapiro did, that apples connote breasts in a natural pictorial lexicon, and so hold a damped eroticism. But then the very apples on that table have this connotation, and not just the apples in the plane of paint. Consider by contrast comic strips, a hugely narrative form, themselves part of the same history occupied earlier by the bands of tableaux in the Arena Chapel in Padua. Cycles of frescoes on the side walls of Renaissance churches were meant to be looked at sequentially and read, as it were, like—well—*Bible Comix*. In comics, wavy lines over a fish imply that the fish stinks, always good for a smile if not a laugh in the coarse world of violent sensations—the world of *pows* and *blams* and *zaps*— which the cartoonist exploits to the end of low entertainment, having taken it over from clowns.

Conventional depiction is a kind of script, in that one has to learn to read it, and no appeal to a common set of neural pathways can account for how we understand that to which such a script refers. Like a language, it has to be learned. But because it is pictographic, it calls upon our independent knowledge of the world, just as the depiction of miracles does. Thus we know that fish very rapidly become far gone and so are paradigms of things that stink ("Like guests after three days," the Italian proverb says); so we quickly form an explanatory hypothesis to the script itself: it must mean stench. Wavy lines over objects with no such known properties are instantly puzzling. If they are drawn over a

stein of beer, we cannot read them as stench marks; so we seek another reading, which means that we seek a property of beer that makes plain why these lines are in a picture of beer. It may be especially strong beer or, if this is consistent with the narrative, perhaps poisoned beer—a visual aside to the reader invisible to the unwary victim as asides are inaudible to the characters in a play: an overheard aside by another character is a sly theatrical joke. In any case, it is required of conventional signs that they not be projected out of the representation into the scene as natural visible parts; so they have to be as arbitrary as they are intrusive, and hence naturalistically as discordant as miracles. Thus the cartoonist could have used, in place of wavy lines, showers of stars or crosses, or, if using the mood of irony uncharacteristic of the comic strip until perhaps "Doonesbury," he could draw a bunch of posies over the fish (ha ha). Almost anything will serve so long as there is no way of making the inscripted scene visually coherent—or no easy way. The most obvious example would be words, meant to be not just read but understood as spoken—which the balloon signifies. Spoken words, of course, are in the reality depicted, as are written words when they appear on the surfaces of objects, like STOP on stop signs. And the comic-strip artist will use conventions just in case common knowledge seems weak, especially in representation of motion: we know unsupported bodies fall, but also know that planes don't fall simply because unsupported, so when a plane is *supposed* to be falling, some circles, some dashes, a rotation of the image, perhaps an *Ay-y-y-y-y* emitted from within the plane are demanded. But sometimes common knowledge is wildly inappropriate, as in an Ottonian miniature that Panofsky describes, where a whole city is apparently depicted as floating in empty space while figures taking part in an action are on the ground below. It is not, as it happens, a city represented as miraculously suspended; as Panofsky observes, "In [this] miniature of around 1000, 'empty space' does not count as a real three dimensional medium . . . but serves as an abstract unreal background." The emptiness of blank paper is not *of* emptiness, and belongs neither in reality nor

in representation. In the standard sort of drawing, sanguine on parchment, say, an angel shown as flying is depicted in midair: the blankness of the page is not representational of transvisible atmosphere.

Common knowledge informs us that certain things are used conventionally in order that certain facts regarding shown characters should be made available to sight. Consider the action Giotto shows in *The Last Judgment* where Enrico Scrovegni offers the chapel in which the painting that depicts this is located to the Virgin and Saint John. The fresco contains the building that contains it, facilitating an intricate set of spatial allusions, but I refer to the fact that Enrico is presenting the chapel itself, not just handing over a model of it, though there would be no disparities in scale to overcome if that were all he were doing. But scalar disparities in this instance present a key to Giotto's use of architecture, namely epithetically and emblematically. Scrovegni has himself depicted in *The Last Judgment*, and so on the Day of Judgment, as donor of the sanctified edifice that portrays him, and that is to earn him a place among the saved. Giotto has the task of showing him *as* donor, which he does by depicting him handing the building, otherwise accurately enough represented that from it we can know how the building originally looked, over to the Virgin. But this is how he uses architecture throughout: it is always symbolic. Giotto is not representing figures in architectural space, like Sanraedam, but representing figures and architecture together in metaphorical space: his figures almost wear their architecture, which in every instance I can think of serves as moral rather than physical space. Open to the viewer, his rooms and porches, doors and windows, resemble nothing so much as stage settings, reduced to the dramatic functions they facilitate. One can imagine them almost as collapsible props to be carted about by a company of commedia dell'arte players for whom the Gospels are the scripts ("Jesus [*in a loud voice*]: 'Lazarus come forth!' "). And who knows but what the quasi-numerical decisions, decisions as to how many personages to show, as in the raising of Lazarus, may not be determined by how many players in the company?

The Last Judgment, of course, though finale, transcends any such limits: it would strain the powers of the film industry to achieve any parallel effect in another medium, even with a cast of thousands.

The theatrical analogy goes somewhat further, in the sense that whatever advances and revolutions Giotto may have made in the direction of natural realism, the personages who enact the narratively crucial imperatives of the script(ure) are virtually congruent with those enactments: they are almost self-allegorizations of their roles. Giotto carries this to an extreme in his brilliant effigies of the Virtues and the Vices: they are what they stand for, with nothing down their sleeves or up their skirts save what is required for condensing a moral idea in a human reality. There is no temptation, in connection with Joachim or the Virgin, to raise questions that cannot be answered, fully, out of the visual text. These are not persons with, as it were, rich interior lives. Their mission fills their souls to the absolute boundaries of their being, and they can have no life to speak of outside the pictures they help form. This is the pictorial equivalent of living happily ever after in ending a story. But this psychological characteristic is exemplary for whatever else Giotto does as a painter, in the sense that what I have referred to as common knowledge is called upon only when narrative demands it. By this I mean that there are vastly many things we know about what is shown without this knowledge ever being relevant to what we are required to know about the shown reality. Common knowledge stands to what is shown in something like the relationship in which the pre-conscious of Freud's theory stands to consciousness; the fact that nothing preconscious is ever appealed to by these works explains their power: they are fully present.

Consider the fish painted in that bountiful genre of still life (of *life stilled*, of *nature morte*) which the Dutch bought in such quantities: oysters and eels and lobsters, halibuts and squids, herrings and rays and mackerels, occasionally even a seal—and nothing without an exact ichthyological identity. (Giotto, were he to have painted the loaves and fishes, would leave it a meaningless question what sort of fish they were,

as the Bible requires no answer: they would be simply fish, as Joachim is simply Joachim, not conventionalized but essentialized and then identified with their essence.) One can learn a great deal about fish by acquiring enough knowledge to identify everything the Dutch fish artist shows us, but anyone who knows fish at all knows from the moist luminosity of *these* fish that they are fresh, knows then how these fish must smell if he knows about fresh fish at all: one might say, as we do say, that we can nearly smell them, as we can almost feel the satin in the courtesan's skirts in Terborch, or the fur in Vermeer, or the unmistakable heft and texture of Delft porcelain. The Dutch artist tries to bring the shapes and surfaces he shows to that point of realism at which the other senses are activated. Classical empiricism was an effort to analyze physical objects into sets of sensory qualities: "a certain colour, taste, smell, figure and consistence having been observed to go together," writes Bishop Berkeley, "are accounted one distinct thing, signified by the name apple; other collections of ideas constitute a tree, a stone, a book, and the like sensible things." It was a great attainment on the part of the Dutch masters, in compliance with their essentially optical impulses, to bring the visual to the point of synesthesia, where sight has folded into it the qualities of the remaining sensory modalities. In Dutch landscapes we know there is something on the other side of the hill, that if we could magically enter the paintings and walk along the road, we would never end in blankness, as it were walking backstage and outside the scene; the world in the picture goes on and on as it does in life. Svetlana Alpers shows us how Sanraedam incorporates two views of the interior of the Burr Church in Utrecht, how within a single painting we see how the church looks to the left and to the right: we would need two glances to take in all that Sanraedam gives us in one. But with Giotto everything is foreground. There is nothing behind or hidden. The Dutch delighted in optical apparatuses that would have been useless to Giotto, since he is interested in showing only how things appear to someone wholly coincident with the action, not with how things really are or with all the qualities they possess in excess of those that happen to fit the action.

There is a logical difference, latterly heavily canvassed by philosophers, between what now are called intensional and extensional contexts. A context is extensional when, among other things, two terms designating the same thing can be substituted for one another without altering the truth-value of the context. If I lose my ring, and that ring happens to have belonged to my aunt, well, I have lost something that belonged to my aunt: *losing* is extensional, like the smell of roses, unaltered by the many names by which roses are called. Believing, on the other hand, is intensional: if I believe I have lost my ring, I may or may not believe I have lost what once was my aunt's. Only certain properties of a thing enter into my beliefs about it, which is why intentionality makes tragedy of a certain sort possible. Though Jocasta is his mother, Oedipus in believing Jocasta will make him a fine wife does not believe his mother will make him a fine wife, yet he is punished as if belief were extensional. Well, in an important sense, Giotto is an intensional painter. There are many properties of the persons he shows, and the things he shows as props for the profound responses, other than those he does show; but he shows only what belongs to the representation, implying nothing beyond that—almost as though reality itself had the structure of a picture, consisting in its appearances and nothing more. The Dutch, by contrast, always show that there is more than they ever show. Their people walk and talk in ways other than those in which they are shown walking and talking. Theirs is a full world. The Dutch could have no artistic objection to the direct representation of things they instead can only imply in the given state of technology, so long as what was added was as convincing as what already was there. Suppose it were possible to add smells to a painting, so that a rich olfactory mimesis evolved. The Dutch masters of this novel skill, to keep abreast of their visual colleagues, would have to bring us, when we entered one of the latter's fishy extravagances, the brine, the sea air, kelp and iodine, tar and rotting rope and salt-soaked timber, as well as the sharp odors of scaled and shelled creatures, so that we might say, One can almost smell the cry of gulls, the chants, the creaking sails. But what good would it be

to add to Giotto an actual stench? *The Raising of Lazarus* does not belong to the history of illusion and synesthesia, or *trompe les yeux*. It appeals to the mind rather than the senses, stands closer to words than to perceptual stimuli.

Let us consider the representation of motion from this aspect. We have grown used to the direct representation of motion, where as in the past artists had at best been able to show that something had moved, as in the case of Bernini's *David* or of Saint Lawrence writhing on the grill of his martyrdom. The suite of frescoes Giotto devotes to the missionary cycle in the life of Christ shows that Christ's arm has moved or is moving—in admonition, in blessing, in resurrecting. But with the mediation of a more and more complex technology, a dream of pictorial ambition has been redeemed. Where once one would say that one could "almost see it move," that *almost* has been erased by cinematography, and just the same pathways as are activated in the perception of real motion respond to the virtual movement on the screen. Nabokov's *Laughter in the Dark* begins with the fantasy of animating actual paintings:

> How fascinating it would be, he thought, if one could use this method for having some well-known picture, preferably of the Dutch School, reproduced on the screen in vivid colors and then brought to life—movement and gesture graphically developed in complete harmony with their static state in the picture; say a pot-house with little people drinking lustily at a wooden table and a sunny glimpse of a courtyard with saddled horses—all suddenly coming to life with that little man in red putting down his tankard, this girl with the tray wrenching herself free, and a hen beginning to peck on the threshold. It could be continued by having the little figures come out and then pass through the landscape of the same painter, with, perhaps, a brown sky and a frozen canal, and people on the quaint skates they used then, sliding about in the old-fashioned curves suggested by the picture . . . returning to the same tavern, little by little bringing the figures and light into the self-same order . . . and ending it all with the first picture.

This is a genuine possibility for Dutch art, which is static only as a matter of external necessity. There is an implicit dynamism in everything the Dutch painter shows, and if paintings could be gotten to have moved, like Nuremberg clocks, that would have been a natural thing for so optically motivated a style. But that style goes with a delight in the infinity of reality. Nabokov gingerly projects the possibility of applying the technology to Italian painting, "even religious subjects, perhaps, but only with small figures." Giotto, with the conceivable exception of his *Last Judgment*, is immune to the enhancements of animation: what could happen that is not already there? Mary and Martha are already kneeling, Lazarus is already exhumed, the stench already fills the air. Christ could lower his arm, the graveclothes could be unwound, the crowd could disperse murmuring. But this would be like telling what they did after saying that they lived happily ever after, abusing rather than enriching the internal boundaries of the structure of narration.

NOTES

1. E. H. Gombrich, *The Image and the Eye* (Ithaca: Cornell University Press), 90.

6

Postmodern Art and Concrete Selves

The Model of the Jewish Museum

THE ART HISTORIAN ERWIN PANOFSKY claimed to perceive certain structural analogies between the art of a given period and that period's philosophy, almost as if there were some single unifying spirit which expressed itself in parallel ways in these two symbolic modes. He believed, for example, that the Renaissance discovery of perspective was not merely the truth of how objects recede in space from a fixed point of view, but was, as well, the aesthetic counterpart of certain Renaissance understandings of the nature of human knowledge. He similarly believed that the altogether different spatial conventions of Byzantine art expressed "the metaphysics of light of Pagan and Christian Neoplatonism." It was not that the artists and philosophers of a given historical moment were especially in touch with one another, or studied one another's ideas, or belonged to some single intellectual community, but that there always is some underlying principle that is made visible and objective in the philosophy as well as the art of that moment. Perspective at once gave Renaissance artists a way of convincingly representing the world

Originally printed in the catalog *From the Inside Out: Eight Contemporary Artists*, published in conjunction with the 1993 exhibition of the same name organized by the Jewish Museum, New York.

and a way of expressing, in the deepest possible way, the culture to which they belonged. Panofsky gave the name *iconology* to the study of these undeniable resonances between the art and the philosophy that together define the internal spirit of a period.[1]

It is striking to how great a degree recent turns in art and in philosophy appear to confirm Panofsky's speculation, and it will be of some value to assess the inaugural exhibition (1993) of the remodeled and, in some measure, rededicated and redefined Jewish Museum against this background. Perhaps as recently as twenty years ago there was a certain consensus, in moral philosophy and in the philosophy of art, that ethical and aesthetic values were universal, invariant in all times and places, and that the task of the good society is the real embodiment of universal principles of justice, just as the task of good art is to embody principles of beauty valid for all human beings. It was, on either side, very much as if individual human beings were themselves deeply the same, throughout all periods of history and irrespective of cultural location, so that their particular concrete identity, in terms of race, of gender, of historical situation and political placement, did not belong to their essence as human. The self, so to speak, was an almost mathematical point, logically situated outside time and space and circumstance, which were as so many inessential garments, to be cast away in pondering what is right and just, what is true and false, what is beautiful and what is not. One's Jewishness, for example, would be a matter of external accident, something one happened to have but which, without losing one's essential identity, one could put on or take off.

The philosopher John Rawls, in a famous and profound work, *A Theory of Justice*, imagines what it would be like were human beings separated by an impenetrable Veil of Ignorance from the society in which they were to live, and then asked rationally to choose the principles of justice which were to define that society. Rawls seems confident the choosers would all pretty much hit on the same liberal principles, giving themselves the best deal they could have if, unluckily, they turned out to be

the least advantaged members of the society when the Veil was removed. The presupposition was that, as choosers, humans are all alike, what a recent critic of Rawls calls "ciphers," and all will spontaneously choose the same universal principles. But that means that the roles they finally put on, when placed in the imagined society, are altogether external to what Rawls allows as belonging to human beings inherently: their ability to make certain rational decisions—their *reason*.

This view of what it is to be human has its origins in the philosophy of Kant, as does its counterpart conception of art. Kant claimed that moral principles have application to us humans only insofar as we are rational beings and hence capable of acting in conformity with moral principles as universal as the laws of nature. Indeed, Kant's celebrated categorical imperative directs us to act only on those "maxims," as he terms them, that we are prepared to universalize and hence to will as binding upon all beings like ourselves. And a moral principle in Kant has no validity whatever if it is not universal. There is, then, no sense in Kant of history making any difference, or culture, or religion, or the deep circumstances that in fact affect us as profoundly as earth and light affect the far less complex composition of wine. And, in his thoughts about art, Kant insisted that the task of art is to induce pleasure of a kind we call beautiful only because we believe that the pleasure is universal: we judge aesthetically for all rational beings. "The subjective principle in judging the beautiful," he wrote, "is represented as universal." He immediately went on to say that "the objective principle of morality is also expounded as universal." Hence the Beautiful, in his philosophy, is "the symbol of what is morally good" in that "it gives pleasure with a claim for the agreement of everyone" (*Critique of Judgement*, §59). The idea that the principles of moral life, as well as the principles of aesthetic judgment and of artistic creation, are deeply uniform expresses what we may call the Kantian consensus in the philosophy of good societies and good art. The recent turn referred to some paragraphs back, in ethics and in art, marks the disintegration of this consensus.

I shall make no effort in this essay to speak of the criticisms of the Kant-Rawls philosophy of the good community. I shall point out merely that its basis lies in a very different conception of what it is to be a self than either of them allows. A self is not an abstract point of pure reason, the same in all times and climes and cultures. The self, rather, is the concrete product of many forces and causes, which mark it totally. It is in particular the embodiment of its culture, its gender, its traditions, its race; and these are not matters to be thought away in asking what the good life for human beings is, where the only satisfactory answer is some universal principle. And so an adequate theory of morality must take into account the concreteness of concrete selves in their immediate societies. Whatever the outcome of such an inquiry, our ethics must acknowledge, must begin with, the multiplicity of our identities and what differentiates us as real.

It is not surprising to find a corresponding particularity in contemporary views on art. Art is too multiple in its sources and too diverse in its satisfactions for there to be, save at the most abstract levels of philosophical discourse, any one thing that art is and must be. Often, theorists of art identified what was in truth but a momentary style with the philosophical essence of art, and insisted that unless works of art attained to this essence they had no justification. The view today is that there is no such essence, at least none that is to be identified with what is after all but a style. It is not surprising, if there is anything to Panofsky's views at all, that in that period in which Rawls was hammering out his philosophy—the late 1950s and the early 1960s—the philosophy of art, and especially of the visual arts, was essentialist, universalist, and historically complacent. The vehicles of the universality were characteristically painting and, to a far lesser degree, sculpture. The endeavor was to identify a genre of painting that was pure and that hence expressed the deepest and most final truths of art. It would be abstract; the pleasure it might afford would be almost intellectual; and in its Platonic absoluteness it stood outside history. It made no concessions to the special conditions of its viewers: their experiences must at last be all alike, exactly as Kant insisted

the ascription of beauty must entail. It made no difference whether the viewer was male or female, white or black, Jew or Gentile, American or European.

A chief proponent of this puristic vision of the work of art was the uncompromising New York artist Ad Reinhardt, and it is worth noting that the major exhibition of Reinhardt's work should have been mounted at the Jewish Museum in New York in 1966. The Jewish Museum in those years was the main venue for the most advanced visual art of the era, far more consistently so than any museum in the city, and especially more so than institutions like the Museum of Modern Art, which had settled for an almost canonical modernism, and the Whitney Museum of American Art, which only sporadically presented art on what has come to be called the cutting edge. For a period of some years, the Jewish Museum was the place to see the art that was self-consciously advancing the theoretical consciousness of what art is and, instructively, the art that was just then beginning to call into question the premises of the tacitly Kantian aesthetics that defined the production and the appreciation of painting in the high phase of abstract expressionism. Side by side with the work of Reinhardt and of Phillip Guston (when Guston was still a lyrical abstractionist and had not yet gone into the charged political imagery that marked his art at the end), one could also see the work of Jasper Johns and of Robert Rauschenberg, who were beginning to dismantle the Kantian aesthetic in ways that no one at the time could foresee.

It must have been perceived as something of an anomaly that the living edge of art history was being made visible in an institution identified as the Jewish Museum, for there was nothing particularly Jewish about the art, and indeed, as we saw, it was inconsistent with the official aesthetics of the mid-1960s that religious or racial identity should figure in any way in the determination of art as good. There was, despite this, some interest on the part of advanced theorists who took a natural pride in the fact that the most advanced art in fact was *American*—that America had broken through and become the artistic capital of the world—and the question was certainly discussed as to whether there was some

special Americanness in the art being made. In my own case, so far as I thought about the question of modern art and Jewish identity, I thought of the propensity of Jews to associate themselves, if not as practitioners then as patrons, with the most advanced intellectual and artistic activities of the time—as patrons of the human spirit in its highest cultural attainments. In fact, I took a certain pride in that association, and it seemed to me that the Jewishness of the Jewish Museum could not more appropriately express itself than in sponsoring this extremely adventurous art, whatever the identity of those who made it. The twentieth century had seen a number of Jewish artists emerge of world-class achievement, but certainly, in my view at least, the fact of their Jewishness had nothing as such to do with their attainment, any more than the Spanishness of Picasso or the Frenchness of Matisse or the Russianness of Malevich had to do with the greatness of their art. It was a fact, but an external fact, that as artists they had these identities. I took it for granted that Jews should excel in the arts, once the barriers, internal and external to the tradition, were removed, much as it seemed to me altogether expected that Jews would excel as physicists or philosophers once it became possible for them to gain entry to academic study. And for much the same reasons that one would have been reluctant to ascribe a particular Jewish content to the work of the great Jewish physicists, or to that of the major Jewish philosophers, many of whom had been among my teachers, one did not see in the art of Jewish artists anything one cared to identify as Jewish, and certainly not when it came to explaining the goodness of their art.

Whatever the case, this ascription of an internal connection between patronage and cultural excellence as itself a Jewish trait could have been buttressed, had one cast about for historical evidence, by the history of the Warburg family itself, which had after all, in 1946, given their marvelous mansion to the Jewish Museum as its building. This was especially true of "Eddie" Warburg, who had been among the earliest American patrons of modernism, in painting, sculpture, architecture, and ballet. His own precocious acquisitions, among them an outstanding Picasso of

the Blue Period, had been installed in the house when it was still the family home. And it is worth pointing out that Edward Warburg's uncle, the scholar and art historian Aby Warburg, was the founder of the Warburg Institute and Library, to which Erwin Panofsky in fact belonged.

Panofsky's iconology, itself a generalization of his 1927 work on perspective (a publication of the Warburg Institute), was intended as a contribution to the philosophy of symbolic forms, a theory advanced by another of the Warburg scholars, Ernst Cassirer. Cassirer's thesis was in fact a criticism of the universalist theory of human nature assumed by Kant, which I have taken as the background theme of this essay. Against the Kantian thesis that the human mind is everywhere and always the same, Cassirer, and after him Panofsky, insisted that experience is processed through a number of "symbolic forms," which include language, myth, religion, art, and philosophy, and these differ considerably from cultural moment to cultural moment and from one historical location to another. The tacit endorsement of the Kantian aesthetic was very much a function of what one might think of as the front portion of the Jewish Museum in the 1960s, and its "Americanness" was dependent in effect on the universalizability principle, which expressed the advanced attitude toward art and social values at the time. It would have been the neglected back portion of the museum, which housed objects steeped in explicit Jewishness, that came closest to embodying the philosophy of symbolic forms, which the members of the Warburg Institute sought to put in place of Kantian psychology in order to get closer to the realities of human mentality.

By deciding to insist on the Jewishness of its exhibitions in the later 1960s, thus turning the museum away from the universalizing temperament of contemporary art, the trustees in fact attached themselves to the other, more particularistic philosophy of the Warburg patrimony. It was as though the Warburg family was connected with two distinct philosophical trends, universalizing and particularizing, through the activities of Edward Warburg and then the philosophical heritage of the Warburg Institute itself. Indeed, the Jewish Museum, with its cultural universalism

expressed in the art it showed, and its sheltering of the palpabable remnants of what everyone conceded was a vanishing if not vanished Jewish culture, embodied, as an institution, the tension between the Kantian philosophy and the more historicizing philosophy of symbolic forms.

The decision to retreat from the frontiers of avant-garde culture was perceived by many at the time, myself included, as the willed destruction of a vital institution. Indeed, given the justification of showing contemporary art by a *Jewish* museum, that is, the connection between high cultural patronage and Jewishness, the decision seemed a betrayal of part of what Jewishness had traditionally been taken to consist in. The argument made at the time, that there were by now many alternative spaces in which advanced art could be seen, making it less and less necessary for the Jewish Museum to play that mediating role between an art that was not especially Jewish for the benefit of an audience that was not especially Jewish, seemed beside the point. For the thought, after all, had been not that the Jewish Museum was doing something because no one else was, but that it was doing what it was expected a Jewish museum might do. In the event, I daresay the decision was precocious in view of the cultural particularism that was destined to overtake American culture—that was destined to overtake *world* culture—in the postmodern era. And who can say whether identification with the avant-garde was not a form of aesthetic assimilationism, an effort to submerge Jewish culture in some dissolutive universality?

Throughout the years of its cultural ascendancy, the Jewish Museum had housed a permanent collection of artifacts, representative of ritual and ceremonial practices of the Jewish people, shown in display cases like anthropological specimens. Younger Jews might conduct their parents through these exhibits, which often elicited memories of life in Europe; the spirit in these objects was released at such moments, like the jinns captive in bottles in *The Arabian Nights*. The difference in response, however, was generational: for younger Jews, the meaning of the Jewish Museum was in the great display spaces of the Jewish Museum, where it was not felt aesthetically jarring that paintings which often renounced

ornamentation were hung in rooms heavy with ornament, reflecting the intricate neogothic taste of the baronial American plutocracy. Unless the life of the ritual objects was released by the catalyst of a parent or an older relative from a different culture, the objects were as distant as those on display at the Museum of Natural History. The religion of Japan, zen in particular, seemed more relevant to contemporary art than one's "own" religion. One's "own" religion was simply something one happened by historical accident to have, but it did not penetrate one's sense of one's being, or one's sense of what one was. There was no outflow from object to sensibility and soul, since there was no inflow, from soul to vessel or manuscript, of meaning and spiritual proprietorship.

The immediate consequence of the decision to vacate as avant-garde venue was that the Jewish Museum dropped blankly from the A-list of aesthetic foci on the artworld's cultural map. It became in part the focus of scholars with a research agenda in Judaica and of those, always a significant number among the culturally avid in New York, who have an interest in the exotic, in the out-of-the-way, as exhibitions with Jewish content must be in the cosmopolitan context. But it also—and this came to be of more and more importance—became a point of pilgrimage for those to whom the very fact that there was, in New York, a *Jewish* museum had begun to mean something; for visitors to New York for whom its being specifically Jewish and a museum had emerged as sufficient reason to visit it, whatever its content and whatever exhibition, of scholarly or aesthetic interest, might happen to be on display on the occasion of their visit. This, as I have come to recognize, is by no means a negligible constituency, and it merits a few paragraphs to explain why.

The prevailing concept of the museum—any museum—in the 1960s, a concept largely formed in the course of the nineteenth century, was that it was a treasury of works of art of the highest quality and a resource for scholars interested in the history of art. Unless one was a scholar, one went to the museum merely to be in the presence of great works, an experience deemed educational in two ways. First, one learned, by visiting the galleries devoted to the various "schools," which were ordinarily

organized chronologically, something of the history the school under-went in pursuit of its highest attainments. And second, because the works that constituted these high achievements conveyed, or were believed to convey, truths and values of the utmost benefit to those who absorbed them, by looking at those works one was edified in those selfsame truths and values.

There was another function, one strongly emphasized in the early days of the modern museum, preeminently in the Louvre when it was the Musée Napoléon, but that had become fairly vestigial by the mid–twentieth century. The Musée Napoléon had gathered, through conquest, the highest artistic products of the nations conquered, and these were displayed nearly as trophies. The French citizenry entered the space of the museum in part to feel the power of the nation to which they belonged, not simply through the artistic achievements of the French School, but politically, through the palpable power that posses-sion of the masterpieces of conquered populations represented. The mu-seum confirmed the French people's sense of themselves as a nation, and it was through the museum experience that a sense of identity with the political community that was themselves was intended to emerge. This experience was the raison d'être of the Musée Napoléon, and it was in part to make this experience possible for their own citizens that the Prus-sians and the British—Napoleon's victorious enemies, after all—estab-lished their respective national galleries. The museum, in the early nine-teenth century, thus became a kind of secular church, where the congregation affirmed and reaffirmed its identity. It became—and this is expressed physically in the architecture of that era's museums—a temple on a hill. And while the intense nationalism the Musée Napoléon was intended, even calculated, to instill perhaps abated over the decades, France and neighboring nations certainly continued to treat their muse-ums as living monuments to the national spirit. The Rijksmuseum, for example, was built as a temple to the Dutch spirit, which expressed itself in the works of the great Dutch masters; and the Dutch clearly felt them-

selves in touch with their Dutchness in imbibing, through eyes and feelings, the national essence distilled in *The Night Watch*.

Museums whose principle was defined along these lines inevitably divided the experience of visitors, depending on whether they belonged to the group whose spirit was embodied by the museum and its content or came as outsiders, as tourists, or as aesthetes to whom that spirit was in every sense external. The one group was strengthened in its Frenchness or its Dutchness by the art, the other had no such relationship to the art to be strengthened by communion with it. Of course, the externalist relationship to art became, over time, the prevailing one. In institutions such as the Museum of Modern Art in New York, the raison d'être of art was seen as aesthetic and its essence as formal, and such considerations of identity that went with the national museums of Europe had no application. This was, in truth, the case with most American museums. Nothing in its great holdings bonded the Detroit Institute of Art to natives of Michigan, for example, and the Boston Museum of Fine Arts was at best marginally identified with Bostonians. The Metropolitan Museum of Art was universalist, as was even the National Gallery in Washington, despite its name; its self-adopted function was, as with most American museums, the promotion of aesthetic cultivation and of scholarship in the arts. The Jewish Museum as an avant-garde venue was universalist in this spirit, if narrower in its scholarly focus, through its collections of Judaica. Its audience was divided, but the audience for the modern art it showed was not: that art was presented in the spirit of universalism that went with the Kantian consensus.

Kant, in fact, rather helps in making clear the difference in cases where one portion of the audience approaches art in the spirit of connecting with a special community. In the *Critique of Judgement* (§13), Kant argues that the experience of beauty has mingled with it no component of what he calls *interest*. The pleasure elicited by objects perceived as beautiful is, in his words, "merely contemplative, and does not bring about an interest in the object." In fact, "Every interest spoils the

judgement of taste and takes from it its impartiality." Kant goes even further: "Judgement so affected can lay no claim at all to a universal valid satisfaction."

As we saw, the claim that something is beautiful entails the further claim that everyone in principle must find it so; accordingly, the idea of there being an admixture of interest is incompatible with the appreciation of beauty. Hence aesthetic judgment is in its nature *disinterested*. Kant's philosophy was formed before the era of nationalism that gave rise to the great museums as among its emblems, and it is clear that his idea of art is altogether different from that which underlies those museums. Their conception of art is very much one of interestedness, and is not at all universal. The art, like the museum, speaks in a special way to the group whose art and museum it is. To experience the art is from the start to have an interest—not a personal or individual interest, but the interest that has as its object the furtherance of the group to which one belongs. The art is there for the sake of that interest. It follows that, from this perspective, the primary concern of art is not that it be beautiful—or in any case, its being so is secondary. It follows further that artistic experience is not aesthetic either: it is instead political and instrumental. The experience of the art is one avenue for entering into oneness with one's group. Needless to say, the art made present to the visitors related to it through interest need not be great art by universal criteria at all. All that is required is that it distill the same spirit they themselves possess, making possible the intended internal relationship. Of course, when the art is great, as with the Dutch masters, this redounds to the overall credit of the group that confirms itself through the masterworks.

It is in this spirit, then, that those who made the Jewish Museum a point of pilgrimage came to it, in increasing numbers, after it renounced its universalism and in some measure its aestheticism. They came to it to be in the presence of art that was Jewish, because the art was Jewish and they were themselves Jewish. The museum, the art, and they themselves were one in this regard. It reinforced their identity to be in the midst of that with which they were one.

The 1960s was a period of active museum construction in the United States. In the early years of the decade new museums were opening nearly every week, and many of our major architects' first major commissions came with the invitation to design a museum. A good many of these museums reflected an interest in art that was itself the result of Americans having traveled abroad or having taken courses in art history and art appreciation in colleges and universities, and of the growing sense that access to art was woven into the good life. Corporations located in smaller urban centers contributed to the growth of museums as a way of providing cultural incentives for attracting executives. The museum, like the symphony orchestra, the ballet, the repertory theater, became a focus of community pride. But this enthusiasm notwithstanding, the premises of the art remained aesthetic and universalist: it was for everyone, and to be experienced in the same way by all. Docents everywhere talked about diagonals and concentricities, surface textures and phenomenological spaces.

There was, however, another kind of museum that came in these years to have increasing importance under various political agendas in the United States and elsewhere. It was part of these agendas that constituencies have museums *of their own*, in which they, through the art of their membership, could celebrate their specialness—not just their identity, but their difference from other groups. A case in point was the Museum of Women's Art in Washington, D.C., a special venue where art by, for, and of women could be made accessible to the enhancement of gender pride. The museum, of course, was open to "others," specifically men; but the experience was in no sense disinterested, and it was in no sense universal. Critics of both genders sometimes noted that the work there was not always of the highest quality. But this was to apply considerations that belonged to a different conception of the museum, of art, of artistic expression and artistic experience. It was to impose an irrelevant conception of the ideal of the museum. To insist that only the disinterested museum had validity as an institution was to beg the question.

The difference between the museum as focus of civic pride and the museum as an agency of interestedness is built into the history of the museum as an institution, and it is not a matter for wonder that in the 1960s the Jewish Museum should, more than most American museums, incorporate both dimensions of the museum concept, or that it should have been perceived as anomalous for this reason. It is extremely difficult to have a conception of art that is at once interested and disinterested, and it is wholly comprehensible that in the period in which the Jewish Museum changed direction it should have defined itself as the kind of museum part of whose reason is to tell the members of its immediate constituency who they are as members of it. Indeed, any number of museums that were initially scholarly museums underwent a parallel transformation, such as the Museum of the American Indian. In the course of the 1970s and the 1980s, the display cases of such museums, installed originally to house objects of study, in which the displayed objects were classified, labeled, and described, underwent a powerful transformation. The change was from objective data for knowledge into subjective opportunities for communion with the past of the viewer's own group. Visitors now came less for knowledge, in the disinterested posture of archeology, than for a kind of inspiration, in the interested posture of the adherent and the celebrant. The objects in the Jewish Museum condensed the history of Jews, and what will be referred to in the reconstructed Jewish Museum as the "Core" Exhibition will have inevitably different meanings for visitors depending on their interests, which in turn depend on visitors' identities. The museum itself, in fact, has two relationships with the Core Exhibition. In one relationship it is external to it, and contains it. In the other relationship it is part of the exhibition. The Jewish Museum itself stands likewise in the two kinds of relationship to visitors that the objects in it must. It continues the history it displays.

It must be plain at this point that the same social and political forces that explain the reemergence of the museum of interest and identity must at the same time explain the breakup of the philosophy of good and right

as Kantian universals which I began this essay by describing. It is exactly those factors which set the group apart in the image of itself possessed by its members that theorists now insist must also belong to the concrete self that is shaped by the group. One does not confront society as a tabula rasa, an individual unsullied by the divisions of gender, race, culture, class, or ethnicity. Moral systems may be as various as the order of concrete selves that compose societies. Of course, this kind of pluralism does not come without costs. The extreme costs are kinds of ethnic hatreds and resentments that rend so many societies today into bitter factions. And there are other, less dramatic costs as well, such as the partitions of curricula into different sorts of "studies"—women's studies, black studies, working-class studies, Jewish studies, Chicano studies— where education continues the work of the museum in reinforcing identities and bringing them more and more into consciousness. All of them reinforce boundaries it was the ideal of the Kantian ethic to overcome by insisting on the universality of morally justified precepts.

That is not our problem here. What remains for us to describe is the way in which the forces that give rise to the museum of interest and identity were able to take advantage of certain changes internal to the history of art, which in turn makes possible a kind of artmaking along pluralist lines. I want now to narrate the other relevant part of the Kantian consensus, that which makes beauty criterial for art and which excludes the ingredient of interestedness as not belonging to the experience of art in its purest state. The art in question is but secondarily to be assessed in aesthetic terms, and it is almost inconceivable without reference to particular interests. It is an art capable of dividing audiences into those internally related to it and those outside the spirit the art attempts to embody.

The history of Western art is spontaneously conceived of as the history of Western painting. It is a history like no other in virtue of having sought, until late in the nineteenth century, the progressive attainment of representational adequacy. Even when *representational* adequacy receded as the goal of painting, the assumptions of progress remained,

leaving participants in the institutions of art with a vocabulary of advance, of breakthrough, of stagnation, even of decline: to be a painter was in effect to see oneself located in a history that lay upon one the imperative always to be carrying the standards of artistic advance into the strenuous future. From the perspective of painting, accordingly, the decade of the 1970s appears to have been less a period of art history (by then it had become common to think of the decade as an art-historical period) than a gap between two periods, perhaps that of the minimalism of the later 1960s and the expressionism of the 1980s, when it seemed to a great many in the artworld that art history was again back on track. It *is* true that very little happened in *painting* in the 1970s, but unless we narrowly identify art with painting, it was a period of astonishing creativity, the art history of which has not yet been mapped, let alone understood.

In fact it began to seem a critical commonplace that painting had come to an end in that period, that against the progressive model there was no further place for painting to go (and tacitly that there was no further point in painting). This itself requires a bit of perspective. The "death of painting" has, in the twentieth century, frequently been pronounced, usually as a corollary of some revolutionary agenda, in which the agency of art was to be enlisted in some social or political cause. And the 1970s, in fact a strenuously politicized period, was no exception. Painting was increasingly impugned as "patriarchal," as the vehicle of some kind of white male aesthetic that may have no application—or, if any, only a forced one tantamount to oppression—to artists who were neither white nor male and whose "language of forms," to use a phrase given currency by Linda Nochlin, might not finally be suitable for women in particular at all. It was in any case inevitable that in a period in which art was *interested*, that painting, as the vehicle par excellence of the *disinterested* apprehension of beauty, or aesthetic form, should have come under polemical attack.

In an earlier era, interestedness would doubtless have found its outlet in representational content, in the form of propaganda or at least of visual

rhetoric. In the era of abstraction, however, this would have meant a backward move (as Guston's cartoony political emblems were regarded as a backward move). Even artistic rebellion in the West takes on the imperative of art-historical advance. So the agenda was unavoidable and clear: to make art alternative to painting without reverting to modes of painting that art had gone beyond. With all the political energy there then was, the period was astonishingly fertile in hitting upon alternative forms of artmaking—in body art, earth art, fabric art, performance art, video, installation, conceptual art, and beyond. As a beneficiary of this fermentation, sculpture underwent a kind of renaissance, merely in consequence of the fact that so many of the new forms required real space for their realization, and thus seemed closer in genre to traditional sculpture than traditional painting. Painting, then, heretofore the spearpoint of progress, became in the 1970s, and perhaps remained and will remain, something also cultivated, but a spearpoint no longer. And of course, with the new art being made, the idea of beauty, so natural and appropriate in connection with painting, seemed less and less relevant, the new kind of work being defined internally in terms of the interests of the artist and that or those of his or her intended audience.

Of the new forms, performance is in certain respects the easiest to grasp. In it, an immediacy of presence of the artist in the work is assured, and hence an immediacy of confrontation between artist and audience, in which both are in some way put at risk. The performance artist is not endeavoring to create beauty, but to achieve the transformation, possibly the explosive transformation, of consciousness. It is a genre to which women have taken in great numbers, perhaps because the concept of consciousness-raising was a strategy of early feminism; and the performance artist will, to this end, do certain things to herself, use certain language, flout certain boundaries, enact certain gestures, which can, which perhaps must, put her audience on a certain precarious edge. In a way, performance connects with a very early form of art, in which the artist was a kind of priest or priestess, who performed in such a way as to obliterate the gap between her and her audience, and perhaps among members

of the audience as well. Whatever the case, the Kantian ideal of contemplation does not go with performance. What instead goes with it is participation, a readiness to undergo change, a willingness not just to have had a certain experience but to have become a different person in consequence of the experience. Performance has lent itself naturally to political action. Through the transformation of consciousness the artist intends a transformed society.

A great deal of the art that came to take the place of painting in the 1970s was, in its own way, critical of the institutions that had grown up around painting: the gallery, the collection, the marketplace, even the museum itself. And by contrast with the atemporality aspired to by art—the thing-of-beauty-is-a-joy-forever criterion of aesthetic goodness—the art was often inherently ephemeral. The consequences of performance might go forward in the form of modified consciousness, but the artwork had a limited duration. It could not be collected; it could only be repeated. It could be funded, but not readily bought or sold. It is something of an irony, if not something of a tragedy, that the major funding agency in the United States, the National Endowment for the Arts, should have found itself being asked to fund art of a kind that was bent precisely on the kind of moral and political action hardly imagined possible at the Endowment's beginning, in 1960, when the aesthetic imperative of art was taken as paradigmatic. I have elsewhere spoken of the "disturbational" ambitions of performance art especially, a purpose that seems almost incoherent with the aims of art as construed by the Endowment.[2] It is hardly cause for wonder that the Endowment's extension should have encountered such heavy weather in the Congress: that body was being asked to subsidize art often critical of the very fabric of the society for which the Congress stands.

Installation art shares many of the features of performance, and it too became increasingly the vehicle for artists with particular interests, for the pursuit of which the art was a means. Installation art is in the first instance participatory rather than contemplative, and subversive rather than gratificatory. Entering the installation, one is meant to emerge

somewhat altered by the experience. In September 1992, an exhibition sponsored by the Museum of Contemporary Art in Chicago opened at the Chicago Armory—a form of architecture inevitably associated with artistic radicalism through echoing reference to the notorious Armory Show of 1913 in New York. The title of the show, one characteristic of this genre of artmaking, was "Occupied Territory." The term "occupation" implies the victorious outcome of armed struggle, and that art should have taken over space heretofore devoted to military drill emblematized what the art itself aspired to. Each of the nearly twenty pieces had an agenda, the AIDS crisis, the crisis of the environment, racism, and sexism being favored targets. These works were not just about AIDS or the environment, though, the way classroom projects would be. They were not there just to give information. They were there to *move minds.*

The constellation of installation pieces in the inaugural exhibition of the new stage of the Jewish Museum will be less diffuse and less trendy. But in a general way, their aim must be the same. They may give information about aspects of what it means to be Jewish, but their intended force is not exhausted by the transmission of information. Or better, perhaps: the content is less to be mastered than earned, through participation of the visitor, who lives through the experience of the installation and grasps its meaning in that way. As with all interested art, this approach will of necessity divide spectators: those not Jewish will not be moved to reflect on the meaning of their Jewishness. But each piece is intended to vitalize some aspect of what is generically called the Jewish Experience, and so should be accessible to all viewers, however great a distance they may stand individually from the immediate content of the work—from Yiddish theater and film in the irresistible work of Eleanor Antin, for example, or, in the severe and exigent work of Nancy Spero, from the brutalization of Jewish women under Nazism.

Precisely because participation is demanded in installation art, it is impossible to speak of the various pieces without having undergone the experiences each provides. One thing, however, is worth emphasizing: in following its own bent, the Jewish Museum has again connected with

the mainstream of contemporary art. By making Jewishness the focus of its exhibitions for as long as it has, the Jewish Museum has in a sense allowed the artworld to catch up. Nothing in the 1960s was more "advanced" than the art of installation is today.

A marvelous emblem of the reconnection is the new building this exhibition celebrates. The original Warburg mansion on upper Fifth Avenue, donated to the Jewish Museum in 1946 by Frieda Schiff Warburg, is a heavily ornamented structure in the style of François Premier, an architectural descendant of the church of St. Etienne du Mont in Paris, or the château de Blois in the Loire Valley. It exudes an unmistakably baronial assurance of power, translated into the language of forms. Within, it is all beams, panels, monumental fireplaces, grillwork, balustrades, and elaborate stucco. There was, in the period of the museum's ascendancy, as remarked, a certain jarring contrast between the dated rhetoric of the building and its fittings and the spare abstractness of the most exemplary of the artworks it showed. That kind of art seemed to cry out for what the critic and artist Brian O'Doherty wrote of as the "white cube" of the official display spaces of the modern gallery, eloquent as metaphors of purity. When in fact the museum first made a bid for architectural modernity, with the construction of the List Building (1959) and Sculpture Court (1963), the discrepancies ran generally the other way: it was modernist, in its plate glass and geometry, at a time when the museum's exhibitions had little essentially to do with this. When undertaking to enlarge the museum, there was an almost dialectical necessity in the decision to go back to the first building and to seek to duplicate its architecture, down to the least mullion and crocket. And in 1992, no more advanced a gesture could be imagined.

As a philosopher, I have always been gripped by examples of the following sort: two things, of philosophically different kinds, look exactly alike in outward appearance. The original Warburg mansion and its reiteration by Kevin Roche raise the same issue, albeit less radically. The old mansion was symbolic of wealth, power, status, and aspiration. Like the wealthy of America generally, the Warburgs surrounded themselves

with the appurtenances of aristocracy, and with the kind of art only the greatest wealth can command: Felix Warburg's pride was an amazing altarpiece by Fra Lippo Lippi, a kind of installation in the sense that its original purpose was not to be looked at but to be prayed before. Kevin Roche's structure refers to that original structure in a perfectly postmodern way: it is at a distance from its subject, the way a quotation is from the sentence quoted; and as with quotations, its meaning and rhetoric are altogether different, even if, on the page or in stone, the pairs are not to be told apart visually from one another. The beauty of the architecture is that it demonstrates how, in seeking one's past, in preserving that past and making it one's own, one transcends it: one is at the future edge of the present. If the works in this exhibition can achieve that same leap, the art will have been as great a success as the building which surrounds it.

NOTES

1. Erwin Panofsky, *Studies in Iconology: Humanistic Themes in the Art of the Renaissance* (New York: Oxford University Press, 1962).

2. Arthur C. Danto, "Art and Disturbation," in *The Philosophical Disenfranchisement of Art* (New York: Columbia University Press, 1968).

The Seat of the Soul

Three Chairs

I sing the Sofa. I, who lately sang
Truth, Hope, and Charity, and touch'd with awe
The solemn chords. . . .
<div align="right">William Cowper</div>

FOR SOME YEARS, the official correspondence of the Philosophy Department of Columbia University went out over my signature— scrawled, urgent, illegible—securely situated above my clearly lettered title: Chair.

In the letterhead universe of officialdom, the seated signature is universally recognized as the mark of power and authority—so instantly acknowledged a symbol that I have often wondered why artists who traffic in punning interchanges between sign and reality, Magritte, for example, should never have produced the artwork of my dreams, consisting of the curvaceous horizontal signature

—elongated atop

CHAISE LONGUE,

in suitably elegant Empire majuscules.

Reprinted from *Grand Street* 7 (summer 1987): 157–76.

In the spirit of such symbolism, when it was important that my status be stressed, the signature went out spread across two chairs, one referring to my stewardship of that crew of scholars and contenders which composes the philosophy department, the other to the distinction conferred upon me as the occupant of the Johnsonian Chair in Philosophy. The academic chair has a long history that takes us back to the medieval origins of the university as we know it, where it would have been designated, in Latin, as *cathedra*, and even now, when one speaks with the weight and authority of one's position in a relevant hierarchy, one speaks *ex cathedra*—from the chair. The cathedra was the bishop's seat, and like my two-chaired title, it carried administrative and doxological authority. The term *cathedra* itself derives from two Greek words—*katha* (down) and *hedra* (seat); it is a redundant expression, it seems to me, as if by saying the same thing in two different ways one drew rhetorical attention, like underlining a word twice, to the object being designated, just as the cathedral itself, majestic, soaring, standing against the sky like a filagreed exclamation point, draws attention to the bishop's chair it emblematizes. It is as if only a structure that awesome is fit to symbolize the chair that is its raison d'être.

So the chair has a locus in the language of authority as a mark and perquisite of power. To remain seated while others stand is to enact the possession of superior value. Standing, while someone else remains seated, is to acquiesce in the sitter's authority; should the latter rise while we stand, to put himself, as the expression goes, on an equal footing, he raises the other in raising himself. "Please rise," as a ministerial imperative, when we are summoned to pray or show respect, is the postural synonym for kneeling in the language of deference. Kneeling is itself to offer oneself *as a chair*—and it is not a matter for surprise that there existed, in ancient times, chairs designed in the form of slaves or conquered enemies. (At the Chair Fair, an exhibition of chairs organized by the Architectural League of New York, I saw a seat with the portrait, unmistakable, of Richard Nixon, which celebrates exactly this meaning.) Bowing and curtsying are momentary acknowledgments of subservience (*Serviteur*, the

courtier murmurs as he executes a *révérence*) by assuming the fleeting form of something that might be sat on, and then immediately reverting to the vertical posture in which we might be joined, by him or her who is seated, in the event we are to be paid the compliment of that person standing. No chairholder, I should think, would ever confer equal status by joining another in a kneeling position, save as in the presence of a higher authority before whom gradations are erased, but to acknowledge a bow with a bow is of a piece with standing up with the already standing. The act of conferring knighthood takes place when the candidate first kneels, then receives the touch, then complies with the order to "Arise, Sir Lancelot!," the Grantor all the while remaining seated. At that point the Grantor may rise, indicating respect and giving the other the right to take a seat at the Round Table. The order of seating, as at banquets or on the dais of authority, where right and left replace up and down with respect to a fixed center, gives precise equivalences in the medium of furniture arrangements to the structures of power that define society or even the cosmos. The seated position implies stability, solidity, the unmoved center around which the remainder of the universe orbits. The degree to which the nobility of the Sun's light and kingliness suggested, as a politico-astronomical necessity, to the early believers in the heliostatic theory that it was appropriate for the Sun to be the center of things, as it were enthroned, still and unwobbling, holding the lesser planets in their whizzing paths by the mysterious operation of action-at-a-distance, not even doing anything to keep them in their place, can hardly be too heavily stressed. It would be altogether appropriate that it should have been called the Copernican Revolution—unseating what went before by way of usurpation of the place of power by a mere lump of mud—though it might be even more appropriately called the Copernican Restoration, given the cosmopolitical assumptions that we reinforce each time we stand or sit in one another's presence.

If to the academic chair and the episcopal cathedra we add the regal throne, the judicial bench, the congressional seat, it is clear that the chair itself occupies the chair of preeminence in the community of pieces of

basic furniture, each of which corresponds to the animal needs they transfigure and ritualize. This is because, so far as I know, none of the others—tables or beds, to take the obvious examples—are ever said to rule or judge or decide or determine, as the chair, the throne, the bench are said and expected to do. I am uncertain why this is so, but I am disinclined to accept an explanation that relies on bodily posture, as opposed to position. There is a notorious chair, associated with but evidently not invented by the Marquis de Sade, which served him as an aid to abrupt seduction: some system of springs tripped the back legs, so that the unsuspecting woman who assumed the sitting posture would find herself rotated into the passive posture of the so-called act of love, where her mental attitude, according to Sade's psychology, would be more or less "What the hell, as long as I'm on my back. . . . " The recognition that the seated posture and the passive sexual position should be rotations through ninety degrees of one another was the sort of thing that recommended itself to an erotic geometrist like Sade; and although orientation must have counted heavily in the psychology—the *seated* woman would not have said, "What the hell . . . "—I am sufficiently impressed by the essential congruence of the two positions to discount posture, that is to say, the deployment of limbs, as the explanation of the chair's political preeminence. My sense, rather, is that it connects with notions of freedom and dignity. The bed and the table are used regularly and recurrently in obedience to the body's rhythms—we eat and sleep at regular times, symbolic of our oneness with the natural material order of the world. The bed and table are empty when not in use—with sickness and lovemaking being states of the same order as sleeping, so far as autonomy or freedom is concerned. We employ the chair at any time and to no set purpose, and our human dignity is celebrated by its existence as an article of furnishing. To be sure, there are bodily functions discharged while seated, or more primitively while squatting, but my speculation is that since these in fact can be exercised through the squat, the chair serves to symbolize that acts of elimination are under our control. In any case, there is, apart from this, no natural specific

function with which the chair is associated, and, as the one article of furniture with no preordained use, it is a natural or obvious symbol of freedom, which is the political corollary of power.

The chair has been available for human use and hence for philosophical metaphor for some five millennia, and I am struck that it is the sitting position that is spontaneously invoked in the philosophy of mind when one speaks of the *seat* of the soul, or of intelligence, or of wisdom or reason. Descartes spoke of the pineal gland, a mysterious organ midway between the cerebral hemispheres—like the seat of Breuer's Wassily chair, suspended between two chromium forms—as the situs of the thinking essence of man. A bed would have been inappropriate for the soul, which, in his philosophy, *always* thinks and *never* sleeps; and what would the soul do with a table? (Locke, to be sure, spoke of the mind as a blank table, a tabula rasa, but that was the mind as the passive recipient of experience and had nothing to do with reason or intelligence. Memory might naturally suggest a chest or cupboard.) But a seat seems altogether appropriate, given the psychopolitical analogies felt to be compelling since Plato, where reason rules the individual as the philosopher rules society. To rule, decide, judge, which are the functions of the soul in Descartes—or to withhold judgment when circumstance mandates circumspection—the soul must be able, from its seat, to survey left and right, like the bishop (a word that, in its Greek form of *episcope*, means to look around or survey) in his cathedra, the magistrate on his bench, the king on his throne. In any case, the chair leaves the senses free for thought and its higher labors. Jerome, the one patristic saint with any claim to intellect in contrast with mere faith or fervor, is standardly represented as seated (the bed would be no place to translate the Pentateuch), though admittedly he is peering into some heavy volume propped up on his scholar's table. But this only underscores the great versatility of the chair, sometimes drawn up to the table for this or that pursuit, but capable of uses of its own. It rests the body, leaving its higher faculties to pursue their more elevated concerns.

Whatever the merits of these speculations, they acknowledge the point of thinking about chairs philosophically to begin with: to think that an object so connected with authority, domination, autonomy, and power is to be construed simply in terms of *comfort* would be equivalent to thinking that sex is to be appreciated solely in terms of pleasure. This is not to deny the importance of either comfort or pleasure, but only to insist that when these become the central considerations in thinking about sitting and sex respectively, a transformation in human meaning will have taken place in which comfort and pleasure themselves have acquired a meaning quite beyond what they possess in themselves. Sartre once said, with characteristic brilliance, that we are not sexual beings because we have sexual organs but—on the contrary—that we have sexual attributes because we are deeply, ontologically, in our ultimate nature, sexual beings—that sexuality is our being-in-the-world, the moral center around which the entirety of life is radiated with meaning. To change the meaning of sex is then to change the whole tone and color of the rest of existence, construed as a system of meanings. And to reduce all this to pleasure is to erase and rewrite what it means to be human—responsive, responsible; to change the meaning of agreeing or refusing physical relationship; to change the point and significance of fidelity, chastity, trust (if all it is is pleasure, why not get it where we can?); to transfer sexual identity from our central essence to an attribute of recreation and leisure. And so I think it is, less momentously but no less certainly, with sitting down: less a matter of taking weight off our feet than of declaring where we are and how we fit in the larger scheme of things. So when the chair becomes an instrument of comfort, it is not as though it loses its political or social meaning, but rather that it acquires a different one.

The English wing chair, in which we sit protected and alone and enclosed, facing the warmth of the fire, embraced by wings as if those of a soft sheltering angel, implies a different form of life and a different set of values altogether from the precarious and portable salon chair of

France, meant to be carried from place to place, from conversing group to conversing group, or to be arranged for a party of whist or in a circle surrounding a string trio, and implying an essential sociability. One's arms are free to gesticulate; one does not settle in one's chair but sits, poised on its edge, like a bird, ready for the flights analogous to conversation. The salon chair's lightness and elegance stipulate the form of life to which it is organically connected; the wing chair's heaviness and solidity stipulate a different form of life, one of security, of immobility, of peace. It is not an accident that Sade should see the salon chair in terms of seduction or think of it as treacherous and betraying. The wing chair goes with the bourgeois interior, the hearth, with an Englishman's home being his castle. One is padded, buffered, cosseted, soothed. One's chair is one's signature.

Perhaps this suffices as justification for treating the chair as something more than where we place our bottoms, and I want now to speak of the chair in artistic representations before going on to speak of the chair *as* art, or as an art form in its own right. My sense is that some of the meanings the chair in art has, and which make it so compelling a symbolic presence, are repudiated when the chair is treated as an occasion for artistic expression. The chair *in* art, as opposed to *as* art, is deeply connected with the kinds of considerations I have just sought to articulate, where its use conveys, eloquently in the cases I mean to present, propositions it would be difficult to convey propositionally. I am anxious to present some images of chairs taken as vehicles of meaning to which their nature as chairs is crucial, but where the meaning goes quite beyond what we would think a mere chair capable of, taken simply as an article of furniture.

Thus I am interested in chairs here not as incidental illustrations in interiors, such as we find in Mario Praz's magnificent volume on the history of furnishing,[1] nor in those wonderful portraits of interiors that visitors to the exhibition of the Thaw Collection at the Morgan Library might have seen—a minor but charming genre which the Thaws have

taken up as a specialty, and with which, you may recall, Charles Ryder, the hero of *Brideshead Revisited*, made his reputation. Even in these portraits, the chair is not innocent of meaning. But the meanings it expresses are expressed equally well by the draperies and carpets, the lamps and hangings, the pictures or carvings. It expresses in the first instance the taste of the owners, their social status and the times in which they enjoyed it. Even then, in the complex conversation between the furnishings, one might be able to identify the specific voice of the chair, what it meant in relationship to the other items, which varies from age to age and even from interior to interior. There is that sense in which the furnishings of a room are a system of signs, and indeed in one of my examples I shall focus specifically on this. But I am interested in chairs that transcend the meanings they are confined to in such a system, where they rise to eloquence in contexts more dramatic than that of domestic interiors, and sound meanings of the deepest order. What I am after all bent on is the revelation of the chair in systems of meaning of the widest human consequence.

Let me begin, then, with a very early representation of a chair, a relief from the ruined Buddhist stupa of Amaravati, which dates from the second century A.D. (Fig. 13). The subject of this relief is a set piece in Buddhist iconography, much, I suppose, as the Crucifixion and the Last Judgment are set pieces in the Christian epic: it shows the Assault of Mara, the Hindu-Buddhist god of death, who is also, under another name, Kama, the god of pleasure, and especially of sexual pleasure. This linking of (sexual) desire and death in a single entity is, of course, familiar in the West in the tale of Tristan and Isolde, specifically in the *Liebestod*, the Love Death, admirers of Wagner are so moved by, and it is in both dimensions of his being that Mara-Kama is making an assault on the Buddha at a critical moment in the story of the Buddha's quest for Enlightenment. The moment is critical because Buddha is not yet the Buddha, but still only the prince Gautama, and the great change, for which mankind is grateful, is the change from prince to saint or even deity—though Buddha himself never spoke of himself in terms

Figure 13. *The Assault of Mara*, relief from the ruined Buddhist stupa of Amaravati, Andhra, second century A.D. Drawing by Barbara Westman.

appropriate to a god. His message, after all, was that what he achieved was something we can all achieve, and hence his essential humanity was essential to his revelation. It is because we can in some measure follow the arduous path laid out by the Buddha that we ourselves can rise above death and distraction, transcend the ultimate limits of our fleshly selves, and hence slip the powers of Mara-Kama and bring his dominion to an end. No wonder Mara-Kama senses the momentousness of the episode in which Gautama achieved Buddhahood, which, as you

know, transpired through a séance of the most intense contemplation, which takes place under the (now) sacred bo tree, in Patna.

The relief is bisected by the bo tree itself, almost perfectly symmetrical. To what would be the prince's right are threatening figures, carrying frightening things. There is to be, by description, a "mighty host . . . causing mighty storms of wind, showers of rain, flaming rocks, weapons, live coals, hot ashes, sand, boiling mud and finally a great darkness to assail him." The discrepancy between these words and what a sculptor is capable of showing is, of course, pathetically in favor of speech—but the frieze of elephants, those emblems of savage strength, give us iconic equivalences not at all contemptible. On the prince's left is a chorus of provocative, swaying women, heavy-breasted and heavy-hipped, like Edwardian beauties. Their arms are behind their heads to raise their breasts to prominence, and a naughty tassel swings between their legs. They symbolize what Heinrich Zimmer calls the "world's supreme distraction"[2]—a man who can stand up against these can stand up against anything; the Buddha, however, is seated. Or rather he *was* seated: the chair is empty. He has transcended that dimension of his being threatened by demons and drawn out toward women. On the Buddha's left side, the sculptor is almost the equal of a poet. But with the empty throne he overtakes him. I know of no more powerful representation of transcendence than the empty throne in the great relief of Amaravati. It bears comparison in religious power to the staggering *Resurrection* of Piero della Francesca in Borgo Sansepolcro, in my view the greatest painting of Christendom.

I want to meditate on that empty throne for a moment, and draw out some of its meaning. I have been at pains to stress the cosmic drama in which this chair plays its role, partly as an example of the way in which this article of furniture fits into schemes of meaning well beyond those of decoration, partly to draw attention to the fact that the chair, as shown by the affecting sculpture in this Assault of Mara, makes palpable, exactly as Gregory the Great demanded artists do, the deep truths of existence. To begin with, it is very much the chair of the prince Gautama, rather

than of the enlightened Buddha, who is rarely pictured thenafter in chairs at all: he is always, or typically, when shown seated, shown in the posture of contemplation, the lotus position—beyond the need for chairs. He is self-contained, in effect not needing an external locus of authority, and I suppose the *absence* of a chair for the seated Buddha, as much as anything, implies his self-containedness: he is in effect seated nowhere, much as, I suppose, were we to represent God, we would not place him in a chair (Christ is seated, often, but that connects with his being *human*). The affecting cushion, left behind, is a terribly touching detail: it belongs to that kind of being who can be frightened by death and injury or drawn erect by the sexual presence of women. Comfort is something that belongs not to the Buddha, but to the prince. But it certainly underscores his royalty. He was a very cosseted and protected prince who never knew that pain existed until he one day walked out of the pleasure gardens that defined his world and, seeing death, old age, disease, embarked upon that itinerary of meditation that climaxed under the bo tree.

My sense is that the comfortable chair, the chair with cushions, must have emblematized the soft life of the ruler: courtiers and commoners must have sat on harder chairs, or even stools and taborets, as in the hierarchies of sitting for which the court at Versailles was celebrated. A profound social revolution is marked when the comfort is transferred from the cushions and paddings, even the coiled springs of the upholstered chair, to the structure of the chair itself, which becomes comfortable through its architectural form. I refer to the cantilevered rocker, invented, I believe, in 1851 in England, by R. G. Winfield. Even without upholstery, or perhaps just because it lacks upholstery, the cantilevered rocker displays its comfort in its form, and it is almost an impossible exercise of social imagination to suppose it could have been invented in France, despite the *liberté, égalité, fraternité* of its revolutionary tradition, or in nineteenth-century Germany: it implies a democratic society, where each is entitled to the comfort reserved previously to princes. The cantilevered chair, of course, took a tremendous surge in the 1920s when

its tubular frame, chromium plated, became the symbol of modernity: here, the point about structural comfort is taken for granted, so one can use cushions with symbolic impunity. A while ago, at the Mies van der Rohe show at the Museum of Modern Art, studying Mies's own Brno cantilevered chair of 1930, so emblematic of contemporaneity, I was reminded, with the force of a Proustian revelation, of an episode in my own childhood, when my father, a dentist, changed the style of his waiting room from tan walls and musty chairs and rickety tables to what my parents referred to, proudly, as "modernesque." I remember vividly my brother and me being taken to see the snappy new room and being encouraged to sit—we were not to worry, it was perfectly safe despite there being no back legs, we would not tip backward—as if (the metaphor would never have occurred to my father or mother) we were *en visite* to the salon of the Marquis de Sade. So we sat gingerly, bounced up and down tentatively, and felt terrifically up-to-date. The day I studied Mies's chair, of which my father's proud furnishings were knockoffs, I thought that what gave my parents the sense of modernity was precisely the implied risk in sitting in a chair with no visible back support. And it then occurred to me that there must have been a fragment of the same zeitgeist there as in another innovation of the 1930s, the strapless evening gown, regarded as a daring thing in its day, but almost certainly as safe in its buttressed security as Mies's chair was in the principle of the cantilever. It was the delicious combination of risk and certitude that made those chairs so appealing to those whose consciousness was continuous with that of my parents.

There is another feature of Gautama's chair that merits attention: the legs. The legs are heavily curved and bowed out—but not in the sense in which the familiar cabriole legs of Queen Anne furniture are bowed. Indeed, the bow of Gautama's chair resembles the legs of a man under tremendous pressure to lift a great weight from a squatting position. It reflects on the weight and hence importance of the princely house to which Gautama belongs, and it carries the message of domination. It is a very political message indeed, and clearly belongs to the world Buddha

must have rejected and which Gautama himself precociously rejected. But it is part of the language of the chair that one has power over what one sits on. There are some terribly funny medieval effigies of the philosopher Aristotle on all fours, with a young and reckless woman on his back as though he were a horse. This perverse juxtaposition between Phyllis (the mistress of Alexander the Great) and Aristotle, whom Dante designates *il maestro di lor chi sanno* (the master of those who know), is the realization of a masochistic fantasy—or it is a philosophical allegory of how passion dominates reason, but it is critical to its meaning that it should be Aristotle, the tutor to the conqueror of the world, who supports a girl as wilful and frivolous as Salome. She celebrates her own power by dominating a man more powerful than her: what one sits on *must* be more powerful than oneself if the domination is to mean something. So the legs on Gautama's chair must themselves belong to a powerful being, a conquered warrior, perhaps a conquered king, or possibly a giant domesticated and made to feel our weight—negligible, save metaphorical, in the case of pretty Phyllis.

The cabriole legs of Queen Anne emblematize the elegantly curved foreleg of the prancing horse, a horse trained and bred to aristocratic ends—not the plug, not the plow horse, not the spavined and heavy-legged horse of the parson, but the exact and delicate foreleg of the thoroughbred—so that in the drawing room itself the mounted postures of the privileged class are reenacted. But legs have almost always, in great furniture design, some such message: the heavily clawed and pawed feet imply an animal realm of savage beasts, of wild and menacing animals, and in sitting upon them we underscore our human superiority. These animate metaphors have disappeared from chair design and today have given way to supports of a different order, but by no means to a less symbolic order. There was an exhibit of modern chairs that bore the title— clearly and wittily derived from the famous definition of the ideal house by Corbusier—*La machine à s'asseoir*. This indeed makes it seem as though the chair had become a "tool for sitting," and if sitting were *merely* sitting, then the question of design to relevant purpose would be the crite-

rion of goodness. But what in fact has taken place is not the celebration of an instrumentalist philosophy of furniture; what we have is the same posture of domination and the same code—so the beast or monster has been replaced by the machine. It is important, then, if the message is to be transmitted, that the chair in question *look* like a machine, polished and functional, powerful and swift. To suppose the Barcelona chair or the Wassily chair is simply an exemplar of fine design is to display a certain blindness to what it means to sit.

I have one further thought to add to this line of reflection before turning to my next example. In the 1970s and 1980s, the chair became funky and droll, as in certain designs by Michael Graves. Chairs became *fun*. My own historico-political sense suggests that more is happening than this: it is precisely the rejection of domination, of imperialism, turning the chair from slave into playmate, almost plunging away from responsibility. The chair becomes the natural locus for asserting the attitudes of the counterculture. My sense is that the way, then, to tell when we have entered a new political era is to look at the legs we sit on next. Think of what it means when we sit on the floor!

This brings me to my next empty chair, Van Gogh's rush-seated chair painted in late November 1888, just a month after Gauguin's arrival in Arles, and just a month before the violent quarrel after which Van Gogh cut off his ear. This was a honeymoon period, and the domesticity of the living arrangement is emphasized through the fact that Van Gogh is doing two portraits of their respective chairs, his peasant chair and Gauguin's measurably more elaborate armchair (it has a carved back, must be made of more expensive wood, and is upholstered). Vincent's chair could not be more simple—you can see the knothole through the yellow paint. On the seat is his famous pipe—the very pipe he is smoking in his shattering self-portrait with bandaged ear of January 1889, and with which his identity is clearly and deeply connected. That everything between seat and pipe is withdrawn, that he is not there as solid flesh to separate seat from smoke, suggests the possibility of his body as absent

from his image of himself—the kind of attitude we might expect from someone who expresses himself by self-mutilation. The painting is signed "Vincent" on the bulb box at the left—but it could also be the name of the chair if we read the painting this way: *self-portrait as chair.* I shall venture, however, a few interpretive remarks against the suggested psychology.

The rush-seated chair is an item of peasant furniture, invented in the late Middle Ages and clearly continuing the connotations of rusticity down to the present era. Until recently, I think, the rush-seated chair would never have found its way into the parlors or social areas of a household with any social pretensions; it belonged in the kitchen, and then, I imagine, primarily in the kitchen of country homes. It would symbolize servitude much as (I have learned from the architectural historian Christopher Gray) oak woodwork connoted servants' quarters in Manhattan kitchens before the First World War, while mahogany belonged in the employer's quarters. Only later, when one began to stress the authenticity of natural materials, would the rush seat find its way out of the kitchen (think of where it appears in Chardin). Today, having a rush seat replaced is pretty expensive, but when labor was cheap, costing almost nothing, as it was in Europe until after the Second World War, the rush seat must almost have symbolized the worthlessness of labor: the effort exerted on worthless material—straw and pine or oak—made plain that the labor itself went for little. Even so, it seems to me, the rush-seated chair continued to carry a certain authority: the peasant would not, of course, have dominion over beasts and strong enemies, but he would at least stand somewhere above the vegetable order. In any case, it is a chair for the lowest human order sitting atop the lowest natural order. So there is a double self-abasement in portraying oneself *as* such a chair. To begin with, to be a chair is to offer oneself as something to be sat on—the first abasement; and then to choose the lowest order of chair in the European cosmic scheme as the chair that one *is* is to execute the other abasement. His tobacco pouch and pipe stand higher than him. And this fits completely with the political and religious

personality we associate with Vincent: with his identification with the most humble; with his readiness to sacrifice himself, if only symbolically, at the level of conspicuous humility. The chair he painted in November 1888, in that profound and creative year, is as much a symbol of a certain kind of Christianity as a crucifix. Think of the fact that he signs it with his first name. Only the inferior is so addressed, or the very intimate, either relation being consistent with my reading.

There is a great deal more to talk about in this picture, as in the companion one of Gauguin—which incidentally has a burning candle on the seat, where Vincent's has a pipe, leaving room for just the kind of psychoanalytical interpretations I abhor and forbear from developing. But I am anxious to emphasize, as a point about painting, that the enterprise of studying it in terms of colors—the celadon and turquoise of wall and door, the red and green of the tiled floors, the yellow with blue aura around the legs (inverting the blue with yellow strips of the door)—that carry forward Vincent's chromatic theories of opponent pairings of the color theorist Ewald Hering, which had begun to be of such great interest to impressionist and postimpressionist painters; that all of the questions of color contrast and composition and spatial invention, made so central in the art appreciation course and the museum lecture, ought not to blind us to the spiritual meaning of the chair in this painting. It is not that the chair recedes in order to allow the neutral pursuit of optical experiment: if anything there is a war in this painting between two dimensions of Vincent's artistic personality.

My (appropriately) final example of an empty chair is Warhol's 1967 electric chair, which he used in various formats, most strikingly, I think, in *Lavender Disaster*, where he exploits the familiar television malfunction in which frame after frame presents itself on the screen as we fiddle with the vertical control in the frustrated effort to achieve stabilization. The chair serves as little to stabilize society as that inadequate control on the television set, and with his usual genius for the selection of images of transcendent power, Warhol confronts us with an image absolutely familiar

but corresponding to something we have never seen. Its grainy format contributes to its obscenity: it is a visual intervention into something that has no business being seen or, which perhaps comes to the same thing, that we have no business looking at save in the spirit of prurience that moves us to slow down as we pass accidents on the highway or, to use an example in Plato meant to demonstrate weakness of will, the way we might direct our greedy eyes at a pile of decaying corpses we know are entitled to the privacy of their own decay under the auspices of decent burial. It is a terrifying image.

The chair itself was introduced into capital penology in New York State in 1888, and although there was controversy as to whether it violated a constitutional prohibition against cruel and unusual punishment, it was put into use in 1890: William Kemmler, in Auburn prison, was the first to sit never to rise again. The chair delivers two thousand volts of electricity, and the theory is that death is instantaneous—much the sort of theory we comfort ourselves with when we plunge lobsters into boiling water, though my theory is that if we need that kind of reassurance, we have no business using such devices in the first instance.

There are two features of the electric chair that bear mention in the present context. One is that it is electric. The electric chair was installed in just the same year, 1888, as Vincent painted the portrait of Gauguin as a chair, and the presence of the candle reminds us that electricity had not reached Arles in that year as a means of illumination. Indeed, the electrification of New York City itself only started, in the form of direct current, in September 1882. In 1886 only, Westinghouse demonstrated that it was possible to transmit alternating current across a distance of about four thousand feet. In 1900 there were 350,000 electrical lamps in Paris, a city of two and a half million people. What is interesting to me in this connection is the idea that electricity should first be thought of as something that could kill: after all, it preceded such things as the electric iron or the electric stove, let alone the electric lamp, in the ordinary home. When electricity was introduced in France, it seemed simply magical and benign. Think of the labor and filth connected with candles

and oil and kerosene lamps: electricity was clean, odorless, and would have been cheap but for the taxes. In its first years it implied luxury, and I read in Eugen Weber's book on fin de siècle France that it was argued in that country, when rumor reached it of the electric chair, that electricity *could not* kill. Somehow the perversion of goodness is tangible in the spectacle of the electric chair; likewise, consider that the first applications of nuclear power were in bombs. So Warhol's image is after all an indictment.

The second fact is that it is a *chair*. What does it not imply about the imagination that saw in electricity a lethal fluid, that it should see in *the chair* the appropriate device to administer death? After all, it could have been an electrical bed, with the victim laid out in the posture of the dead. It could have been an electrical cross. Or the victim could have been required to kneel, as in the guillotine, or under the executioner's blade. Or there could have been an electrical noose, with the victim, standing on a metallic plate, closing the current transmitted through the cable around his neck. I have no idea what went through the mind of the inventor; I have no idea whether what we see in Warhol's picture is the first electric chair or whether there have been "improvements" over time. But my sense is that the execution connects sufficiently with the symbolism of the chair that its being done in the sitting position gives a certain dignity to the death administered, as though it were like the last words, the last meal, all those concessions to the prisoner's ceremonial humanity as we send him from our midst: as though giving him a chair to sit in were a form of forgiveness. Meals, farewells, chairs are dense with symbolic transaction, and something of what I have been seeking to convey regarding chairs is made tangible through this remarkable image.

The chair, then, is eloquent enough—less eloquent than the nude human body but eloquent enough—to carry into art a set of powerful human meanings. They may not be universal, just because the chair itself, no more than the sitting position itself, is universal. But in Western culture and in large parts of oriental culture, the meanings are clear enough

and part of the shared semiotics of life as a lived system of meaning. That the chair should in recent days have entered art as a medium or a form, rather than as subject; that the chair should have become art, subject to a range of surrealist modifications—as in the work of Lucas Samaras— strikes me as a sign that a certain barrier has been made visible by being broken. In the act of artistic celebration or artistic aggression (they are perhaps inseparable), we may be trying to liberate ourselves from forms of life the chair condenses as part of its steady message.

What these forms are and whether we can succeed I leave as an exercise for others: the history of the present will reveal itself only when the present is past, perhaps long past. I was struck by the fact that so many chairs ranged in rows at the Chair Fair in Long Island City, at the International Design Center of New York (IDCNY), bore the sign "Do not sit in this chair," as if commanding us to reorient ourselves with regard to these objects. To be sure, there were certain chairs there we would not dare sit in—one covered with white feathers, one made of cereal cartons. None, so far as I could see, was carved in ice, though I have seen, at the Baccarat showroom in Paris, glass chairs conveying the message not to sit without benefit of signs. But institutions and human practices change very slowly, and my sense is that it will be a long time before the chair loses the meanings I have sought to sketch or drops out completely from the forms of life it anchors. And perhaps when it does so, the chair as art will itself have lost the meaning that comes with treating it with daring and disrespect and fantasy, as in the IDCNY exhibition, which but underscores the extreme potency of the chair as symbol.

On the other hand, the fact that we now show ourselves as having power over the chair, making it funny or foolish or amusing, implies, to me at least, that the chair has lost a measure of its power and that we in consequence are representing ourselves as having lost a measure of *our* power. The great chairs of the modern era, the chairs of stunning design, conveyed a confidence in human power where, in our shining chromium, profoundly industrial, sitting pieces, we convey our command of the future. We do not have that bold confidence in ourselves that the Barcelona

chair or the Brno chair or the Eames chair expresses, and the chair, having ceased to be an emblem of our power, becomes a kind of plaything. The postmodern period of the chair is the postmodern period of human power. So I wonder if the age of the chair is not past because the age of human confidence is past. We simply do not have the kind of control over the forces we need to control to reclaim our dignity, and turning the chair into art has some of the surrender that turning swords into plowshares has. Or, in a more revolutionary way of thinking, the shambling of chairs, the artistic attack on chairs, may be an attack on a concept of power, rank, submission, domination, subservience which we feel to be inconsistent with a more liberal form of life. We could not have found a more potent symbol if these are the social intentions that move the chair from the space of meaning to the space of art.

NOTES

1. Mario Praz, *An Illustrated History of Interior Decoration: From Pompeii to Art Nouveau* (New York: Thames and Hudson, 1994).

2. Heinrich Zimmer, *Philosophy of India* (New York: Meridian Books, 1956), 472–73.

Munakata in New York

A Memory of the 1950s

IN THE HEROIC YEARS of abstract expressionism, when a metaphysics of painting was exploited that had been evolved when American art found itself, in consequence of the war, isolated from cultural influences from Europe, the New York artist became remarkably receptive to philosophical and religious ideas then beginning to come over from Japan. This was the second wave of Japanese influence on modern Western art. The first had come primarily through the discovery of the woodblock print, whose sharp, flat, decorative patterns of line and color, and seeming freedom from the tyrannies of linear perspective, had an effect of optical liberation on postimpressionist painters—on just those painters, in fact, Van Gogh and Gauguin, to whom Shiko Munakata was so attracted when, as a young man, he aspired to be the Van Gogh of Japanese art, not realizing, perhaps, that the Western art he sought to re-create was already an artistic re-creation of Japanese ideas, so that it was an indirect return to his own tradition that he in fact would have achieved. In the West, of course, the woodcut print through its content produced an idealized Japan of artistic imagination, a Japan of cherry-

Reprinted from *Print Collector's Newsletter* 10, no. 6 (January–February 1980): 184–89.

blossom picturesqueness, of kimonoed ladies on red bridges in abstract gardens, and a kind of hyperaesthetic sensibility that contrasted poignantly with what the European artist impugned as the materialism of his own time and culture.

The second wave had little of that. Japan had been now a military enemy, popularly regarded as treacherous and aggressive, its national character defined, in the American mind, by a kind of kamikaze fanaticism. But by the 1950s another, probably equally idealized, aspect of the Japanese spirit had begun to emerge, primarily through the concepts of Zen, which celebrated an instantaneous salvation and enjoined a sort of disciplined spontaneity. These notions almost exactly coincided with a parallel obsession with creative action, which after all played so central a role in New York painting of the period, and which was embodied, or seemed to be, in the great painterly swags of de Kooning, the fluid, intricate skeins of Pollock, or the paracalligraphic architectures of Franz Kline, all laid down in the general belief that inspiration emerged together with commitment in sweeping paint across a field of canvas. And in the mistrust of the rational intellect, the glorification of impulse, the rejection of forethought and premeditation, all of which were thought to be Zen ideals and which deeply accorded with the ideas of painterly creation that had been internalized by the Tenth Street artists of the time.

Whether the shape of Japanese ideas played a causal role in this development, or only confirmed an artistic program whose origins were local and properly American, must be left to the historian of art to determine: we discover our predecessors when we are ready for them. But whatever the case, New York painters underwrote a number of their most characteristic postures with Zen citations, admittedly secularized and adapted to the times, and typically abstracted from the Buddhistic structures for which Zen was a kind of technology. It was a different Japan, then, for the New York artist than it had been for the fin de siècle Parisian artist, a more energized Japan, a Japan of abrupt enlightenment and immediate gesture and spiritualized action, rather than a Japan of paper landscapes, exquisite taste, and elegant, poeticized ceremony. Delegates from

the downtown artworld made weekly pilgrimages to Dr. Suzuki's semi-
nars on Zen, held in Philosophy Hall at Columbia University, and dis-
seminated what they learned there in the endless chaotic discussions of
the Cedar Bar and the Waldorf Cafeteria and the Club. The art historian
of this era will have to assign Suzuki's lectures a primordial role in the
era's cultural life. Artists came as pilgrims and left as converts to the
amazing thoughts to which Suzuki's slow intonation gave an almost
sculptural form. Japan, as Greece once had done, imposed a new civi-
lization upon its conquerors.

I, too, had at the time been deeply moved by Japanese artistic ideas,
though rather more in keeping with what I described as the first wave of
Japanese influence than the second. This was in consequence of a kind
of artistic trauma I sustained when I visited a marvelous exhibition of
Japanese art sent over in a conciliatory gesture by the Japanese govern-
ment after the war and shown at the Metropolitan Museum. Entering
that show was like walking into a garden under spring rain: the screens
and scrolls of chrysanthemums and fish, the washed-in landscapes that
intimated seas and mountains, figures bent under straw parasols, imparted
a physical sense of light and water, clouds and breezes, so transfigurative
that when I emerged from it into the galleries of familiar Venetian paint-
ing I felt revulsion, as though I had passed from a world of feeling to a
world of fat, and it was years before I could look again at Tintoretto or
Titian or Veronese without something like aesthetic nausea. Of course,
New York painting was hardly *less* gross, in this sense, since paint was
celebrated for its physicality, laid down in drips and splashes or spread
with housepainters' brushes into thick and fleshy pastes; and save for a
common respect for spontaneous action, the great works of the 1950s
were, after all predictably, nearer of artistic kin to the Venetians than to
Kōrin or Sesshū. For that matter, Japanese art carried its own implica-
tion of violence made explicit in the Japanese films everyone flocked to
see, where the bloody counterface of Japanese preciosity was available
to anyone willing to acknowledge it. But consistency has seldom been
the mark of artistic ideology, and to a greater or lesser degree Japan

became for many of us, and certainly for me, a moral refuge and an existential fantasy, fragments of which we sought to live. It was moral rather than intellectual, since few of us were concerned with the historical and economic realities of the actual country, or felt compelled to master its language; and it was existential because we sought less to know about than to translate into acts and attitudes what we believed was there. Ours was a vision built from the paintings and films we saw and, for those who had not forsworn reading, out of the widely canvassed translations of Donald Keene.

It was, indeed, through a film made by some enthusiast which documented the style and life of three contemporary Japanese masters that I first came to know of Munakata. The film showed him at work, a slight, wiry, intense man in a checked shirt, with wild hair and huge glasses, bending over a woodblock so close one felt he was *feeling* it with his eyes, cutting away with an incredible sureness and speed, or whirling about his studio like a compact cyclone. I later learned that speed was Munakata's essence—he once turned up at a gallery on the eve of a scheduled exhibition with an armful of canvases and a color box, and painted the whole show in the time it would normally take just to *hang* one—but I was struck, in the film, by the rate at which he pulled prints, brushing ink across the face of the block, slapping on paper, wiping the image through with a baren, the whole process consisting of just three rapid movements, tirelessly repeated, like the steps of a dance, executed with an urgency at once breakneck and calm. I forget the whole of that film, though I retain an image of the potter Hamada, a great friend of Munakata's, a dignified and reposeful man, in what I think I remember as a robe of some sort. As artists, and indeed as men, they seemed to belong almost to different species, but both were depicted as belonging to a tradition each was also renewing, living a continuity between present and past, heroes of an inalienable integrity, exactly characterized in the line from Matsuo Bashō with which the film closed: "I do not seek to follow in the footsteps of the masters; I seek what they sought." And this precisely condensed the Americans' attitude toward Japan. No one

was seeking to become a replica of Japanese artists, or to submerge in a reconstituted and necessarily dead Japanese atmosphere—with what a Japanese friend of mine contemptuously dismissed as "a lot of soy sauce"—but to reinvent in some way the internal relation between artist and work, between work and reality, which the figures in this film showed to be possible.

Of the graphic media, woodcut is perhaps the most direct and expressive and requires the simplest apparatus. Any piece of plank will serve, and the life of the wood—its grains and knots and splinters—can be transferred to the print itself. But printing even of woodcuts can be slow and tedious enough, so it was the extraordinary speed with which Munakata, in that film, made his prints that especially impressed me. I only later came to learn that this was made possible by a difference in the sorts of ink he used. In the West, printers' ink is a sort of paste. In Japan, and by tradition, the ink is fluid, it is splashed onto the block with a brush, and only the slightest pressure is required to effect the transfer. The weight of the paper is almost enough for that—another contrast, I suppose, between fat and fluid. But the differences are deeper and more systematic. The philosopher Heidegger describes, at one point, what he speaks of as a *Zeugganzes*, a complex of tools, where the members of the complex imply one another and derive their shape and function through their location in the total system. Thus the hammer refers to the nail and the nail to the board, and any technical change at one point entails a change at every other, revolutionizing the total system and all its component elements. So it is, I think, with the Japanese woodcut. The fluid ink will not adhere to the waxy surfaces of a pine plank, for example; it requires the receptive face of *katsura* wood. Nor will ink transfer smoothly onto just any sort of paper; it requires the marvelously felted density of rice or mulberry paper. Changing a single element in this complex induces distortions at every point.

Munakata, when in New York, tried, like a good guest, to use some Western wood for one of his prints. It did not work out at all. Whimsically, or as an exercise of deep artistic intuition, he felt he had to use a

Western subject this time, rather than one of his favored Buddhist, or at least Japanese, themes. The print, which he gave me—and for all I know it may be the only copy in existence, since it can hardly be counted a success—shows two nude women upside down in relation to one another. He called it *Nude Descending—and Ascending,* a wry salute to an alien artistic tradition to suit the alien material of the block. There is, I think, a fascinating question of the degree to which the materials of an art form penetrate the structure and content of the work. Modifications in musical instrumentation undoubtedly show up in the compositions to be executed on them, and, for all one knows, the shape of modern literature may have to be explained in part by the fact that much of it was written on a typewriter (some change, certainly, in poetry would have been due to the fact that it was to be *seen,* on a printed page, and not just heard). In any case, there was a lesson of sorts to be drawn from that print: one cannot merely *will* to be Japanese—or Western, for that matter—the whole material base of art contributing, conspicuously in the case of woodcut, to the final blend of vision and feeling in the work. I cannot imagine Munakata himself putting it in anything like these terms, of course. *Nude Descending—and Ascending* condenses, like a koan, an entire philosophy of art in a sort of joke.

Munakata had, to an almost religious degree, an obsession with the materials of his craft, a feeling for the integrity and connectedness of paper, ink, tools, wood, and image. His series of large prints, the *Ten Great Disciples of Buddha*—which won first prize at the São Paulo Biennale in 1955 and was exhibited the next year in Venice and which first brought his work to the consciousness of the West—was cut on blocks just over a meter high, which would have been big for that period, and certainly represents an expansion in scale over his previous main achievement, the series *Forbidden Birds.* What particularly interested him in these prints, just as prints and, if possible, in abstraction from their subject matter, is that the boundaries of the images should coincide with the edges of the block, as though there were a living connection between the two, or at least a philosophical connection, the reference

between edge and line having an analogy to the reference between the color of ink and the color ink is meant to show. These prints (they are not, of course, separate prints, but components in a ten-part composition meant to be seen as a whole, and in a certain order, two groups of five facing one another, etc.) were made in 1939, years before prints on anything like that scale were tried in the West, at least in modern times. Until the 1950s, when the entire art of printmaking underwent a sort of expressive revolution, prints had spontaneously been thought of in miniaturist terms, as though their natural exhibition space was the album of the connoisseur, with the possible exception of lithographic posters, whose claim to the status of fine art was, in the reigning ideology of the time, somewhat compromised by their commercial intention, as in the case of Lautrec's posters. And even when etchings or engravings were done in large format, they typically retained the impact of the miniature, the impression of fine, detailed work, almost like jewelry, made, as it were, to be collected. The conventions of print collecting reinforced this rather artificial preciosity, with its fixation on rarity and limited editions (it is not accidental that prints are housed in what still are designated *cabinets d'estampes*). But the print itself was after all a popular medium originally, and the possibility of multiple sales must have been a factor in the decision of artists like Rembrandt to turn to etching, quite apart from its expressive possibilities: the print stood in a commercial relationship to painting not very different from that in which wallpaper did in the late eighteenth and nineteenth centuries, enabling, in the latter case, people to decorate their rooms considerably more cheaply than if they had had to hire painters. The twentieth-century artist found release from these imposed conventions in the woodcut, with its possibilities of rough directness, but even so, in Germany and in Scandinavia in the work of Munch, the woodcut retained its relatively small dimensions, as though artists still respected boundaries that no longer were internally enforced.

In New York, however, in the 1950s, largeness of scale became an artistic dynamism, perhaps initially in painting to accommodate the large sweeps of paint, the material trace of a full artistic gesture, that

began to be the vocabulary of artistic expression (for other, complex cultural reasons), and paintings made on a scale heretofore reserved for the walls of palaces and cathedrals became typical. It was essentially a public art, destined for the space of museums, though at the time it would have been presumptuous to suppose that anything like this success really awaited them. More likely, living as they did in lofts, out of necessity then rather than fashion, artists in their natural sensitivity to such matters must have felt a discrepancy between the size of their studios and the disproportionately reduced dimensions of the easel painting, and since nobody was going to buy things anyway, why *not* make things more suitably sized? Again, it was a kind of *Zeugganzes* phenomenon: the paint can replaced the palette, the housepainter's brush the finely pointed *pinceau* of the beaux arts technology, blue jeans replaced the smock, and artists flaunted their paint-smeared working clothes like emblemata of their labor—the way interns wear stethoscopes at the lunch wagon. Everything changed together and at once, art and artist and art place, and something like this spilled over into printmaking as well, and prints began to use *real* space—space as large as the space of the real counterparts of the images, somewhat in the way in which filmmakers like Antonioni began to use real time: time as long as it would take for the events shown to take place in. In any case, it was for their size that I especially admired the prints in the *Disciple* series when I saw them, I forget where, even if Munakata arrived at this as a necessity imposed by a different set of artistic demands, and from a wholly different, probably incommensurate, tradition. He was to do larger and larger prints. The *Flower Hunt* mural of 1954 is 131 × 159 cm; *Flowers and Arrows (Hanaya)* of 1961 is 227 × 692 cm; *Seas and Mountains (Kaisan)* of the next year is nearly as large. "A world as vast as space itself, without measure or limits, infinitely great: such is the world that offers itself to the printmaker," Munakata says about this largeness of scale. But nothing like this justifies the scale of the *Flower Hunt* mural, or the substantially larger *Flowers and Arrows*, and I do not really know exactly what large size in general meant to Munakata, whose prints must be among the largest ever made.

Because he was a bohemian at heart, an impulsive, improvisational man for whom rules meant nothing final, were there to be broken when some higher artistic morality demanded it, Munakata never felt obligated by the boundaries of the single block, never elevated into the imperative or applied, as though it were a recipe, any of the principles that emerged from his community with the logic of the material. (Irwin Hollander, who introduced Munakata to lithography and printed some wonderful plates for him, told me that in a demonstration at Cranbrook Munakata cut a strip of paper from a sheet he was to print on and wrapped it like a band around his head. A shock went through the audience, and what was only an impulse, if a marvelous one, for Munakata became a ritual for the students in printmaking at Cranbrook.) The *Ten Disciples*, though a single work, consists in ten discrete blocks, the integrity of each of which is respected. But the *Flower Hunt* is made of fourteen irregular-sized blocks, printings from which are pasted together to make the final print. Munakata clearly was not going to be limited in the size of his prints by the physical limits of actual pieces of wood or, for that matter, of paper. When the integrity of the subject required it, the integrity of the block was sacrificed, whatever the cost to dogmas of material integrity. And something like this is true for colors as well. The *Flower Hunt*, that great image of mounted archers in a field of animals and flowers, who hold no bows or arrows in hands positioned as if they did—for, as Munakata put it, "they are after flowers, and so must hunt with the heart"—this print derives some of its power, certainly, from the fact that it, like so many of Munakata's works, including the *Ten Disciples*, is in black and white. This is modulated by accidentalities of gray where the wood shows through or where the ink was uneven (some of the whites belong to the spaces between the blocks and not to the image, and some of the edges of the images are parts of the blocks, as where the edges of some of the wings of the birds are one with the edges of the blocks they are carved on). I have often wondered what it might look like had Munakata colored it, but so far as I know he never did, since color, I assume with him, was not something one *added*; it either was

demanded by the work or not, and, as we shall see, black and white had an almost mystical importance for him. Had he colored it, however, he would have painted the print, not printed the colors, and I want to comment briefly on this.

When woodcut is printed in color, a considerable loss of directness inevitably occurs, and a corresponding loss in expressive power is to be expected. This is due to the fact that typically, or at least classically, several blocks are required for a single print, and these must be coordinated and exactly superimposed on the same sheet through repeated rubbings, demanding a considerable concern for precise registration, which would have been at odds with the inherently slapdash method of printing Munakata favored. The traditional ukiyo-e woodcut was made in that way, and indeed the ukiyo-e artist—Hiroshige or Hokusai—would not have done his own printing, even if he might have supervised it. In fact, the making of a print in Japan involved a division of labor, artists and artisans coordinating their skills to the achievement of the final product, carving and printing and color separations being relegated to specialists. Much the same separation of functions was found in the West—Dürer seldom did his own carving, for instance, though it is clear when he did so—and the great lithographic artists, like Lautrec, would have acknowledged their relative inadequacies as printers. Munakata integrated all of these stages in a single creative process—artist, carver, and printer in one. The spirit of freedom and impulse that defined his entire artistic personality rejected the patient and exact matching up of several blocks to produce a colored print, quite apart from the fact that he had almost philosophical reasons for preferring the black-and-white print. Yet he did on occasion want colored prints, and when he did so, he simply colored them, by hand, producing remarkably subtle effects by a characteristic device that exploited the sorts of accidentalities he especially cherished: he painted the print from behind, allowing the colors to soak through to the other, visible side. And once more he showed himself willing to repudiate as irrelevant any set of rules that seemed to him to thwart the life of the work.

It is difficult to convey the boldness this mode of coloration implied. Printmaking is an activity that lends itself to rules the printmaker is expected to adhere to as a price for making prints to begin with. Coloring a print by hand would have been ruled out as much as coloring flowers by hand in a horticultural contest. And just the same stigma would have attached to the former process as to the latter: colors must be deposited by a printing process, as flowers must derive their color from their genetic structures; and knowledge that a printmaker had instead brushed on his colors without the mediation of a printing process would have disqualified a print from any of the exhibitions sponsored by the print societies of that time, as insistent on their regulations as garden societies would be. Touching in by hand perhaps was felt to compromise the integrity of the print concept, producing some bastard intermediary between print and painting. Such artificialities have often grown up in art. At one time, for instance, when verisimilitude was an explicit ideal of European and American sculpting, there was an obvious temptation to cheat, to cast figures from an actual human body rather than from a model made in imitation of one. Rodin, who was a master of verisimilitude, was hard put to prove that he had done no such thing when he first exhibited his *Age of Bronze*, which the judges threatened to reject on just those grounds. And to a degree the rules can be justified: the thing in mountain climbing is not just to get to the top of a mountain but to get there in a certain way, namely by climbing, so that the discovery that someone had used a helicopter would seriously disqualify his as an act of mountaineering. But as goals change, the rules, instead of being guides to integrity, become just beside the point. Picasso demonstrated a revolution in art when he pasted a label from an aperitif bottle onto a painting instead of imitating one in the required academic manner. The contemporary sculptor George Segal actually uses living humans—friends and family and neighbors—as models on whose bodies he makes his plaster figures, rather in the manner of the death mask (which may account for their eeriness), and he feels no need to disguise the origins of his figures. Recently I saw a show of his prints in which the same

impulse may be seen, friends pressing themselves against a soft-ground plate, and the result etched and printed to striking effect. Munakata had refined his artistic goals in such a way that rules of coloration simply had no application. He was interested in and realized himself through the woodcut because of its immediacy and strength. These were the values the medium subserved. When the medium fell short of this, he altered it, refusing to be constrained by some artifice of connoisseurship. Soaking color through as he did meant that prints from the same block varied enormously. But then, what would uniformity have meant to a mind like his? He was not, after all, printing newspapers. Any mechanization of the processes of creation would have been contrary to his artistic personality: he sought what the masters sought, but found his own way to that, breaking down fences that stood in his path. There is an attitude recorded in his biography, according to which he discovered his artistic mission on seeing a black-and-white print by Kawakami. This was after he had decided that oil painting, with which he had had some success, was not really "Japanese" and he had been experimenting with color prints. The black-and-white print showed him his way, and when he then needed color, he found his way to that as well. "I am a teacher," he once said, "who is not interested in techniques so much as in ideas."

Munakata came to New York in the late 1950s, to a certain advanced acclaim. There were articles about him in magazines and newspapers, and even a gallery, I recall, the Munakata Gallery, that was to be devoted exclusively to his work. He showed his work here and there, and gave demonstrations, though he had no English to speak of. At the time, he was accompanied by a young Japanese woman, a journalist sent, I believe, to write about him for some Japanese magazine. I owe her a special debt, since it was through her that Munakata and I met and became friends. I would like to describe our relationship, and to mention some episodes, less as anecdotes than as philosophical vignettes, but I hardly can do this without a bit of autobiographical indulgence, since it was the terms of my own life at the time that determined our relationship, which was, in its way, a friendship, even a deep friendship, if a discontinuous one. A tie of

fundamental sympathy bonded us, despite immense differences in our personalities and backgrounds and histories.

As might be surmised from things already said, I was myself an artist at the time, and had discovered the woodcut as an expressive medium, for reasons that have no special pertinence here. Printmaking was flourishing in this country just then, and a number of very fine artists were exploiting it, though probably no one quite of Munakata's stature. One of the things that distinguished him, I think, was that he was unquestionably a major artist, but one whose primary medium was the print. Many great artists in the past had made prints, and had made great prints, but almost always as a secondary voice—only Piranesi and Dürer, I think, might be considered primarily to have been printmakers—and Munakata was somewhat unique in being a major artist as, and not just also as, a printmaker. My own relationship to the artworld was complicated by the fact that I also taught philosophy, though I sought to keep my two activities somewhat separate and to live in two worlds at once. I cannot pretend that it was comfortable to live so duplex a life, and the compartmentalization made of me somehow a philosophical Dr. Jekyll and an artistic Mr. Hyde. My prints were not conspicuously philosophical, and the philosophy that attracted me was austere and logical, with scant room for aesthetic considerations either in subject or in style. New York artists liked to think of themselves as philosophers, even as metaphysicians, but they had no real sense for philosophical responsibility, and it was simpler to spare myself embarrassment in discussion with them by concealing, as well as I could, my intellectual identity when with them. My colleagues at Columbia, on the other hand, were cheerfully oblivious to the artistic life downtown. They knew I was in some way involved in that, and occasionally I would be asked how my "art work" was going, but no one thought of it as more than a curious hobby, or at worst an eccentricity, and it was tolerated when not ignored. Now and again I would encounter a tourist from the artworld in Dr. Suzuki's classes at Columbia, but these would commonly be too bent on satori to ponder my presence there, and except for certain internal tensions, the

two worlds were sufficiently sealed off from one another that I could have lived peacefully in both for all that they were concerned. The internal tensions, on the other hand, became increasingly difficult to live with, and I had a sense that sooner or later I would have to decide which way to go. It was in fact decided for me a few years later when, working on a large block, the thought suddenly struck me that I would rather be writing philosophy, and I realized immediately that my life had been resolved in some subterranean way. I gave art up definitively, and have never touched it since. Munakata was aware of both my sides, and accepted them as even natural. I often have thought that Japan would have been hospitable to the coexistence of two such drives, and the tensions I refer to would not even have been intelligible in that culture. All of this is personal, and its details belong to a different narrative. It is mentioned here because it explains in part the direction from which I was open to Munakata's art, as well as the circumstances under which we met. I had just had a show of woodcuts that was very nicely reviewed in the *New York Times* by Dore Ashton, whose husband, Adja Yunkers, was a distinguished printmaker. The review also reproduced one of my woodcuts, which was seen by Munakata's charming interpreter when she was reading the paper at her hairdresser's. She thought my work had similarities to his, showed him the picture, and I was absolutely astonished to learn from Leda Berryman, the director of the gallery, that Munakata wanted to meet me. In this way our relationship began.

Munakata knew no English, then or ever, so far as I know, and I no Japanese. I have wondered how we managed to carry on what I hesitate to call conversations and must term sustained communications. At the beginning there was his interpreter, and at other times Parigi, his son, served as a splendid intermediary, but often enough we were alone, and in some complex semiverbal way we managed, even over the telephone, when there was not the possibility of pointing and shoulder-pounding to signify comprehension, to get through to one another. I have the recollection that we understood one another transparently and fully, and especially what either wished to say about some picture or

other, whether of his or mine, or of some other, in a museum or gallery we might visit together. He was famously myopic, and got so close to whatever he looked at that it was as though he perceived synaesthetically, combining touch and sight in some way peculiarly his own: indeed, his fingers were almost extra eyes. The characteristic image one retains of Munakata is of a man bent over some woodcut, his face so close to it one could hardly suppose there was space enough between object and eye for enough light to enter to allow transmission of an optical image. He communicated images out of wood and paper in a way not remarkably different from that in which he communicated thoughts out of persons, and he brought enough of inner radiant illumination to dissolve any of that sort of opacity that commonly persists between persons; he did not acknowledge such opacities, and one felt oneself radiant in his presence. I think this was the experience of everyone who knew him: to have light drawn out of themselves. He was a remarkable presence, with nothing of the solemnity this description of him might suggest. He was always enthusiastically merry.

We exchanged a number of prints. I have two of his self-portraits. One of them he gave me, I think, because it shows him in New York, in a part of New York he especially liked, the upper West Side, by the Hudson (fig. 14). Some kind of boat sails past his left ear as he stares out of the print, goggle-eyed and quizzical. Smoke rises from its funnel to mingle with the clouds, and the sun drops, heavy and dark, behind silhouetted shreds of New Jersey. It is a familiar atmosphere for West Siders who know those sunsets, among the most spectacular in the world. The view is out the window, facing Riverside Park, of his studio—his "ataryay," as the Munakata family referred to it, whether as a private gallicism or using what might be the standard Japanese word for *atelier* I never found out—in the Park Crescent Hotel, since become a nursing home. My wife and I once were there for a tea ceremony made, or perhaps performed, by Madame Munakata, a broad, agreeable woman who wore splendid kimonos designed by Munakata himself: on that afternoon there was a

Figure 14. Shiko Munakata, *Water and Cloud
Self-Portrait.* Woodcut, 16″ × 12″. Collection of
the author.

pattern of owls. The ceremony was as original as everything associated
with this uncategorizable man. There was an element of tradition, as
Munakata believed in this, but adapted to the place: the Munakatas had
discovered Mounds bars, which they felt went perfectly in substitute for
what was taken in Japan with the bitter green tea. The studio had racks
of woodblocks, since Munakata traveled with an immense supply of *kat-
sura* planks. It was an afternoon of great gaiety, as most times with him
were, and I recall the red sun, framed by the window, splashing the skies
with Munakata colors. It was on this occasion that he gave me the self-
portrait. Years later he gave me another, again with a river, this time the
Mississippi, in the background, with some birds, herons or storks or

whatever, having only a vague ornithological affiliation; were it not for my sense that his was an art of exact observation, I would suppose they had a real existence only in the mind of the artist.

One day we all drove out, my family and the Munakata family along with the interpreter, to André Racz's studio in New Jersey. Munakata was got up in one of his amazing costumes, a sort of shiny tweed overall, with clogs high enough to carry him drily across deep puddles and a hat wide enough to protect him from the desert sun, prepared for any climatological extreme. He carried a box of oil paints, and as soon as we arrived at Demarest, where Racz lived and worked in what was once a church, he dropped to the ground and began to paint furiously whatever happened to be in front of him. He did I think six or eight oil sketches in about thirty minutes. Parigi, who has a fine critical eye and was never especially bamboozled by his father, grumbled about these works, finding them too easy and too fast and reckless. I cannot pretend that they were major works or impressive achievements in any artistic way, but the *act* of painting them I found very impressive indeed, and the moment remains a high point for me in my Munakata experience. What struck me with the force of a revelation was that there were for Munakata no *views*, no scenes, that everything was paintable, that whatever was there, before the eye, was equally worthy of being put into paint with everything else. A patch of light on a bench, a telephone pole, a cellar door, a garbage can, a scrap of paper—or my daughter Lizzie's red hair—were as suitable to artistic transfiguration as alps or flowers: just as such, because they were there, it being no business of his to discriminate. Alan Watts tells of a monk who once spat on a statue of Buddha. When scolded for this gross and sacrilegious act, he responded that he had been told that Buddha was everywhere and everything: so how was one to spit *without* spitting on Buddha? How could Buddha be especially more there in the statue than anywhere else—in an ant heap, a torn leaf, the sole of one's foot? Munakata's act of painting that afternoon seemed to exemplify this teaching: the whole face of the world, including these daubed-in representations of arbitrarily picked out fragments, was equally sacred at every point.

Buddha was in this sense certainly everywhere in Munakata's work, and accordingly not just as a frequent religious subject, but in the fact of paper, wood, and ink, in everything, indeed, that in a more formalized tradition of printmaking would have been dismissed as excrescences or accidents. These were acknowledged and even validated in Munakata's work, as though, to paraphrase a saying of Flaubert's, the good Lord is in the accidents. Not there alone, but there certainly, in the variations and in the folds and wrinkles, the knots and splinters, the errors and over-sights. It is almost as though Munakata prized those factors that would have justified someone else in discarding a work, perhaps because what he was after showed through with a special luminosity, in the interstices between what will and skill imposed on the faces of paper and reality. Giacometti once told me, when he showed me one of his skimpy drawn-out figures, whose thin arms waved when he sat it down with force in the middle of his studio in Montparnasse, causing shadows to dance on the opposite wall, that if he could just keep the shadows he would cheer-fully dispose of the statue—as though the statue were of interest not in itself but in what it made possible. And something like this was implied in the almost mystical celebration of the drip in New York painting of the time: painting was a way of making accidents possible, and these somehow redeemed the act of painting. They could be caused but not willed; at most they could be allowed to happen. To wipe *away* the drips would be to have missed the point of the act of painting as an invocation of reality rather than an inert representation of it. So it would be what it is, and not just what it shows, that is Buddhistic in Munakata's work.

Munakata, for all his volatility, his sunny character, and unremitting laughter, was a deeply reflective person with an astonishing way of putting philosophical thoughts vividly. Once he wrote in this way about the woodcut: "I advise the layman to spread india ink on an uncarved board, lay paper on top of it, and print it. He will get a black print, but the result is not the blackness of ink, it is the blackness of prints." The blackness of the print and the blackness of the ink: one might read a shelf of treatises in philosophical aesthetics and not find a distinction so fine.

And I do not know a passage that so exactly records the way in which reality, while undergoing no change at all, is transformed into art.

No one the least familiar with the imagery of oriental thought can fail to perceive in this passage an allusion to the powerful symbol of the Uncarved Block, that expression of an original nature that it is the aim of oriental religious exercise to return us to—that state of self with which one must always compare oneself when the rock has sustained the shaping fall of experience. It is in these essentially Taoist terms that Munakata continues the passage:

> Now the object is to give this print greater life and greater power by carving its surface. Whatever I carve I compare with an uncarved print, and ask myself, "Which has more beauty, more strength, more depth, more magnitude, more movement, and more tranquility?"
>
> If there is anything here that is inferior to an uncarved block, then I have not created my print. I have lost to the board.

I am uncertain how many prints, even how many of Munakata's prints, pass this severe and profound test. But I know of two especially that allude to the test. One of them is witty. It is called *The Black Plank (Kuro-ita)* and the left of the print indeed is an uncarved rectangle of black (fig. 15). The right half is a self-portrait, showing the artist full length, costumed somewhat as he was that day at André Racz's, stepping jauntily away from the black, swinging a cane like a vaudeville dancer, an emergence from the black that is the self and image of the artist. The other is less fantastic and, I think, more profound. I first saw it at a party given in his honor by Rose Pfeffer, an aesthetician. Munakata came, as always, with a gift, and the print I allude to was what he brought. It was a picture of a mountain—Mt. Fuji—number 13 in his version of the celebrated Japanese theme of the 53 stages of the Tokaido route, illustrated by great artists before him, Hokusai and especially Hiroshige. It was almost completely black, the blacks of ink, mountain, and print united as one. Only the corners were carved away at the top, producing a five-sided figure with a blunt point at the tip, the sides and bottoms of this

Figure 15. Shiko Munakata, *The Black Plank (Kuroita)*, 1973. Woodcut, 11¾″ × 6½″. Munakata Museum, Tokyo.

abstract mountain coinciding with the sides and bottoms of the block. Of the prints of his I have seen, it is the one I most cherish as illustrating and realizing his artistic mission as I understand it. It is also the print of his most easy to misunderstand and to misjudge. His gift of it to Mrs. Pfeffer I must regard as a great compliment.

In the ensuing years, before his death, we sent messages back and forth with friends. Now and again the phone would ring, and someone I did not know would say that Shiko Munakata had sent greetings. I was away when he last visited New York, in 1974. Now I am seeking to define this picture of what he was like as an artist and man before the memory of him fades still further. I remember almost nothing that I have not written here, and I would not wish to lose what, by the fact that it is remembered, must have meant a great deal to me. I have deliberately adopted the voice of nostalgia, a mood that penetrates a great deal of Japanese art and expresses a deep Japanese sense for the fleetingness of things, their fragility and insubstantiality and preciousness. But memory had better not be fleeting, or the sense of fleetingness will itself be lost, and we shall merely wind our lives out with the present, with no sense that it is present because we forget what was past. Our lives intersected and ran parallel for a time, though in fact we had in common only the circumstance that each of us, from wholly different directions and for wholly different reasons, managed to deposit a few black marks on some pieces of paper, which to an outward and superficial eye might seem to have had some independent resemblance. We fell into a sympathy that survived my leaving the world of wood and ink behind. Places in New York and moments in my life are enhanced by his presence there and then. That presence was unique, and only the memory of it tempers the sadness that it is gone irrevocably. I have wanted to put it into words, against the oblivion that is our terror and consolation.

Louis Kahn as Archai-Tekt

While we look not at the things which are seen, but at the
things which are not seen: for the things which are seen are
temporal; but the things which are not seen are eternal.

For we know that if our earthly house of this tabernacle
were dissolved, we have a building of God, a house not made
with hands, eternal in the heavens.

Saint Paul, 2 Corinthians 4.18–5.1

I BEGIN THIS DISCOURSE on the architectural thought of Louis
Kahn with a scriptural citation not simply because of its appropriateness
to the latter's own architectural imagery, but because one of Kahn's own
best thoughts, in which he distinguishes *form* from *design*, is already
inscribed in the words of the Apostle. And since Paul himself has appro-
priated to religious ends a tremendous philosophical vision that almost
defines classical culture at its height—the Theory of Forms, as articulated
by Plato, together with a plausible account of how Form, eternal and vis-
ible, gives structure and such order as the mutable earthly realm is capa-
ble of—the passage from Second Corinthians unites, under a single
formulation, a philosophical, a religious, and an artistic thought. Kahn
wrote: "When personal feeling transcends into Religion (not a religion
but the essence religion), and thought leads to philosophy, the mind opens
to realizations. Realization of the existence will of, let us say, particular
architectural spaces."[1] The cranky expression "existence will" connects
with the question Kahn always proposed in dealing with "particular

architectural spaces," namely, what does the space *want*, it being his task
as an architect to help the space realize its internally defined goal or,
to use the ugly ancient term, its *entelechy*. And this will refer us finally to
the Form, of the reality of which religion (Saint Paul) and philosophy
(Plato) assure us.

So it is, roughly, the same piece of thought that unites three out-
wardly distinct human endeavors—metaphysical explanation, religious
assurance, and architectural embodiment—in three distinct historical
moments—the Athens of Plato, the Mediterranean of Saint Paul, and
the Philadelphia of Louis Kahn. And I think there are very few architects
of modern times whose representation of their own activity brings
together so much that is at once metaphysical and practical, historical
and eternal, spiritual and concrete. It would have pleased him, I think,
since he was philosophically ambitious without being at all philosophi-
cally literate, to have learned that it was a thesis, perhaps the crowning
thesis, of Hegel's great system that art, religion, and philosophy are three
aspects, or as he terms them, "moments," of Absolute Spirit. *Der absolute
Geist* has exactly the right organ tone for Kahn's own oracular style of
verbal expression. "This must have been the way Dostoyevsky talked,"
Richard Sennett, who as a young man knew Kahn, once told me; at least
Dostoyevsky ought to have talked the way Kahn actually did. The mir-
acle is that it took so long for the art to catch up with the language. Until
the Yale Art Gallery extension of 1951–53, built when Kahn was himself
in his fifties, his work looks banal: it would have taken a very discerning
eye to tell that what all that public housing "wanted" is expressed in the
Yale edifice. I quote here from his influential essay "Form and Design,"
which was produced at the end of that decade and which in his own, per-
haps mythologizing eyes, captured his own procedures. He famously
described the successive designs for the First Unitarian Church of
Rochester, New York, of 1962, as embodying the same ideal form: "The
final design does not correspond to the first design," he wrote. "But the
form held."

"Form," Kahn stated, "has no shape or dimension." It is, exactly like its Platonic or Pauline counterparts, invisible and eternal. "Form is 'what,'" he continued. "Design is 'how.'" Form belongs to, or simply is, the concept of something, or what Plato explicitly calls its *Idea*. It compasses all and only those features lacking which a thing will not fall under a given concept. Kahn's example of Form is that of a spoon, which must, in order to be a spoon at all, have a handle and a bowl. But the design of a spoon will have reference to *how* the *what* of the spoon is given concrete embodiment: "silver or wood, big or little, shallow or deep." The Spoon Museum, were there to be one, will have in it spoons of all shapes, sizes, materials, and provenances, all of them exemplifying the one single concept. It would be a mistake to say: A spoon by definition is a bowl attached to a handle by which it can be lifted, and is made of silver. In traditional terminology, Form is essence, design is accident. "In my opinion," Kahn said, "the greatness of the architect [rests] on his powers of realization of that which is House, rather than the design of *a* house, which is a circumstantial act." *Form* as such "has nothing to do with circumstantial conditions." In analogy with Spoon–capital-S, House–capital-H is composed of essential features—walls, perhaps, and roof—that have as function protection and shelter in the way in which the bowl and handle of a spoon have as function lifting and containing, and serves as a portrait of the body that uses it, made with hand, arm, and mouth. That it has a flat roof, a pitched roof, a thatched, shingled, or tile roof is a matter of circumstantial condition.

In the course of his discussion, Kahn distinguishes marvelously between space and area. Area, which belongs to design, is measurable. Space belongs to form and has not so much measure as it has meaning: the space is the meaning the area expresses, the way philosophers used to say the proposition is the meaning of the sentence. Spiritually, we pray in the space of a church, which of course, since the church has to be built, has a measurable area. The formula might be: Find the area—or areas— that express the space. Or we might say: There is a range of specified

areas, all of which express the same space and hence have the same architectural meaning. If you like, Plato, Saint Paul, and Louis Kahn all express the same thought—their thought has the same form—although their language and intentions vary according to circumstance.

Distinguishing form from design in this way, it might seem an attractive challenge to bring design as close to form as possible, and so to produce the basic house, an architecture that is the very form of houseness, the realization in whatever material of the Platonic idea of House–capital-H. And inasmuch as it was a commonplace of cultural history to associate Plato with the exaltation of geometry, the "Platonic house," one feels, must be a composite of archetypal geometrical solids: a pentahedron atop a cube, or a cone or hemisphere atop a cylinder. Or just a cube, with symmetrical fenestration and without ornament. The house designed by Ludwig Wittgenstein for his sister in Vienna might aspire to this severe austerity, softer instances of which one finds in Palladio. The whole International Style, whose paradigm is the glass box, seems to collapse the distinction between form and design. But Kahn, so far as I can tell—and this is part of what distinguishes his architecture from modernism generally—was quite hospitable to diversity in design, and his structures are no more geometrical than any. The fact that he seemed to use geometric forms as decorative motifs, as in the triangular or circular openings at Sher-e-Bangla Nagar, surely his masterpiece, or in the Indian Management Institute, strikes me as slightly polemical: a repudiation of geometricism as such, and a qualified endorsement of ornament.

In fact, Kahn was more in the spirit of Plato than architects whose buildings look like diagrams for geometric theorems. It is true that Plato wrote that "geometry is knowledge of that which exists forever" and that its study "draws the soul toward truth and produce[s] philosophical thought." In the late dialogue *Timaeus,* the eponymous thinker constructs four of the regular geometrical solids—the cube, tetrahedron, octahedron, and icosohedron—from two basic triangles: the right isosceles and the right scalene whose hypotenuse is double the shortest side; and he argues that the constructed solids are the shapes of the cor-

puscles of earth, air, fire, and water. Notwithstanding these cosmological speculations, Plato speaks of geometry's practical benefits—in the conduct of wars, for example; and in the most celebrated passage of all, book 10 of *The Republic*, where the Doctrine of Forms is brought forward in order to belittle the mimetic arts, his paradigm is not a geometric body but that most human of practical furnishings, the Bed–capital-B! I am not here especially concerned to press the fact that Bed–capital-B stands to the beds made by craftsmen in that relationship in which House–capital-H stands to houses made by carpenters, and so exemplifies the Form-Design distinction. Rather, I draw attention to the fact that there, in the realm of Pure Eternal Forms—in what Plato and Saint Paul after him certainly think of as heaven—is the archetype of that article of furniture which underscores, if anything does, our frailty, our vulnerability, and our fleshly needs. In bed we're born, in bed we die; in bed we laugh, in bed we cry. And eight of our daily hours are spent in restoration of our raveled energies. So Bed–capital-B internally refers to human requirements, just as the Platonic spoon refers to our having a mouth, and the bed is a symbolic portrait of one of the conditions of being human. The same of course is true of House–capital-H. The very essence of the house is constructed in the image of our weakness and needs. To be human is to need a roof over one's head and walls against the world (and to be homeless is to be exiled from the human condition so portrayed). So any house, like any bed, is already Platonic enough, without having to possess sharp vertices and impeccable proportions.

This is not to say that Kahn was particularly concerned with physical needs, regarding which he could in fact be airily dismissive. "Need is so many bananas," he said in a 1968 lecture at Drexel. "Need is a ham sandwich." It was not that he subscribed to an antiutilitarian philosophy of architecture, but that he defined architectural function in terms of what one might term spiritual needs—"learning, meeting, well-being"—which answer to architectural realizations like schools, assembly halls and churches, or research facilities. In an early review of the Yale Center for British Art, Paul Goldberger, otherwise enthusiastic, speaks of the

difficulty in finding the restrooms. My sense is that Bed–capital-B conveys a more robust sense of human needfulness, though it is perhaps worth reflecting that the portrait of Socrates sketched in *The Symposium* by Alcibiades is of a man remarkably indifferent to physical needs: Socrates seems tireless, not subject to cold, with no great appetite for food, capable of drinking others under the table without showing the slightest intoxication, and—what perplexed Alcibiades more than anything—unaffected by sexual stirrings and interested only in what, on the basis of that dialogue, has come to be known as Platonic love. And the form of life Socrates sketches in *The Republic* is one of an austerity so reduced and severe that no enemy would have the slightest desire to take it over. However, *The Republic*'s political architecture is derived from a different order of need, those basic things needed in order to have a state at all, and the state Socrates there designs responds to these needs rather in the way in which Kahn's designs answer to such needs as "learning, meeting, well-being." These, which in Plato and in Kahn alike define human life, Kahn calls *beginnings*, and much of this essay will be addressed to those.

Platonic metaphysics was designed as an antidote to change: forms, outside the temporal order, were immune to alteration and decay. *The Republic* projects a state minimally subject to alteration. It is a profoundly conservative vision, and one must seek to imagine how terrifying change was to its author if politics and philosophy together were conceived from the perspective of keeping change at bay. If there were a Platonic architecture, it would specify buildings as little subject to change as possible. There is, however, one sort of change the Greeks, so far as I know, had no sense for, and that is that houses–small-h are historically sequenced. A Platonistic architect, living in the twentieth century, would have a vivid sense of historical change, and would have to see design in a historical sequence of designs, all generated by the same Form. Any house, to be a house, has to exemplify the form of House–capital-H, as any spoon, to use Kahn's example, has to capture the essential features that specify Spoon–capital-S. So historical differences do not penetrate the

essence. But designs do explain subsequent designs: historical explanation has a different logic from the one appealed to in the formal explanation of classical metaphysics.

Kahn's own view of history was complex. He clearly saw the past in part as a repository of meaningful forms, and my sense is that he would have been altogether opposed to an architectural vision that projected an erasure of the past and its replacement by rational forms, as in Corbusier's stupendous project of a razed Right Bank of Paris and its conversion into a park with Cartesian high-rises placed in it with exactitude. If Corbusier was the archetypal modernist in this sense, who saw his mission to invent architectural forms for the men and women of the modern era, Kahn was not a modernist. He was an eternalist. Or: he already saw modernism as a circumscribed style, like Gothic or baroque. So he would no more want to be a modernist than a classicist, say; no more see himself making modern buildings than classical ones. There are historical borrowings or appropriations in Kahn's work—he after all belonged to the beaux arts tradition—but I think they are not meant to celebrate whatever they are taken from: Kahn wanted to ground his architectures in the timeless traits of being human, deeper than history—in "beginnings." So when he used historical references, the intent was often subversive. Kahn is never neo or post. That is why his forms have their stunning originality. He belongs of course to his time, but his buildings do not express their time the way I think Mies's buildings do, or Michael Graves's. They express the idea the building is meant to exemplify, but the idea itself is connected to some primordial dimension of human activity like "learning, meeting, well-being"—the way the bed is connected with sleep, love, convalescence, birth, and death. That is why they are Platonic without *looking* Platonic, either in the sense of looking classical or looking geometrical. They look, if anything, primordial.

Let's consider just one example: Kahn's use of the barrel vault in the Kimbell Art Museum in Fort Worth, Texas. The barrel vault is of course the triumph and the emblem of the Romanesque style, a solution to certain severe problems of fire. Built of stone, they would not burn, but

Figure 16. Kimbell Art Museum, Fort Worth, Texas, 1966–1972. Louis I. Kahn Collection, University of Pennsylvania and Pennsylvania Historical and Museum Commission.

being heavy, they necessitate very thick walls to sustain the thrust. The first vault at the entryway to the Kimbell rests on no wall whatever, which gives it a conceptual lightness, especially in light of the realities to which the Romanesque church was an inspired response. It is like an architectural miracle. But the barrel vault is also a kind of defilade of congruent arches, whose keystones form a kind of ridge. Kahn has plucked these out and replaced them with slits that admit natural light into the galleries below, which in the Romanesque would as much have meant collapse as withdrawing the walls (fig. 16).

Two structurally defining features of the barrel vault have been subtracted at the Kimbell, leaving merely the shape of the vault and an exquisite lightness that Kahn was able to exploit because of prestressing, at the time a fairly recent constructional technology. It was as though the lightness, achieved in the Gothic, was what the Romanesque structure "wanted to be"—its "existence will," to use Kahn's expression. And here it attains it without sacrificing its identity. Why Kahn should in the first place have used barrel vaults at the Kimbell is another matter, but I use

the example here to indicate the way he used historical forms when he did so. He was not a Richardson, seeking to re-create the Romanesque. Nor does he use the barrel vault in some spirit of pastiche, as a postmodern architect would. Possibly, because the Kimbell was intended as an art museum, it seemed to Kahn that the building itself should offer an example, or more than an example, of a historical form the visitor could experience architecturally. The point would in any case be that the museum, like the school or the church, should be grounded in, should refer to a beginning in, some primordial human endeavor. The museum is traced back to the *Wunderkammer*, a space of marvels: so why not make the space its own marvel, a barrel vault resting on nothing, and a whole rhythm of such vaults undulating like a magic carpet? I know that is far-fetched; so let us turn to the concept of the beginning, so important to Kahn's philosophy of architecture.

I, somewhat pedantically, would like to call what Kahn calls "beginnings" by the term given philosophical currency in pre-Socratic times: *archai* (sing., *archē*). As used by Anaximander, the *archē* is a kind of beginning without a beginning of its own—"the source and origin of everything, which is at once eternal and divine." It is like the later idea of First Mover, in the cosmology of Aristotle; and if we think of Plato's Forms as playing a causal role in the generation of things—House–capital-H *giving form* by "participating in" houses–small-h—then the Forms would be *archai* in precisely Anaximander's sense. Kahn's architecture is historical in the large sense that it refers to and derives from what he speculated must be the basic forms of human conduct and inter-action, and these, as *archai*, are the beginnings on which true architecture rests. It is only secondarily historical in the sense that it uses forms from the history of design, like the barrel vaults of the Kimbell. The distinction is apparent in architectures in which historical forms are employed to evoke the "beginning" in the larger, human, functional sense, as when Gothic halls are the favored form for university buildings, just because of the associations the Gothic has with the life of learning in the medieval "schools"; or when the temple is used as the form of the museum in order to evoke the connotation of sacred treasures contained

within it—which also, I suppose, explains why the classical temple lent its form to bank architecture. The real *archē* of learning, however, is less architecturally constrained than this, and need not be historically constrained at all. Kahn gives us a memorable example of the beginning of the school: "a man under a tree who did not know he was a teacher discussing his thoughts with a few who did not know they were students." Kahn used beginnings as a basis for architectural criticism. Thus he stated that there were a good many schools held to be architecturally distinguished that are "good to look at but shallow in architecture because they do not reflect the spirit of the man under the tree." His overall architectural psychology was that when we find the beginning, we connect with that in human nature which expresses itself spontaneously in the mode of an institution, and the architecture then should follow as a matter of course. That is why "it is good for the mind to go back to the beginning because the beginning of any established activity of man is its most wonderful moment." And one can, in a way, see the same impulse in generating the architecture of the state in Plato: Find out what are the basic needs, which themselves generate the primordial human activities, and find institutional ways of organizing these into a total political structure. Kahn's *archai* underscore the way in which his is the Platonism of the bed rather than the sleek geometrical form; why the Kimbell's are to be read as vaults rather than half-cylinders. And I think as well that Kahn's sense for archetypes, which refer to our basic human nature, accounts for his success in other cultures—a man under a tree is exactly an Indian image. There is the Buddha under the bo tree, beginning to address disciples eager for wisdom.

So beginnings are connected with Form: the archetype of the class of schools, or churches, or houses, or museums (where we have probably lost the form since we no longer know what the museum "wants to be"). But the realization of the form in actual design connects us to history, and to contingencies of circumstance, like the kind of building materials available to us or the price of labor. (New York buildings of about the 1850s are often miniature Kimbells, with shallow brick vaults resting on

steel beams, which in part means that bricks and bricklayers came cheap.) But design, historically considered, is never, and certainly never in Kahn's reading of it, to be understood in narrowly materialist terms. He marveled at the Baths of Caracalla in Rome, which he counted his favorite building. "It is ever a wonder," he wrote, "when man aspires to go beyond the functional. Here was the will to build a vaulted structure 100 feet high in which men could bathe. Eight feet would have sufficed. Now, even as a ruin, it is a marvel." The soaring space transfigures the function into something cosmic. And something like this transfiguration dimension situates the barrel vault of the Kimbell in symbolic space, specifically by erasing the material constraints. He wrote of the Pantheon that "because of its shape [it] presents a statement in form of what may be a universal religious space."[2] So we can read through historical architecture to the way those who built conceived of beginnings not in functional but in ritualized terms. I incline to think his impulse in this direction, and what kept him finally from sliding into modernism, was his residence in Rome, at the American Academy there at the time the Yale commission came through. I think that Rome was for him a kind of *rupture*, as the French would call it, between the distinguished banality of his early work and the inspired work that begins with the Yale Art Gallery. I believe this because a stay in Rome achieved the same for me. Like many New Yorkers in the 1950s, caught up with the art of our time and place, I felt Europe had nothing to teach. I went to Rome to write a book, and to have the experience of living there. But somewhere along the line I discovered Wittkower, and all at once the old forms began to disclose their meanings and from then on I saw everything in terms of historical transfiguration. I was never able after that to settle for formalism. Similarly, though this is projection, I don't think Kahn was ever able to settle for modernism after his Roman experience, though the Yale Art Gallery must have struck contemporaries as a modernist structure.

What is intoxicating in Rome is the way forms from different architectural eras are forced into aesthetic collaboration, the way the Arch of Trajan is jammed into the fortified wall of the Frangipani Palace as a

gate, or a baroque porch attaches itself to the carcass of a Roman struc-
ture, or simply the way Renaissance stucco-work is placed below the
point at which the great flat dome of the Pantheon springs. I feel some
of that disjunctiveness in the Yale building, which transcends even the
modernism it incorporates. I have in mind something like this: Logicians
distinguish between the *use* of an expression and its *mention*. Thus, one
uses the word *window* when one talks about windows; one *mentions* it
when one talks about the word itself, for example, "*Window* begins with
w." It is possible to make that distinction in architecture, where one, for
example, uses windows to make a modern statement, as against making
a statement about modernism, which is analogous to the operation of
mention. What I want to say is that Kahn is not so much making a mod-
ernist statement with the Yale building as a statement about modernism,
and it is in this sense that he transcends modernism and situates himself
somewhere beyond it. He sees the modern as a style and is, in that
respect, already beyond it. But let's look at the building closely, to see
what this means.

The south façade, along Church Street in New Haven, is of roman
brick, horizontally partitioned by four string courses in limestone (and
topped by a nearly matching cornice). It cannot have been an intention
of Kahn's, for the paradigms did not, so far as I know, exist in 1951, but
whenever I look at the face I see it as a great abstract composition,
whitish stripes on a beige ground, and I cannot help but feel that it had
to have been perceived in these terms when Yale's art school ascended to
greatness in the next decade, along with the minimalist movement to
which Yale's graduates made so considerable a contribution: I have
always hoped to find something by Brice Marden, for example, that can
only be explained with reference to his having seen Kahn's façade. Stu-
dents of Kahn's building make the point that the four white lines
"express" the floor lines and so constitute a kind of drawing of a vertical
section through the space, but I tend to see the face, with its white bands
against tawny ground, as reminiscent of something one might see in

Rome, the roman bricks being a meaningful choice. But more than that, the bands are transformed, rounding the corners, into the heavy mullions of the glasswork, and the abrupt transition—stone into metal, brick into glass—conveys to me exactly the disjunctive spirit of the Roman aggregate. The glass wall with fenestration is an emblem of modernism as the brick wall with limestone is an emblem of ancient construction, and the line formed by string course and mullion bind these together into a single structure, past and present, old and up-to-date, ancient and modern. Seen this way the spirit of a museum, which is to contain artworks ranging from Siennese tableaux to Duchamp's *stoppages*, is embodied in the museum itself.

This past-into-present is carried out in the interior scheme through the stunning use of coffering, which is after all a Roman invention and whose greatest ancient example is certainly the dome of the Pantheon, which we know meant so much to Kahn. I feel the spirit of the museum, construed in terms of some beginning out of which that institution springs, is condensed in these marvelous spans. The coffer serves to lighten the material of the vault while at the same time revealing its thickness by penetrating it. The Yale Art Gallery's floors are three feet thick, and Kahn emphasizes their massiveness in two ways: by showing the thickness through the glass, and then by means of the coffers themselves. The heavy coffering works together with the glass to give the past-present contrast, but the spans themselves are ancient through reference to Rome and contemporary through reference to Buckminster Fuller's space frames. And there are even two of the Platonic solids, the tetrahedron and the octahedron, which Fuller himself used. As it happens, the honeycomb cells were ideal for handling the utilities the building needed to be functional, but I don't think it consistent with Kahn's aesthetic to suppose that that entered into the decision to use them—not when the architect expressed himself as he did on the symbolic weight of the Pantheon vault. Rather, the ceilings with their complex of historical and humanistic references and meanings express the museum's

archē. It is worth pointing out that the fact that Kahn made use of con-
crete in what would have been anticipated as the refined space of an art
gallery licensed an early classification of the building as part of the New
Brutalism movement, which is a good example of the difficulty of good
criticism in art and in architecture. But at the same time one has to admit
that, for all the lightness induced by the coffers, the ceilings press down.
The Pantheon vault soars, after all; the coffers grow gradually smaller as
they ascend toward the open sky, like a chorus of angels. But the Yale
ceilings, for all their humanistic geometry, brood too heavily for the
fragile objects beneath them. I think I can understand the reservations
expressed at the time toward the "ceiling treatment." I think I can also
understand why, in his next museum, Kahn not only opted for something
lighter—the adapted barrel vaults—but also took the idea of the oculus
over in using the slits (of course not open to the elements!) to admit the
natural light. The spaces in the Kimbell soar.

It is tempting to project the stone/metal, brick/glass binarism from
the Yale Art Gallery to Kahn's next building, the Richards Medical
Research Facility at the University of Pennsylvania, for the glassy labo-
ratories appear "modern" while the brick-clad towers appear, if not
Roman, then somehow Renaissance, with affines in Bologna, in Venice,
and in Mantua. Indeed, the entire complex reminded the writer of an
early monograph on Kahn of San Gimignano, as if a miniature Tuscan
hill-village were encapsulated in a West Philadelphia campus, and pho-
tographs of the building silhouetted against the sky only accentuate that
reading. I would not deny the resemblance, but it seems to me inadver-
tent, and there is no serious way in which one can reconcile the idea of
a towered village with the relationship Kahn would have sought, be-
tween the functions of a medical research facility and something that is
relevantly a beginning, like the man sitting under a tree. Moreover, the
Richards is not a museum, certainly not an art museum, where it would
make good sense to display—to "mention"—the architectural elements
used. It was no part of the building's internal aesthetic function to make
a statement about modernism.

I think it helps in understanding the building to appreciate that Kahn was enough impressed by the difference between art—whose architectural expression is the museum—and science—whose architectural expression is the laboratory—to want this difference marked in an architectural way. The Richards Center, Kahn wrote, "was conceived in the recognition . . . that science laboratories are not studios, and that the air to breathe should be away from the air to throw away."[3] What is marked, in my view, is precisely the distinction between two kinds of airs, salubrious and dangerous, whose architectural markers are transparency and opacity, or glass and brick. The building is a device for dividing airs. (Kahn was proud of the fact that he had to deal with "isotope air, germ-infected air, noxious gas," and one wonders if he did not think of his towers in terms of this taxonomy, each venting a different order of toxicity.) So as I see it there are no art-historical references here at all. The history the building connects with is the *archē* of medicine and magic. The building looks like a vast piece of chemical apparatus, the glass cosubstantial with the material of test tubes and alembic and retorts, the brick with the ovens in which the alchemist sought his distillations and reductions. This may sound far-fetched, but Kahn's masterpieces in India strike me as nearer of kin to the gigantesque astronomical instruments that Indian civilization evolved—specifically, Jantar Mantar in New Delhi, erected around 1725 by Raja Jai Singh of Jaipur—than to any buildings in the world.

This of course is mere conjecture, though I shall seek to deepen it when I discuss the Salk Institute. But to the larger question of whether it would be consistent with Kahn's architectural impulse to design a building in the form of a scientific instrument, which sounds almost kitsch, almost in the same genre as designing an orange juice stand in the shape of an orange or a duck stand, to allude to a famous Long Island landmark, in the shape of a duck—which sounds *almost* as if Kahn had been learning from Las Vegas before Robert Venturi, with whom he was in constant interchange, evolved that revelation—there is an answer. I need only remind the objector that the façade of the Fort Wayne, Indiana, Center

for the Performing Arts actually has the form of a face. As such, it has embarrassed a good number of Kahn's enthusiasts, who needlessly apologize for what really after all belongs to his philosophy of beginnings. The emblem of the dramatic performance in classical times was the actor's mask. The masklike façade proclaims the origin of the activity the building was made to sustain.

I want to end by discussing the Salk Institute in La Jolla, California, which in some ways synthesizes art studio and science laboratory—and that is just as it should be, since one of the conditions specified by Jonas Salk was that the possibility of inviting Picasso to work there should be inscribed in the architecture. The building should be equally hospitable to science and art, just as Salk's own marriage (to Picasso's former mistress Françoise Gilot) was. And in truth I think this reflects the thought that biology, at least the biology of human beings, must be regarded as a humanistic activity, something to which the intuition of the artist might make a contribution quite as much as do the experiments and conjectures of the working scientist. There was a resident humanist at the Salk in the period in which I came to know the building, Jacob (Bruno) Bronowski, a person I found somewhat wanting in humanity but who had written with insight on science and literature, on Blake and on Leonardo. He expressed, if he did not altogether embody, the ideal Salk visionarily had in mind.

That was in 1973, when I was a visiting professor at the University of California, La Jolla, a place I loved in those days for its edge-of-the-world feeling. I had left a sour, cold New York and found myself in this farthest corner of the country in the company of eccentrics who had themselves found themselves there with no further place to go: Herbert Marcuse, Angela Davis, Doctor Seuss, Jonas Salk and his wife, Bruno Bronowski, Fred Jameson, Louis Marin, together with a chorus of surfers, beach boys, California beauties, and the armada of whales spouting their way past toward the mysterious waters of Baja. I was pleased to read in Alexandra Tyng's memoir of her father, appropriately titled *Beginnings*, that Kahn had the same feeling toward the place, which must

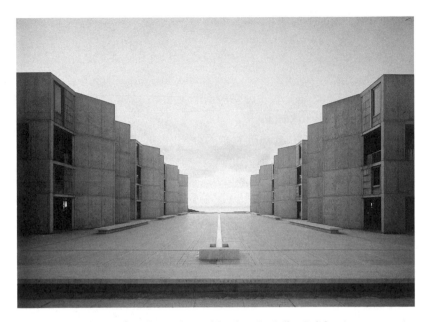

Figure 17. Salk Institute for Biological Studies, La Jolla, California, 1959–1965: courtyard, facing west. Photo by Grant Mudford.

have felt even more an outermost point in those days before the Salk got built, as he paced along the bare headlands looking out over the Pacific, the Torrey pines behind him. The Salk's plaza likewise draws a sharp line beyond which there is only empty world. In a wonderful image, the two rows of studio-laboratory modules are shown, like two ranks of square-eyed Cyclopes, peering out into the unknown. The edge and the windows looking out past the edge represent an exact poetry of site for a complex designed to press the limits of knowledge back: gazing squarely into the uncharted is a marvelous metaphor for that. I like it that each module has an unimpeded view into the uncharted. The proximity of the sea suggests two rows of conning towers (fig. 17).

Kahn expressed satisfaction with the aesthetic symbiosis of travertine with concrete, and of both of them together with the weathering teak-wood he used for framing. He felt it gave the place its "ancient, weathered

cast," as indeed it does. I am uncertain what the plaza feels like today, but in 1973 it had a certain desolate look. The south rank of laboratories was not being used, I imagine because of some funding problem, and that lent the entire complex an air of abandonment, which the stark emptiness of the plaza, swept by sharp winds that stirred the sea grasses growing in the cracks, only underscored. Kahn, driven by his romanticism for beginnings, had envisaged scholars walking up and down the plaza discussing the problems of the world, pausing before the slabs of slate conveniently placed there to chalk an equation or draw a diagram. Nobody was ever there that I saw—nobody but architectural tourists.

Kahn was almost hopeless in his romanticism, hoped people would rise to the architecture, but they rarely did or do. When approached in the mid-1960s to design the Dominican Motherhouse of St. Catherine Ricci, he sought an architectural embodiment of his own ideas of the contemplative life for a sisterhood that was in fact embarked on a program of social action. He wanted long refectory tables, whereas the nuns insisted on small tables for intimate conversation, which struck Kahn as too much like a restaurant.

> Kahn and the Media sisters were on different trajectories. The pattern of convent life that so fascinated the architect was changing swiftly. Already there were signs of relaxed discipline that was coming to characterize convent life in the late 1960s. The sisters were asking about swimming and tennis, and such modern amenities as intercoms and air-conditioning. And Kahn's refectory, for example, was to be less mystic and communal, and to have more "family room atmosphere." It was even meant to permit "cafeteria style serving"!4

The building never came off, but it provides a beautiful and in certain ways a useful lesson regarding the aspirations of architecture and what one might call, following Nietzsche, the human-all-human. I sometimes think, though this is not the place to ventilate the matter, that Kahn himself sought to live his life on architectural principles, with three children

by three different women, and saw no reason why love should not constrain the stresses of emotional life, as if there were an architectural solution to raw feeling. In any case, we rarely rise to the vision architects have of the life their buildings subtend.

I thought of the Salk Plaza years later when I visited the abandoned royal city of Faitpur-Sikri, on whose now-empty plaza the ruler of the land and his consort played backgammon, using court ladies in fluttering saris as the pieces they ordered from position to position, as they contemplated their moves from a balcony. I think the feeling of immemoriality, which haunts both those sites, was something Kahn would have prized in the Salk. It feels as though it has been there timelessly, like those ruins that so moved Kahn when he saw them in Rome. I like to imagine coming upon a place like the Salk at the edge of land somewhere, with the waves rolling against the cliffs and the seabirds wheeling through the empty sky, as an explorer, who asks what this strange complex was. My sense is that I would think of it as we now think of Stonehenge, as a contrivance for observation and for bringing its builders' activities into conformity with the recurrences of nature. I would imagine a population of seers or priests, searching for signs. I would try to infer abductively to the form of life the structure implied.

As a complex, the Salk seems to me to connect with something timeless in human nature, the desire to know, to measure, to see, to understand. It is archaic if we think of the meaning of the term *archai*. The Greek term also means leader, and the two ideas—of chief and of origin—are united in the great vision of a first mover and of highest being at which ancient theology arrived in the reflections of Aristotle. "Architect" is in effect archi-tecton, or master of the building. I have fashioned a neologism out of *archai* and *tekton*, which fits Kahn to perfection, but perhaps fits no one else. He was a builder of beginnings. The Salk is a composite of historical density and of a human *archai*. It is the *archai* not of a man under a tree, but of someone at the edge of the world, trying to penetrate the mysteries beyond. In this country there is no building like it.

NOTES

1. Quotations in this essay are from Louis Kahn, "Structure and Form," *Arts and Architecture* 78, no. 2 (February 1961): 14–15, 28–30, unless otherwise specified.

2. David B. Brownlee and David G. De Long, *Louis I. Kahn: In the Realm of Architecture* (Los Angeles: Museum of Contemporary Art; Rizzoli, 1992), 54.

3. Ibid., 90.

4. Ibid., 387–88.

10

Moving Pictures

PERHAPS THERE IS NO serious reason to consider film as especially nearer of artistic kin to drama than to painting. Indeed, the expression "moving pictures" implies an evolutionary expansion of representational possibilities of much the same order as we would find were painting to have developed out of drawing and the new forms called "colored drawings" (though we ought to be cautious in regarding any artistic genre as a progressive step beyond an established one, inasmuch as a colored drawing is not thereby promoted to the status of a painting any more than a black-and-white painting is demoted by monochromy to drawing).

Possibly a basis for considering film and drama together lies in the fact that both are viewed in theaters by a seated audience focused on a common spectacle. But this may be adventitious. Concert halls and opera houses, after all, are not remarkably different at this level from theaters; nor, for that matter, are hippodromes, circus tents, sports arenas, or even churches—there being some basis, I suppose, for regarding theaters as mutations of churches and audiences as secularized congregations. The racetrack and the basilica were equally charged with

An earlier version of this essay appeared in *Quarterly Review of Film Studies* 4, no. 1 (winter 1979): 1–21. Copyright Overseas Publishers Association, Amsterdam B.V.

religious energy in Byzantine culture, where supporters of different teams were divided along lines of theological partisanship. In any case, it is not essential to films that they be projected onto screens; early films were viewed in peepboxes, and technology has so evolved that vastly more films are viewed through the VCR than in the local multiplex. I do not wish to deny that our response to film is in some measure a function of our being members of an audience, since some of our feelings are doubtless collective and due to contagion, and I doubt anyone would be very deeply moved by something seen through a hole while assuming the compromised posture of a voyeur. Or if there is a special artistic experience to be had here, it is due less to what is seen than to the fact that it is seen *in a box:* for the box encloses and transforms a space encapsulated in, but distinct from, real space—the space of the spectator—like a holy object deposited in the real world but not of it, belonging to another domain of reality.

That there should be a space we can see into but cannot enter explains in part the uncanny power of Joseph Cornell's boxes or the perspective boxes of seventeenth-century Holland or the looking-glass world, all of which give a kind of literal exemplification of something essentially true of art: namely, that it logically excludes its spectators from the space and often the time it occupies. We can see in a play, for instance, the transpiration of events in which we have no possible point of intervention. I can stab the man who plays Hamlet, but only Laertes can stab Hamlet; Juliet is logically restricted to the embraces of Romeo, even if the woman who plays her is in fact a rake. I own a crystal paperweight, vintage Baccarat, scarred by a hammerblow, which I cherish for its philosophical meaning. Some child must once have been frustrated by the distance he thought physical, which in truth is metaphysical, between himself and the spun glass flowers embedded in the transparent hemisphere, and he tried to collapse it by shattering the glass, not realizing that the value of those colored bits lay precisely in the fact that they escaped his touch. The invention of the projector enabled the audience to enter the box, which then receded into the mere walls of the theater, whereupon some

different method for marking the space between audience and spectacle was required: but this way a lot of people could see the same show at once, with measurable economic advantages to the impresario, chairs being cheaper than optical contraptions like Reynaud's praxinoscopes.

Whether this mysteriousness survives translation into videocassette aesthetics is of course linked to the aesthetics of television screens (and boxes): there is already a marked difference between high art video, made to be viewed in a box, and films transferred to videotape—the little-screen as opposed to the big-screen format. In truth, the practices associated with home viewing have tended to domesticate the theater and to demystify it through loud talking, eating, and going to the restrooms. Before the VCR the movie house had some of the quality of the cathedral, a place of silent raptness.

Proust, who practiced voyeurism to the point of genius and who sought to transfigure his life into art by taking a stand outside it from which to look in on it as a whole (and who almost literally stopped living in order to do so), imagined as a child (or at least his narrator imagined) that the theater was a kind of elaborate peepshow: a columbarium of matched spectacles. And I suppose if we bred actors for smallness, like bonsai trees, plays could be mounted in boxes for Gulliver-type spectators. But there would still be a difference to draw between film and drama, which we may see if we elaborate Proust's fancy, in which "each of the spectators looked, as through a stereoscope, at a scene that existed for himself alone, though similar to the thousand other scenes presented to the rest of the audience individually."[1] I wish to stress the phrase "though similar to the thousand other scenes," since "though" would have no application to the different showings of the same film in the same peepbox at different times or different peepboxes at the same time—nor to the common suburban experience of every television set on the street tuned to the same program (or the display of television sets at Nobody Beats the Wiz, all showing the identical program). The set of performances of the same play stands to the latter in something like the relationship in which the set of Platonic particulars stands to the same archetype, or as the various interpretations of

it stand to the same sonata, while the showings of the same film stand to one another somewhat as copies of the same newspaper do (hence Wittgenstein's joke),[2] so that there is no relevant difference between reading the same paper twice or two papers one time each.

A missed inspired performance of a certain play or opera is unrecoverable, but I have no idea what a man might mean who tells me that I missed something marvelous if I did not see *Last Tango in Paris* at the Trans-Lux 85th Street on Friday at 8:00 P.M. I don't mean to deny the possibility of a kind of perversion of connoisseurship of the sort that animates stamp collectors, but conceptually I shall have to suppose he is not talking about *Last Tango* itself, since nothing stands to it as a playing by Alicia stands to a piece by Granados, the relationship between negative and print being too mechanical to count. Showings of the same film stand to one another in the manner of classes as conceived of by Aristotle rather than Plato, with the basis of similarity *in rebus* rather than *ante rem*. Whether this difference is deep enough to subvert a natural comparison between film and drama may be questioned, and it in any case equally subverts a comparison between film and paintings. If we have two paintings that resemble each other as much as two showings— or two performances—this will either be a coincidence or more likely a matter of one being a copy of the other, while two showings of a film are not copies of one another at all, and though one actor may imitate another, it is not part of the concept of performances that they should be copies of each other in the sense in which A is a copy of B only if B explains A. A fresh performance of one of Goldoni's plays may not be explained at all by earlier ones, and we may indeed have no idea how such plays were first put on. And neither, save adventitiously, are two showings of the same film related as copy to original. We may appreciate this more profoundly if we recognize that our experience of a painting is seriously compromised when we are told it is a copy, certain historical presuppositions regarding provenance and history having a deep relevance even if copy and original should exactly resemble each other. Nothing remotely parallel compromises our appreciation of a showing that hap-

pens exactly to resemble another one, since matters of provenance and history are irrelevant here; and neither does it compromise our appreciation of a performance of it, were we to learn that this performance was copied from another—unless its being copied was an artistic ingredient in the performance, as when we are told that a certain performance is exactly like the performances of Shakespeare's day and the result of hard antiquarian research.

In the end, showings are related to one another more or less as closely as are edition prints from the same plate, both being members of what we might pay homage to Walter Benjamin by terming "Mechanically Reproducible Classes"—it not mattering conceptually if by accident or decision there is only one showing or only one print pulled from a given plate.

But to use this as a basis for drawing serious artistic parallels between prints and films would be to use taxonomic principles with the same crazy accuracy with which Uccello used those of linear perspective—to produce something distorted to the point of parody. Prints seem vastly more to belong to the same artistic phylum as paintings, as may be seen from the fact that historical beliefs function here as well—our experience of a print being compromised, for example, by the knowledge that it did not come from the same plate as an original it exactly resembles. And nothing like this matters with films at all, so far as I see—not that historical beliefs are irrelevant to their appreciation, but they enter at a different point in their ontology. It is difficult to see that "an original" has any artistic significance in the appreciation of films, even though there are originals and epigones among filmmakers. And films still seem to have some more natural affinity to plays than either of these has to paintings or to prints. Possibly this felt parity has less to do with dramatic form than with the way in which each involves events in some special temporal way.

"Some special temporal way" is a makeshift way of saying that there will remain a difference with paintings, even though paintings may involve time in the sense of showing an event, as in *The Rape of the Sabine*

Women or *The Drunkard's Farewell*. We mark this to a degree with verbs of perception, for while we indifferently speak of seeing or watching a show (as of hearing or listening to a piece), we do not watch paintings, save in senses irrelevant to experiencing them as art, such as guarding them against theft or observing them disintegrate, as with the frescoes in Fellini's *Roma*. We don't, because everything to happen is already before us; there is nothing further to watch for. The most energized baroque figures will never move a step, but stand locked in logically immutable postures like the personages on Keats's urn: "Bold lover, never, never canst thou kiss, / Though winning near the goal. . . . " This is so even if there are films in which nothing happens.

Imagine, for instance, if, inspired by Warhol, I produce a film called *War and Peace*, based on the novel. It consists of eight hours of footage— a saga!—of the title page of Tolstoy's novel. Or suppose an ill-advised avant-garde dramatist mounts a play consisting of an actor seated on the stage through three acts. "Lessness" by Beckett has an immobile figure this way. Nothing happens, either in the film or in the play, in the sense that what happens is nothing. Yet the contrast remains with a painting, even one featuring the most energetically deployed figures; for a person who stood before such a painting in anticipation, say, of an event—like the dancers in Breughel taking some step—would be mad, or hoping for a miracle of the sort that earned Pygmalion a place in mythology, whereas one has every right, however frustrated, to expect an event in the monotonous film or play just described. It would be a sardonic concession to the legitimacy of this expectation if the title page burned up to end the film, or the seated man scratched his ear in act three.

Film and drama seem essentially temporal in a way somewhat difficult to pin down directly, though perhaps one way to do it indirectly would be to mark the difference between projecting a slide of the title page for eight hours and running a film of the title page for eight hours. There is a considerable difference here in the circumstances of projection, none of which need be reflected as an element in the image projected on the screen—though we can imagine matters so arranged that

no difference is perceptible, such that one could not tell by patient visual scrutiny whether it were a slide or a film. Even so, whereas what they experience may be indiscernible between the two cases, knowledge, however arrived at, that there is a difference should make a difference. Although nothing happens in either case, the truth of this nonactivity is logically determined in the case of the slide, whereas it is only a matter of a perverse artistic intention in the case of the film, where something could happen if I wished it to. So a perfectly legitimate right is frustrated in the case of the film, whereas in the case of the slide there is no legitimate expectation either to be frustrated or gratified. Again, at the end of eight hours, the film will be over, but not the slide. Only the session of its dull projection will have come to an end, but not it, since slides logically lack, as do paintings, beginnings and endings. Our viewing of a painting may indeed have a beginning and end, but we don't view the beginnings and endings of paintings (discounting the case of serial paintings, as in the Arena Chapel, where the narrative of Christ's mission has already the form of a precocious film).

The same contrived contrast may be drawn between a tableau vivant, in which living persons are frozen in certain positions, and a play in which by artistic design the actors do not move. Again, though no difference may meet the eye, a difference is conferred by the logical differences of the two genres. We have, in brief, to go outside what is merely viewed to the categories that define the genre in question, in order to establish differences and to understand what is philosophically distinctive of more natural artistic examples. Finding the difference between pictures and moving pictures is very much like finding the difference between works of art and real objects, where we can imagine cases in which nothing except knowledge of their causes and categories make the difference between the two, since they otherwise look exactly alike. It is the initial foray into categorical analysis that has given us some justification for considering films together with plays, since both seem subject to descriptions that, though in fact false, are not logically ruled out, as they are in the case of pictures. If in a film "bold lover" does not succeed

in kissing "maiden loth," this will not be because the structure of the medium guarantees these works of art to be a joy forever in consequence of logical immobility. Here, immobility has to be willed.

Let us stand back, for a moment, from this proliferation of cases and ponder the methodology that generates them. I am not engaged in botanizing, in seeking for a new classification of the arts. Rather, I am seeking for what may be philosophically relevant in film as an art. And one method for isolating philosophical relevance is to look for principles that must be invoked if we are to distinguish between things that are otherwise exactly alike. Consider epistemology. The skeptic supposes that our experiences might be exactly as they are, but only, in fact, as the product of a dream. Then the difference between dream and veridical experience is that experiences are caused by what they are of, but causality and reference are relations at right angles to the experiences, which the experiences then underdetermine. Thus there is no possible hope for finding—within the experiences in question—whether these external connections hold or not. But the method of matching experiences in this manner is certainly a method of conceptual discovery, for without it we might never have appreciated how complex the analysis of experience must be, and how dependent, finally, it is on factors logically external to what we experience, on what does not meet the eye. Or consider, again, induction, where a body of data supports not only a natural hypothesis but also an immense set of unnatural ones (this is Goodman's "New Riddle of Induction"). Because the data underdetermine the set of possible hypotheses, we plainly have to look outside the body of our data to determine which is the correct inference and, more important, what are the factors other than consistency with known data that have to be invoked in order to identify an inductive inference as correct.

In art, an important sort of case arises with fakes. We are asked what difference it makes if a work is produced that is exactly like the genuine one. Obviously the distinction between genuine and fake must be established with reference to factors external to the works themselves—for

example, with reference to their histories. However, the serious question is whether knowledge of these differences in any way impinges on our appreciation of a work whose structure underdetermines the difference between authenticity and trumpery, or whether it makes no difference. I think one cannot say in advance whether it makes a difference or not. Consider, for example, the possibility of duplicating persons. Suppose a man is killed in an automobile accident, but the widow is promised delivery in, say, three weeks of someone exactly like her husband in all obvious respects. Would it matter? Is she required to love, honor, and cherish the exact simulacrum of her husband, or what? Would the known history of this reconstituted mate make a difference or not? I am certainly unprepared to say, but my feeling is that it would make an *enormous* difference, and my philosophical point is that the possibility of doubles, in which the pairs are exactly alike relative to some schedule of descriptions, may reveal factors outside this set with reference to which our attitudes toward one or the other of the counterparts may differ. The method of philosophical duplication is a powerful lever for lifting factors into consciousness which otherwise never would have been acknowledged—presuppositions upon which our attitude toward the world has always depended, though we might not have realized their crucial role, since it never had been challenged. These factors will always be logically external to the thing in question. The most striking contribution to have been made to our understanding of art by the artworld itself has been the generation of objects, ones in every manifest regard like perfectly ordinary objects, things like bottle racks, snow shovels, Brillo boxes, and beds. We are (1) to regard these "things" as artworks, and not as the mere real objects from which they are indiscernible; and (2) to be able to say what difference it makes that they should be artworks and not mere real things. Indeed, I regard the matter of furnishing answers to these questions the central issue in the philosophy of art. But since it hardly can have been a question before the possibility arose, philosophers of art who merely studied artworks would have been blind to just the sorts of factors with which a philosophy of art must deal; for these

factors would be logically external to the objects in question, which underdetermine the difference between artworks and real things.

In times of artistic stability, one might have learned to identify artworks inductively and to distinguish them from other things (much in the way we learn to distinguish cabbages from carrots) and to think the essence of art must then lie in the differentiable features. A theory of art based on such induction will necessarily fail if something can be an artwork but share all the manifest features of an erstwhile ordinary object. To understand what art then is requires us to avert our eyes from the manifest appearances of things and ask what it is that does not meet the eye, which is what makes the difference between art and reality—where knowledge of this difference then makes the difference in our experiences of objects as artworks or as real things. Think, after all, of the difference it makes whether the man in the lobby is threatening the woman or—using the same words he would use were he threatening her—is merely going over his lines as he waits for the elevator to carry him to his audition. The difference is not merely one of attitude: the difference is ontological and between things that otherwise are indiscriminable. This is my purpose in manufacturing cases in which things, though they may appear the same, are seriously different, and it is what animates my preoccupation with the difference between slides and films. Usually the differences are obvious, but we don't learn much philosophically by sticking to obvious differences. It is with this in mind that I want to explore some differences between film and drama.

Although there are many ways in which one can directly modify a strip of film to produce a cinematic image (through the techniques of the photogram, by drawing or painting on the film itself and using the latter after the manner of a microscopic slide, or even by gluing things onto the film), I shall be concerned primarily with analog photography, largely because photographs stand in interesting relations to the real world (almost as interesting as the relations in which perceptions do) and because the camera has so many remarkable analogies to the eye. These

remarkable properties are diluted in digital photography, as will shortly be seen. Consider, for example, what is involved in identifying a photograph as being of something—of the cathedral of Rouen, for example, or of Princess Anne. Here I believe we have an almost spontaneous representationalist theory of photographic content that almost precisely resembles a parallel theory of perception. Something is an analog photograph of x when it is caused by what it denotes, so that if the causal condition fails, the semantical identification fails as well, in that it no longer is of x if x does not enter into a causal explanation of the state of the photograph we speak of as the picture, and in a natural sort of way.

It seems to follow that there are no false photographs—that is, photographs which retain a constant semantical content invariantly as to their semantical value—and it is here that digitalization subverts the forensic value of the photograph. Unlike a sentence, the meaning of which does not vary with variations in truth value, a photograph has its closest linguistic peer in the "proper name" (if Russell is right that names without bearers are noises and if Kripke is right that a name denotes only what it is causally connected with).[3] Thus, something exactly like a photograph of Rouen Cathedral is itself not a photograph of the cathedral of Rouen if not caused by the cathedral of Rouen. I am thinking here of exposing a sensitized surface to the light in some random way, developing and fixing the result, and finding that one has produced a pattern of darks and lights exactly of the sort one would identify as of Rouen Cathedral had it a proper causal history. This has nothing to do with the sharpness of the image. A blurred snapshot of Rouen Cathedral has this identity, while a sharp but fortuitously caused pattern does not; or to suppose the latter after all to be of Rouen Cathedral is to suppose the cathedral of Rouen after all to explain its provenance. To see the most sharply articulated pattern as being of the cathedral of Rouen when it was in fact uncaused by that cathedral is like seeing faces in clouds: a cloud can look exactly like the profile of Voltaire—as much so as the bust of him by Houdon—but this is merely the result of an uncanny happenstance, a lucky bit of nebular configuration that is to be explained by whatever are

the forces that account for cloud formation, not Voltaire! We refer to Voltaire only with reference to why we see the cloud as we do, not with reference to why the cloud is the way we see it.

So photographs are very tightly linked to their causes when construed representationally rather than as abstract patterns of light or (in the intermediate case) as scanned into a computer and modified in conformity with the photographer's interests. Indeed, they are linked in the same ways ideas are in a Lockian or Cartesian view of representation: (1) They are of their causes, in the respect that their having any real content at all is put in question the moment we have doubts as to their provenance. (2) If my ideas are caused by some condition of myself rather than, as I would spontaneously believe, by things in the external world, they directly lose their representational qualities and have just the sort of content clouds do, which is to say none. (3) As ideas they become meaningless, even if they exactly resemble what would be representations of the world on the routine assumptions of causality and denotation. Suppose a drunken driver has a car that leaks oil, and you notice that the erratic trail of drips has just the shape of an English sentence, for example, "Your dog is pregnant." Are you, if a dog owner, going to heed this and treat it as a message? And suppose you do, and the dog indeed—and to your surprise—is pregnant? Will this still be anything but an accident? I am not going to advise you regarding signs and strange portents, but if you regard the marks as a sentence, with truth and meaning, you are going to have to suppose a very different causal structure than the one I have just described concerning the way those marks got deposited in the world. In this case, all the signs provide evidence for is that something is wrong with the driver and something amiss with his engine.

We can, of course, liberate ourselves from these severe constraints by letting a photograph be of something other than its cause if we transform the cause into a model and (1) let it acquire a semantical structure of its own and (2) let it stand for something ulterior—in which case we require a rule of interpretation. Reynolds painted a portrait of Mrs. Sid-

dons as the Muse of Tragedy. The subject of the painting was Mrs. Siddons got up as the tragic muse, not the tragic muse *tout court*. But imagine an alternative history for Mrs. Siddons, a possible world (if you like that sort of semantics) in which Mrs. Siddons, rather than having become a famous actress, instead became merely an artist's model whom Reynolds happened to use as a model for a painting of the Muse of Tragedy. Then the subject of the painting would be not Mrs. Siddons— she was only the model—but the tragic muse herself, though the painting looks exactly like *Portrait of Mrs. Siddons as Tragic Muse* does. The model here would become a vehicle of meaning through which we see the muse. Similarly, we see *L'embarquement à Cythère* as an allegory of love rather than a group portrait of some of Watteau's chums, though indeed they were his models. Much the same thing is available to photography. The famous 1857 collodion print of Henry Peach Robinson's *Fading Away* is of a dying virgin, a bit of Victorian saccharinity. However, he was not documenting a touching demise; he instead used models who stood for the dying girl, the grieving parents, and so forth. The model becomes the subject only of a picture of a model, whether the picture be a photograph or a painting; whereas the model becomes, as it were, semantically opaque and stands this once for nothing—or for itself. Leonardo may have used a bit of available majolica in setting up *The Last Supper,* but it stands for the vessel of the Lord, and the vessel is the subject of that portion of the fresco, not the crockery itself. Leonardo was not painting still lifes.

Let us resurrect the term *motif* from the vocabulary of yesterday's art schools, where something was a motif if it provided an occasion for painterly representation—for example, an old fisherman's shack. The identical object may be motif or model; it will be the latter if, by dint of some rule of interpretation, it stands for something other than itself. Thus in Reynolds's portrait, Mrs. Siddons as tragic muse is motif, whereas in the other possible world she is model, and the tragic muse herself is subject. Of course, we might learn a good deal about Florentine ceramics by studying the dishes Leonardo used as models, that is, by

disinterpreting them and viewing them as motifs. And this will be remarkably and inevitably the case with photography, whatever the interpretive intentions of the photographer. A tremendous amount of sheer reality—simply in consequence of the physical circumstances of the process—is recorded through the blank uninterpreting eye of the camera, which simply transcribes whatever is before it (discounting for retouching, which, like digitization, raises problems of its own). The objects that we see in old movies have often far greater interest as motifs than as models, and the films themselves have a greater interest as inadvertent documentaries than as screenplays. They stand as testimonials to vanished realities. But this takes us considerably ahead of our analysis. In any case, any representational form has the option of treating objects as motifs, in which case it is documentary, or as models, in which case it is anagogic. What is immediately important to us in photography is that it is inescapably dependent on the objects it records, a limitation that may be overcome in cinema by the other sorts of techniques for modifying film I began this section by mentioning, where spontaneous reference to an external reality is considerably more elastic and less direct than in the photographic case, and where the option of documentarity is necessarily compromised, if not lost. This is part of the reason I am making photography so central. We would lose considerable interest in the so-called photographs of Earth taken from outer space were we to discover they were painted on film—unless the astronaut were painting what he saw and had adequate mimetic gifts.

Let us utilize these somewhat gross semantical distinctions to differentiate between a film of a play—*Hamlet*, say—and what we might speak of as a screenplay proper, where *Hamlet*, so to speak, is in the film, but no stage version is actually photographed. (Before the advent of the medium of cinema, of course, we could not have spoken of stage versions, since plays were *only* staged; this, then, is a case where the advent of new genres created boundaries for old ones.) Filming a staged play may employ specifically cinematographic techniques by showing the action from angles not normally available to a fixed and seated audience

(though science fiction theaters might be imagined in which the spectator is moved around, sometimes seeing the spectacle from the "normal" vantage point of the fixed seat, sometimes from above the stage, sometimes being literally brought up to a closeup view, and so forth). But even so, it is a staged play that is being filmed, an event having an existence external to the film, which could in principle take place whether recorded or not, much as, in a realistic epistemology, we regard the world as there and determinate invariantly whether we perceive it or not. Of course, the knowledge that the play is being filmed may have some effect in transforming the reality we think of the film as recording, much as the knowledge that we are being perceived (or observed) may alter the way in which we behave. The presence of an eye—or a camera—may precipitate a kind of *pour autrui* different, through the fact of perception, from the stolid *en soi* the realist intends, but this intervention, however interesting, leaves the semantics of the situation unaffected: even if the fact that it is being filmed modifies the reality the film itself records, the play in question is still an external, ongoing event, there whether filmed or not. The same perturbations of consciousness would, for instance, occur if the actors merely believed they were being filmed, or if the director forgot to put film in his cameras and believed he were making a film—falsely, as it happens. In any case, the film here is documentary, as much so as a newsreel, and the play in question is what the film is about, as much so as a newsreel of the events of May 1968 in Paris is about those events. (The difference here, of course, is that the 1968 events themselves were not about anything the same way the play happens to be about something rotten in the state of Denmark, or *whatever Hamlet* is about—though the protesting students might speak of something rotten in the state of France.) But a photograph of a piece of New York graffiti, say, remains about the piece of graffiti, even though the latter may be itself about something and have a content in its own right. As denoted by its filmic representation, then, the film of a play in this sense is subject to the rigid semantical structures of photography as such. It is about a particular performance of a particular play, whatever may be the

subject of the play itself. Of course we may, in seeing the film, get caught up in the play, just as we may read the piece of graffiti; however, the play remains the motif of the film, even if we happen spontaneously to treat it as model.

In a screenplay proper, by contrast, the film is not about what is photographed, any more than Delacroix's *Liberty at the Barricades* is about a certain woman, whatever her identity, whom Delacroix happened to pose in a Phrygian cap with a flag in her hand in his atelier in the Place Furstenbourg. Delacroix meant us to see through that woman to what she stood for, which is the subject of the painting. A film of the play is about actors, whereas a screenplay is not about actors, except in the special sense in which what the actors play is actors, as in a certain Hollywood genre in which films were made about struggling young actors or skaters or singers or whatever; a screenplay continues to be not about the persons who play the roles but about the persons whose roles they play, and even if the film should actually show the play in which they get their break and become stars, the play is in the film and the film itself is not documentation of the play.

Of course, the inverse possibility to the one we noted before is a danger here: just as we may treat the actors in a filmed play as models rather than as motifs—see Hamlet rather than the man playing Hamlet—so in screenplays we may see the actors as motifs rather than as models—refuse to see Hamlet but see rather Olivier. That is one of the problems of the star system, in which the actor becomes so autographic a cultural artifact as to render himself opaque, which perhaps explains the motivation for finding anonymous actors, or just ordinary passersby. This is supposed to enhance realism, whereas what it does in fact is to enhance artifice, for the very naturalness of the persons "playing themselves" renders them transparent in a way in which Garbo or Gable never could be, nor Elizabeth Taylor, who is in movies in which she appears like Mrs. Siddons was in Reynolds's portrait. These movies provide mixtures of document and anagogy; they are about Elizabeth Taylor as ———, hence compromising the illusion, since we are always aware of the actor

as actor—something Proust's Berma managed to overcome. One won-
ders, for example, if in the typical Hollywood film the audience even re-
membered the names of the characters their favorite stars played; for in
describing *Our Dancing Daughters*, say, they speak not of what Diana
Medford did, but of what Joan Crawford did.

The movie star is a metaphysically complex personality, retaining an
identity so strong as to swamp the role he or she plays, to the point that
we speak of Robert Mitchum rather than Philip Marlowe as doing this
or that, as though roles were like lives through which a Hindu soul trans-
migrates. The same is not true of opera stars or stage stars, not merely
because the roles in the dramatic or operatic repertoires have strong
identities of their own, whereas film roles are often ephemeral, but also
because the same role may in opera or theater be played by different
actors. We cannot compare performances in films in the same way, for
the role is exclusively preempted by one person who plays it in a movie,
so much so that we almost cannot separate the person from the role. Of
course, different versions of the same thing are possible in films, but if
someone today decides to redo *The Thin Man*, it would not be like a new
staging of *A Midsummer Night's Dream*, with its largely invariant lines
and scenes, but a whole new work—like a version by Giraudoux of the
same general story but differently done by Euripides and Racine. In a
movie, a role belongs to the person who plays it such that were another
to play the so-called same role in the same story, it would be a different
work. So the fact that films use actors ought not to mislead us into think-
ing of film as an essentially performative art, inasmuch as nothing counts
as a different performance of the same work. The star is intimately
woven into the substance of the film, almost in the same way Mrs. Sid-
dons's appearance is woven into her portrait. But even so, the film is not
about its actors or stars, any more than a play is. And this returns me to
my subject.

Let us consider once more the difference between a film about a play
in the documentary sense and a film in which a play is put on. Imagine
a film called, say, *Our Daughters, Our Dreams*, in which the famous star

Delilah De Lillo plays the role of Mary Mutt, a struggling actress waiting for a break, which she gets at the climax of the movie. We then see her in her moment of triumph, playing the role of Blossom Beauchamps in the Broadway hit *Tepid Latitudes*. *Tepid Latitudes* can be, if you wish, a play about Blossom Beauchamps's moment of triumph as an actress in a play called *Broken Playthings*, in which she plays the role of Susan Seaward, a debutante who achieves erotic redemption. The high point of the film shows Delilah/Mary/Blossom/Susan leaving her fiancé, a stockbroker, and embarking toward orgasmic authenticity with someone named, inevitably, Brian. *Tepid Latitudes* is in the film much as *Broken Playthings* is in *Tepid Latitudes*. Neither exists in real life, and the film is never documentary.

The point I wish to make is that the difference is considerable between seeing a play and seeing a play of a play—as considerable as the logician's distinction between use and mention. Consider the second act of *Ariadne auf Naxos*, in which a play is presented that has been discussed in act one. In a recent staging of this work at the New York Opera, the second act did not so much present the play as present a play of the play, putting a small stage onto the main stage along with some people playing the part of audience. So what we saw was some people seeing a play, along with seeing the play they saw—which we saw the latter *as a play*. The act was about the play itself, in other words, rather than whatever the play, were we to see it, would have been about. Thus, instead of seeing the characters Ariadne, Zerbinetta, and the like, we saw actresses and actors playing these parts: hyphenated personages, which complicates identification of the dramatic object. In a staging of *Ariadne* in Rome, by contrast, we were actually presented with the play, rather than the play of the play, and so saw Ariadne and Zerbinetta directly. The difference is astonishing. Since in the New York production we were presented only with actors on a stage, there was nothing strange, only something comical, in seeing *commedia del arte* actors together with classical tragedians. But in the Rome production, where we saw Ariadne on her island singing her heart out, it was an artistic shock to see *commedia del-*

l'arte figures occupying the same dramatic space. How could they be on that island? How could figures from eighteenth-century Italy be contemporary with a figure out of Greek mythology? That someone may *represent* Ariadne next to someone *representing* Zerbinetta is no more shocking than seeing a painting of Ariadne next to a painting of the Italian comedians. What we cannot see without shock is Italian comedians in the same painting with Ariadne; it would be like seeing one of Picasso's cubist women being carried off on one of Titian's bulls.

So in the documentary film of a play, we are supposed to see actors playing roles, whereas in a screenplay—apart from the complexities introduced by the star concept—that there are actors is not part of what the film is about. We are not supposed to see the actors, and if we do see them, we will have misidentified what the film is about. It would, then, be consistent with a film which documents a play that it might also show members of the audience without in the least inducing aesthetic shock. But there is no room for shots of an audience in a screenplay, except in the sort of contrived genre I sketched above. What a nondocumentary film is about cannot be photographed. Nondocumentary films stand to documentary ones—a common photographic base notwithstanding—in the relationship in which perception stands to imagination, or history to fiction.

This strong conclusion holds even if the director decides that the way she is going to make a film version of *Hamlet* is to have her actors actually put *Hamlet* on, which she then shoots, so that there would be no internal difference between the film she produces and the film someone might make who is documenting a performance of *Hamlet*. Of course, this is not the ordinary way in which movies are made. Scenes can be shot anywhere; the man who plays Hamlet can recite his soliloquies in New York and stab Polonious at Cinecittà. In a parallel way, Leonardo might have painted the Last Supper by setting up a table in Milan with twelve models for the disciples and a thirteenth for Christ, in which case a documentary painting of Leonardo's set-up might in fact be indiscernible from *The Last Supper*. Of course, Leonardo did not do it this way at all,

so far as we know—he drew his models from here and there—and perhaps there was no such table as the one we see in the painting. At the same time, it would be interesting were we to learn that he painted Christ from a model who happened to have had very broad shoulders. Then the fact that Christ in the painting has very sloping shoulders (supposing we can discount draftsmanly ineptitude on Leonardo's part) acquires iconographic or at least expressionistic content. But the History of Models, alas, is yet to be written. It would be instructive at this point to discuss such matters as space and time in films: how the space of a photographed setting differs from the space of the action, and the time of the photographed scene differs from the time of the action meant. I recall how striking it was to recognize that in *L'avventura*, Antonioni used real time as artistic time. (In *Simon Boccanegra* twenty-five years lapse between the prologue and act one.) But I want to say a few words about movement, which the decision to treat films as moving pictures appears to demand.

Moving pictures are just that: pictures that move, not simply (or necessarily at all) pictures of moving things. For we may have moving pictures of what are practically stolid objects, like the Himalayas, and nonmoving pictures of such frenetically motile objects as Brueghel's reeling peasants or Rosa Bonheur's rearing horses. Before the advent of moving pictures, it would not have been illuminating to characterize nonmoving pictures as nonmoving—there would have been no other sort. With statues, of course, because they already existed in a full three dimensions, the possibility of movement was an ancient option, with Daedalus being credited with the manufacture of animated statuary, and not just statuary of moving things. Any good carver was up to that (though possibly not Daedalus's contemporaries, it being difficult to characterize the content of archaic sculptures in terms of the presence or absence of overt kinesis). Calder introduced movement into sculpture as an artistic property of his mobiles, but it is not plain that his mobiles are *of* anything, even if, if they are so interpreted, it seems almost foreclosed that they would be of moving things: of branches in the wind or

bodies in orbit or graceful spiders or whatever. Calder invented the striking predicate *stabile* to designate his nonmoving statues, but I suppose all statues, even such dynamic representations of movement as Bernini's *David* or Rodin's *Icarus*, would retrospectively be stabiles, or at least non-kinetic as such. Keats's observation holds true of these works. David remains eternally flexed in his gigantocidal posture in the Villa Borghese, though the slinger he represents could not have maintained that position, given the reality of gravity. He is represented at an instant in a gesture where a next and a preceding instant would have to be anatomically marked, in contrast with Donatello's or even Michelangelo's *David*, whose models could have held their pose—subjects for a daguerreotype, on which Bernini's model would have registered a blur. But Keats's observation would not have been logically true of sculptures or pictures as such, as mobiles and moving pictures demonstrate: things of beauty can be joys just for a moment.

In a philosophically stinging footnote to the First Critique, Kant observes that a representation of permanence need not be a permanent representation, and comparably a representation of motion need not be a moving representation—as is conspicuously true in descriptions of motion, which do not swim about the page. But even with pictures, it had long been recognized that the properties of the thing represented need not also be properties of the representation itself. This was most apparent in one main triumph of representational art, the mechanism of perspective rendering, where it would not have been the trivially present third dimension in a canvas which accounted for the depth in the painting. Although I suppose an artist could have introduced real depth as Calder introduced real movement—for example, by using boxes in which figures were deployed or by letting one real space represent another—it is not clear that this would have enhanced his or her powers of representation. In fact, it might have had the opposite effect, just as animation of Bernini's *David* might have reduced or severely altered its representational power, resulting in something more like a toy than a man, more like the fetish of Abraham Lincoln delivering the Gettysburg

Address as misbegotten by Walt Disney. We are struck by the discrepancies between representation and subject which we have learned to overlook, unless we are the technicians, in routine examples of representational art.

On the other hand, the first movies used moving pictures to represent motion, and despite Kant's dictum, it is difficult to think that this was not a breakthrough in representation, much as it would have been a breakthrough to use colors to represent colored things, heretofore represented only in white and black (in contour drawings, for example). Perhaps the difference can be brought out this way: Chiang Yee told me of a celebrated Chinese painter of bamboo who, having repeatedly been importuned to make a drawing for a certain patron, decided to comply, but had at hand only the red ink normally used for seals. The patron thanked him, but asked where had he ever seen red bamboos, to which the artist replied by asking where the patron had ever seen black ones. Why infer from the fact that if the representation is red, the subject must be red, if we don't infer from the fact that the representation is black that the subject is black? In a way, it may be a matter merely of convention; after all, we take sanguine and grisaille drawings in stride. However, there is more to the matter than that. For example, the shape of the image has to reflect the shape of the subject. If the artist had painted his bamboos zigzag, he would hardly have been in a position to counter the obvious question by asking where had the patron ever seen straight ones. So some properties, one feels, must be shared by representation and subject; some structural parities must hold, for at least this class of representation.

Perhaps the difference is this: In describing our experience with David, we might say that we see he is in movement, but we don't see him move. And with the bamboos, we see that they are yellow, but we don't see their yellowness. "Seeing that he moves" or "seeing that they are yellow" is a declaration of inference, supported by an initial identification of the subject and some knowledge of how such things in fact behave. To paint the bamboos in color reduces the inference, and there is always a

serious question as to whether, say, the use of red ink is merely a physical fact about the medium or if it has representational (or today, expressional) properties in its own right. Obviously, we have to learn. An emperor was fond of a concubine and commissioned that her portrait be done by a Jesuit painter in China who was master of chiaroscuro. She, however, was horrified at the result, believing that the artist showed her with a face half black, not able to see yet that he was representing shadows rather than hues and that the portrait show solidity rather than coloration. But the problem remains and is as much a function of our antecedent knowledge of the world as of our mastery of pictorial convention: a painting of a tapir could appear, I suppose, to the zoologically ignorant as of a monocrome animal half in shadow, rather than a dichromatic animal in full illumination.

In any case, with the movies, we do not just see that things move, we *see them moving*, and this is because the pictures themselves move, the way the pictures themselves must be colored when we would correctly describe ourselves as seeing the colors of what they show. The earliest moving pictures, then, also showed things moving: not just trains shown *as* moving, such as we see in Turner, but moving trains that we in fact see move; not just moving horses, but horses moving; and the like. Of course, photography is not required for this. A series of pictures would suffice, moving past at a certain speed; these could be drawings, as in the Zoopraxinoscope or, for that matter, the animated cartoon, where the several representations are synthesized into one (in a manner strikingly anticipated in the First and Second Analogies of the *Critique of Pure Reason*) and the viewer sees them as pictures of the same thing in different stages of a movement, spontaneously smoothed out to continuity by the optical mechanisms we are born with. That the matter is conceptual as well as perceptual is illustrated, I think, by the fact that if the pictures are of different things, or of the same thing but not at different stages of the same movement, we would simply register a quantized stream of images rather than a smooth motion—as we do in a way with some of Brakhage's films, where, though the pictures move, they do not show movement

because the discontinuities are so abrupt. We must, as it were, be able to synthesize the images as being of the same thing at different moments of the same motion or the optic nerve will not help us at all—as students of Descartes's bit of wax would know, however ignorant they might be of the physiology of perception.[4]

At the level of kineperception, I think, the distinction between photography and drawing comes to very little. Indeed, photography was originally less satisfactory in certain ways. The problem Leland Stanford's cameraman, Eadweard Muybridge, had was how to make it look like the horse was moving when in fact what the eye registered was the background moving and the horse deployed statically before rushing trees, an effect that is disconcerting in something like the way it ought to be that the wagon's wheels turn backward as the wagon goes forward. We have learned to live with the eye and mind being in a conceptual antagonism.

Where photography opens up a new dimension is when, instead of objects moving past a fixed camera, the camera moves among objects fixed or moving. Now, to a degree we could do the same thing with drawings. We could have a sequence of drawings, say, of the Tower of Pisa, displayed in increasing order of size; of the cathedral of Rouen, seen from different angles. We know as a matter of independent fact that buildings are not easily rotated or brought across a plain. Still, although we may describe our experience here in terms of seeing the tower closer and closer up, or seeing the cathedral from all sides, is our experience, phenomenologically speaking, of the tower's being brought closer to us or ourselves brought closer to the tower; of the cathedral's turning before us or ourselves circling the cathedral? I tend to feel that when the camera moves, the experience is of ourselves moving, which the phenomenon of Cinerama dramatically confirms. And on this I would like to say a few words that will bring us back to the semantical preoccupations raised earlier.

An experience of kinesis need not be a kinetic experience. The experience itself, based on rather natural Cartesian assumptions, is

akinetic—neither kinetic nor static, beyond motion and stasis, these being only the content of experience, like colors and shapes, and logically external to the having of the experience as such. It would be wholly natural to treat the camera in essentially Cartesian terms, as logically external to the sights recorded by it—detached and spectatorial. When the early cameraman strapped his apparatus to a gondola and rolled the film while riding through the canals of Venice, it was his philosophical achievement to thrust the mode of recording into the scenes recorded in a remarkable exercise of self-reference. At this point cinema approaches the proper apprehension of architecture, which is something to be not merely looked at but moved through, a quality that, in turn, the architect will have built into his structure. In a way, I think the kinetification, if you will, of the camera goes some way toward explaining the internal impact films make on us, for it seems to overcome, at least in principle, the distance between spectator and scene, thrusting us like movable ghosts into scenes that a kinetic photography locates us outside of, exactly like disembodied Cartesian spectators. We are within scenes that we also are outside of through the fact that we have no dramatic location, often, in the action that visually unfolds, having it both ways at once, which is not an option available to the audiences of stage plays. Or this at least happens to the degree that we are not conscious of the mediation of the camera, and transfer its motion to ourselves inversely to our deep-seated geostatic prejudices. Whether, of course, the film actually achieves instillation of kinetic illusion (in contrast with the illusion of kinesis, which is the commonplace form of cinematic experience) is perhaps doubtful, especially if the film is in black and white and manifestly representational—in contrast, for example, with holographs, where it is difficult to believe we are not seeing three-dimensional objects even if we know better.

Even so, I think the chief innovation of the moving camera is to make the mode of recording part of the record, which in turn thrusts the art of cinema into the image in a singularly intimate way. This happens

when, for instance, the swinging of the image through an abrupt angle is to be read as a movement not of it but of the camera, as in a mob scene, where the camera is, as it were, "jostled," or when, more archly, the camera literally climbs the stairway with an eye and a lubricity of its own and pokes into one bedroom after another in search of the lovers, as in one of Truffaut's films. In such cases, the movement of the camera is not our movement, and this has precisely the effect of thrusting us outside the action and back into our metaphysical Cartesian hole. When this happens, however, the subject of the film changes; the story is no longer one of young lovers, rather, it is about their being observed and filmed, as though the story itself were but an occasion for filming and the latter is what the film itself is about. Film becomes in a way its own subject; the consciousness that it is film is what the consciousness is of. In this move to self-consciousness cinema marches together with the other arts of the twentieth century in the respect that art itself becomes the ultimate subject of art, a movement of thought which parallels philosophy in the respect that philosophy in the end is what philosophy is about. It is as though the director became jealous of the characters who heretofore had absorbed our artistic attention to the point that we forgot if we had ever thought about art as such, and at his ontological expense. Of course, we have to distinguish a film about the making of a film—which is merely another form of the Hollywood genre of films in which the making of a play is what the film is about—from films whose own making is what they are about. Only the latter, I think, graduates (if that is the term) from art to philosophy: but a price is paid, and a heavy one. When, instead of transforming real objects into artworks or parts of artworks, the transformation itself is what we are aware of, the film becomes a documentary with the special character of documenting the making of an artwork, and it is moot if the film itself will be an artwork in its own right, however absorbing it may be. For the artwork that is being made is not in the end what the film is about when the film is about its own making; indeed, if this were perfectly general, there would be no artworks at all.

Or perhaps the model is wrong. Perhaps films are like consciousness is, as described by Sartre, with two distinct, but inseparable, dimensions: consciousness of something as its intentional object, and a kind of non-thetic consciousness of the consciousness itself—and it is with reference to the latter that the intermittent reminders of the cinematic processes as such are to be appreciated. In that case a film achieves something spectacular, for it does not merely show what it shows, but it shows the fact that the thing shown is shown; it gives us not merely an object but a perception of that object, a world and a way of seeing that world at once, the artist's mode of vision being as importantly in the work as what it is a vision of.

This is a deep subject, one with which I will end this paper: I cannot hope to treat it here. I wonder, nevertheless, of the degree to which we are ever conscious of a vision of the world when the vision is ours. We are aware of the world yet seldom aware, if at all, of the special way in which we are aware of the world. Modes of awareness are themselves transparent to those whose they are. And should they become opaque, then, I think, they no longer *are* ours.

Atget recorded the city of Paris. His photographs are precious for their documentary value, in that they preserve a reality that has achingly dissipated, but they also reveal a way of seeing that reality which, I am certain, Atget was not aware of as a way of seeing. He simply saw, as do we all. What is precious in old films is often not the "gone" artifacts and the dated modes of costume and acting, but the way these are taken for granted. The people who made those films saw their dress not as a "mode of costume" but merely as clothes, and their gestures not as modes of acting but as acting, *tout court*. A way of viewing the world is revealed when it has jelled and thickened into a kind of spiritual artifact, and despite the philosophical reminders our self-conscious cineastes interpose between their stories and their audiences, their vision—perhaps in contrast with their style—will take a certain historical time before it becomes visible. In whatever way we are conscious of consciousness, consciousness is not an object for itself; and when it

becomes an object, we are, as it were, already beyond it and relating to the world in modes of consciousness which are for the moment hopelessly transparent.

NOTES

1. Marcel Proust, *Remembrance of Things Past*, trans. C. K. Scott Moncrieff and Terence Kilmartin (New York: Vintage, 1981), 1:79.

2. Wittgenstein's joke: " . . . as if someone were to buy several copies of the morning paper to assure himself that what it said was true" (*Philosophical Investigations* 1.265).

3. Bertrand Russell, "The Philosophy of Logical Atomism," in *Logic and Knowledge: Essays, 1901–1950*, ed. R. C. Marsh (New York: Macmillan, 1956), 187; Saul Kripke, *Naming and Necessity* (Cambridge: Harvard University Press, 1980), passim.

4. Toward the end of his Second Meditation, Descartes notes the way a piece of wax, left near a fire, changes all of its perceptual properties: its smell, taste, shape, texture, and so forth. Yet it is the identical piece of wax, whatever the changes, and the identity, accordingly, cannot consist in the properties that undergo change. Descartes is struck by the notion of sameness underlying change, which cannot be referred to his experiences. Rather, the experiences refer to it. He concludes by saying that the more he understands how he judges objects, the better he understands himself. "All the reasons which serve to know and to conceive the nature of the piece of wax, or of any other body, more readily and with greater evidence show the nature of my mind" (my translation).

Gettysburg

Then the whole of things might be different
From what it was thought to be in the beginning,
before an angel bandaged the field glasses.

John Ashbery

PITY-AND-TERROR, THE CLASSICALLY prescribed emotional response to tragic representation, was narrowly restricted to drama by the ancient authorities. In my view, tragedy has a wider reference by far, and pity-and-terror is aroused in me by works of art immeasurably less grand than those which unfold the cosmic undoings of Oedipus and Agamemnon, Antigone, Medea, and the women of Troy. The standard Civil War memorial, for example, is artistically banal by almost any criterion, and yet I am subject to pity-and-terror whenever I reflect upon the dense ironies it embodies. I am touched that the same figures appear and reappear in much the same monument from village to village, from commons to green to public square, across the American landscape. The sameness only deepens the conveyed tragedy, for it is evidence that those who subscribed funds for memorials, who ordered their bronze or cast-iron or cement effigies from catalogs or from traveling sales representatives—so that throughout the land one could find the same soldier, carrying the same musket, flanked by the same cannons, and set off by the same floral or patriotic decorations—were blind to the tragedy that is, for me, the

Reprinted from *Grand Street* 7 (spring 1987): 98–116.

most palpable quality of these cenotaphs. That blindness is a component of the tragedy inherent in the terrible juxtaposition of the most deadly armaments and ordnance known up to that time, in what, under those conditions, was the most vulnerably clad soldiery in history.

The Civil War infantryman is portrayed in his smart tunic and foraging cap. Take away the musket, the bayonet, and the cartridge case, and he would be some uniformed functionary—messenger, conductor, bellhop, doorman. This was the uniform he fought in, as we know from countless drawings and photographs that have come down to us from that war. Armed, carrying a knapsack, he moved across the battlefield as though on dress parade. But the weapons he faced were closer in design and cold effectiveness to those standard in the First World War, fifty years in his future, than to those confronted by Napoleon's troops at the Battle of Waterloo, fifty years in his past. What moves me is the contradiction within the code of military conduct, symbolically present in his garments but absent from his gun. We see, instead of the chivalry and romanticism of war as a form of art, the chill implacable indifference to any consideration other than maiming and death, typical of the kind of total combat the Civil War became. That contradiction was invisible when the memorials were raised, and it is its invisibility today that moves me to pity-and-terror.

The rifled musket—one with a helically grooved bore, giving a stabilizing spin to the bullet and making possible a flat trajectory—was known in the eighteenth century, but it was used then primarily for hunting. The smooth-bore musket was military issue. There is an affecting Yankee pragmatism in the fact that the citizen-soldiers of the American Revolution should have used their hunting weapons to such effect against the celebrated "Brown Bess"—a smooth-bore musket with its barrel shortened and browned—that the rifled musket had to be adopted by British and European armies. But the Brown Bess had been Wellington's weapon in Belgium, in the style of warfare conducted on the classical battlefield, with disciplined infantry firing in ranks at short distance: a row of blasts from these muskets, as from deadly popguns,

could be pretty effective in stopping or driving back an opposed line. Even the rifled musket, at that time, used the round ball. The elongated, cylindro-conoidal bullet was invented only afterward, by Captain John Norton, in 1823, and although it has been acclaimed as the greatest military invention since the flintlock, Wellington could not see how it improved on the Brown Bess, as indeed it did not if battle were conducted as Wellington understood it. The elongated bullet with its lowered wind resistance, making its charge much more powerful, was understood by Sir William Napier as profoundly altering the nature of infantry, turning the infantry soldier into a "long-range assassin." Napier intuited that a change in the conduct of battle at *any* point would entail a change at *every* point, given that warfare is, like what Heidegger calls a *Zeugganzes*, a complex of instruments, men, and arms forming a total system that functions *as* a totality. Napier's objection implies the very code that the Civil War uniform embodies, and defines a certain moral boundary, the other side of which is not war so much as slaughter. Rifling, the Norton bullet, and the percussion cap, established as superior to the flintlock by 1839, certainly changed the face of warfare. There was no room in the new complex for the cavalry charge, as had to be learned in the Charge of the Light Brigade in 1854 and relearned in the Civil War. In any case, the standard Civil War issue was the 1861-model Springfield rifle: percussion lock, muzzle loading, .58 caliber, shooting a 480-grain conical minié bullet. It was effective at 1,000 yards, deadly accurate at 300. The smooth-bore was of limited effectiveness at 100 to 120 yards. Civil War soldiers faced the kind of fire that made obsolete the way they were used by generals who had learned about battle at West Point and had studied the Napoleonic paradigms. The guns faithfully depicted in the Civil War memorial statue made the style and gallantry of the men who carried them obsolete. Even the brass button would be a point of vulnerability in battles to come.

The 1903 and 1917 Springfield models were used by American infantry in the First World War. Increased muzzle velocity flattened trajectory; the ammunition clip, easy to change, speeded charging the

magazine. But those rifles were fired over the cusp of trenches, and the steel helmets protected the riflemen's heads. Of course, helmets have existed since ancient times and, in fact, were worn by Prussian and Austrian observers at Gettysburg, though more for ostentation (they were brightly polished) than protection. "The sword carries greater honor than the shield" could be repeated by a military historian in very recent years, since it gives a reason why Robert E. Lee should have achieved greater honor through losing glamorously than his opponent, George Meade, earned through winning stolidly, by fighting a defensive battle. Lee had been mocked as "The King of Spades" when he used entrenchments at Chancellorsville. The steel helmet reduced injuries in the First World War by about 75 percent. The casualties at Gettysburg, for the three days of the battle, totaled about 51,000, of which 7,058 were outright deaths. There were 33,264 wounded. The Roman legions were better protected, and their sanitary conditions were better than those prevailing in the 1860s. A wound in the July heat festered and went gangrenous quickly. The wagon train that carried the Confederate wounded away under driving rains on July 5 was seventeen miles long. Over 10,000 were unaccounted for, and I suppose their bones would still be turned up at Gettysburg had the battlefield not become a military park. In any case, I am uncertain the soldiers would have worn helmets if even they had had them, for they were men who lived and died by an exalted concept of honor. You went to your death like a soldier, head held high under your jaunty cap. "As he passed me he rode gracefully," Longstreet wrote, years after, of Pickett leading his stupendous charge, "with his jaunty cap raked well over on his right ear and his long auburn locks, nicely dressed, hanging almost to his shoulders. He seemed rather a holiday soldier than the general at the head of a column which was about to make one of the grandest, most desperate assaults recorded in the annals of war." Longstreet thought the great charge a terrible mistake. He thought Lee wrong from the start at Gettysburg. Lee was deaf to Longstreet for the same reason that mourners

and patriots across America were blind to the message of their memorials. Longstreet is my hero.

I recently trudged the battle lines at Gettysburg. The scene of that great collision had, according to the architectural historian Vincent Scully, been transformed by the National Park Service into a work of art, and I was curious to see how the locus of agony and glory should have been preserved and transfigured under the glass bell of aesthetic distance into a memorial object. An interest in memorial art and in the moral boundaries of war would have sufficed to move me as a pilgrim to what, since the Gettysburg Address, we have thought of as consecrated ground. But I had also been enough unsettled by a recent remark of Gore Vidal's that had come up in the civil strife between *Commentary* and the *Nation*, in regard to Norman Podhoretz's patriotism, to want to think out for myself whether, as Vidal claimed, the American Civil War is our Trojan War. Podhoretz had pretended to a greater interest in the Wars of the Roses than in the Civil War, and this had greatly exercised Vidal, whose family had participated on both sides and thus had internalized the antagonisms that divided the nation. The Trojan War was not, of course, a civil conflict. A better paradigm might have been the epic wars between the Pandavas and Kauravas, as recounted in the *Mahabharata* and given moral urgency in the *Bhagavad Gita*, where the fact that it was a *civil* war was deemed by the great warrior Arjuna (until he was persuaded otherwise by the god Krishna) a compelling reason not to fight. No one's remembered ancestors participated in the Trojan War when it in fact was *their* Trojan War in the sense Vidal must have intended—when the Homeric poems had emerged out of the mists to define the meaning of life, strife, love, and honor for a whole civilization. The Civil War, if it were to be our Trojan War in that sense, would have to be so even for those whose families were elsewhere and indifferent when it took place. It has not received literary embodiment of the right sort to affect American consciousness as the *Iliad* affected Greek consciousness (or the

Aeneid affected Roman consciousness). And so a further question that directed me was whether the artistic embodiment of a battlefield into a military park might serve to make it our Trojan War in the required way, where one could not pretend an indifference to it because it was not part of the matrix of our minds and our beings.

Like Tewkesbury, where the climactic battle of the Wars of the Roses took place in 1471, the name Gettysburg has an irresistibly comic sound, good for a giggle in music hall or vaudeville. It could, like Podunk, serve as everyone's name for Nowheresville, the boondocks, the sticks. It was one of hundreds of "-burgs" and "-villes" named after forgotten worthies (James Gettys had been given the site by William Penn), indicating, before the place "became terrible" (Bruce Catton's phrase), simply where life went on. Gettysburg in 1863 was the seat of Adams County and a poky grove of academe, with a college and a seminary. But Gettysburg was no Troy: the battle was *at* but not *for* Gettysburg. When Lee withdrew on July 5, its 2,400 inhabitants had more than ten times that number of dead and wounded to deal with, not to mention mounds of shattered horses. The miasma of putrefaction hung over the town until winter. Gettysburg became host to a cemetery large in proportion to its size, though there is a strikingly prophetic Romanesque gatehouse at Evergreen Cemetery, which gave its name to Cemetery Hill and Cemetery Ridge and which seemed waiting to welcome the alien dead: you can see artillery emplacements in front of it in a surviving photograph. You can count the houses in Gettysburg in another photograph of the time, looking east from Seminary Ridge. That the battle was there, between Cemetery Ridge and Seminary Ridge, was an artifact of the war. Gettysburg was not somebody's prize. Longstreet called it "ground of no value." It was a good place for a battle, but that particular battle, which it was clear had to happen someplace soon, could have happened in any number of other burgs or villes. Meade, knowing there was to be a battle, would have preferred Pipes Creek as its site. Lee was heading for Harrisburg, a serious city and the capital of the state, and decided to *accept* battle instead, knowing he would have to do so some-

where, and Gettysburg, by geological accident, was as good a place as any to fight.

In his novel *Lincoln*, Gore Vidal puts Mary Lincoln in the War Room with her husband. She is supposed to have had, according to the novel, a certain military intuition, and Vidal describes her looking at a map, pointing to the many roads leading in and out of Gettysburg, and saying, in effect, My goodness—whoever controls Gettysburg controls everything. Perhaps this in fact is intended to underscore Mary Lincoln's acute frivolity; if it meant, instead, to show how the mind of a general got lodged in the pretty head of the president's wife, it simply shows the limits of Vidal's own military intuition. Gettysburg was not that kind of place. It was not, for example, like Monte Cassino, anchoring a line because it controlled roads up the Italian peninsula, so that when it fell, its defenders were obliged to fall back to the next line of defense. Gettysburg really *was* nowhere, of no importance and no consequence: like Waterloo, it was illuminated by the sheer *Geworfenheit* of war. The essence of war is accident.

This is how it happened to happen there. It was known in Washington in late June that Lee was somewhere in Pennsylvania, but not known where he was exactly. Despite the telegraph and the *New York Times*, there is a sense in which men were as much in the dark regarding one another's whereabouts as they might have been in England in the fifteenth century, fighting the Wars of the Roses. Lee had heard rumors that the Army of the Potomac was somewhere east of him, but he had no clear idea of where. This, too, was a matter of accident. In classical warfare, the cavalry served as the eyes of the army. But Lee's glamorous and vain cavalry leader, Jeb Stuart, was off on a toot of his own, seeking personal glory. He turned up only on the last day of the battle of Gettysburg, trailing some useless trophies. Buford, a Union cavalry general sent out to look for the suspected Confederate troops, more or less bumped into General Pettigrew's brigade marching along the Chambersburg Pike into Gettysburg to requisition shoes. They collided, as it were, in the fog, and each sent word that the enemy was near.

Buford perceived that it was good ground for a battle and sent for reinforcements. Lee perceived that it was a good *moment* for battle and began to concentrate his forces. It happened very fast: the next day was the first day of the engagement, July 1.

Here is Longstreet's description of the site: "Gettysburg lies partly between Seminary Ridge on the West and Cemetery Ridge on the South-east, a distance of about fourteen hundred yards dividing the crests of the two ridges." This is a soldier's description, not the imagined description of a novelist's personage: you can deduce the necessary orders to infantry and artillery from Longstreet's single sentence. The battle seethed and boiled between the two ridges, as if they were its containing walls. The village of Gettysburg had the bad luck to lie partly between the ridges; it had the good luck to lie between them *partly*. There was only one accidental, civilian death: the battle took place, mainly, to the south of the village. The ridges formed two facing natural ramparts, as though two feudal lords had built their walls within catapult distance of each other.

To visualize the terrain, draw a vertical line and label it Seminary Ridge. This is where the Confederate Army formed its line, along the crest. They seized it after a heated battle with Buford's forces, which, despite reinforcements, were driven 1,400 yards east to Cemetery Ridge. Now draw a line parallel and to the right of Seminary Ridge, only curve it to the right at the top, to form a sort of fishhook. This was the shape of the Union line (indeed called "The Fish-hook") on July 2 and 3. Gettysburg itself is a dot between the lines, just about where the hook begins its curve. Where the barb would be is Culp's Hill. Farther back along the shaft is Cemetery Hill. At the eye of the hook is Big Round Top, about four miles from Cemetery Hill. About half its height, and upshaft, is Little Round Top. The four hills served as battle towers. The rampart itself slopes to the west to form what is designated a *glacis* in the vocabulary of fortification. It was a formidable defensive position, but Seminary Ridge too would have been a formidable defensive position. "If we

could only take position here and have them attack us through this open ground!" Lee's chief of artillery, Porter Alexander, recalled having thought. "We were in no such luck—the boot, in fact, being upon the other foot." A defensive war, though, was not what had brought Lee north and onto enemy territory. He had to attack if there was to be battle.

Longstreet did not think there needed to be battle. Standing beside Lee, he surveyed the Union position with his field glasses for a very long time, then turned to Lee and said:

> If we could have chosen a point to meet our plans of operation, I do not think we could have found a better one than that upon which they are now concentrating. All we have to do is throw our army around by their left, and we shall interpose between the Federal Army and Washington. We can get a strong position and wait, and if they fail to attack us we shall have everything in condition to move back tomorrow night in the direction of Washington.

"No," said General Lee—the words are famous and fateful—"the enemy is there and I am going to attack him there."

Perhaps Longstreet was wrong: Meade was as cautious a man as he. Why need Meade have attacked them, even though he stood between Washington and its army? Lee's supply line was long and vulnerable, and Meade might have ringed any position he would take and wait out a siege. Still, wars are fought not so much by generals as by governments, and Longstreet knew that Washington would pressure Meade to attack, needing a victory and in fear for the city itself. And Lee was probably right: if he could crush Meade's army here, where it was, he would have free access to Washington or Baltimore or Philadelphia. He needed, or thought he needed, a *brilliant* victory. He had invaded the North not for conquest but to astonish. And he could sustain a defeat as Meade could not. If Meade were defeated, pressure to negotiate would be exerted on Lincoln by the Peace Party in the Union. There might be foreign

recognition. And morale was at the time disastrously lowered, since the Union had just undergone a series of brutal defeats. Lee might, on the symbolic date of July Fourth, achieve independence for the South. Whereas if he lost, well, he could have swaggered back to his own territory, as after a dashing raid, trailing glory. Besides, rounding the Federal left would have baffled his troops, who had driven the enemy back to that position. Morale is a precious factor, a form of power. Lee would have to *smash* the Union left. He would have to take Little Round Top, as he nearly succeeded in doing on the second day of battle.

A battlefield has something of the metaphysical complexity of a work of art: it stands to the terrain on which it is spread as a work of art stands to the physical object to which it belongs. Not every part of the physical object is really a part of the work of art—we do not take the weave of canvas into consideration in identifying the meaning of a picture, for example; there is no coherent way in which we can read the roughness of surfaces into, say, the iconographic program of Tintoretto's Scuola di San Rocco. We rarely consider the fact that a surface is dry when interpreting a painting. Richard Wollheim, in his recent Mellon Lectures, borrowed from phenomenology the useful term *thematization*, and would use it to say that not every part or property of the physical object is "thematized" by the work. Doubtless the concept can be taken further—I am seeking, for instance, to thematize the contradiction, which most would not even see as there, in Civil War memorial statuary. But what I want to say here is that battle thematizes certain features of the terrain, transforming them into what soldiers call "ground." At Gettysburg, the flanking hills of the Federal line were thematized in this sense on the second day of battle; Cemetery Hill and the sweep of field and meadow between the ridges were thematized on the third and last day. It is doubtful the two ridges would have been so thematized in an imagined encounter between Napoleon and Wellington: their artillery would not have reached far enough, and besides, the explosive shell had not been invented in 1815. (Its invention meant the end of the wooden

battleship.) What would be the point of lobbing cannon balls across the fields? One follows the structure of battle by grasping successive thematizations. War is a deadly artist. A battlefield is already more than halfway to a work of art.

On July 2, Lee strove to take either or both Culp's Hill and Little Round Top. Meade's defensive line along Cemetery Ridge would have been untenable had Lee succeeded: he would have had to draw back to Pipes Creek, and it would have been a defeat. The fighting that afternoon was fierce but uncoordinated—each commander had difficulties with his generals—and the outcome of the engagement was sufficiently ambiguous that Lee could interpret it as a victory. Still, no thanks to General Daniel Sickles, the tempestuous Federal general who had left Little Round Top undefended, both the contested hills remained, it may have seemed precariously, in Union hands. Had Meade's engineering chief, Gouverneur Warren, not happened to see that no one was holding the crest at Little Round Top and on his own authority diverted troops to its defense in the very nick of time, the outcome of that day's fighting would have been different.

It is worth contemplating Little Round Top from the perspective of weaponry. Little Round Top was called "the Rocky Hill" by the Confederates. (Armies improvise a nomenclature with their thematizations.) Its slopes are strewn with heavy boulders of the kind that, piled up, gave the name "Devil's Den" to an adjacent site. It is full of ad hoc shelters and one-man fortresses, and offers an object lesson in the military imagination. It cried out for a kind of weapon—the grenade—that was to be indispensable to infantry in the world wars but that was considered extinct at the time of the Civil War because of the increase in range and accuracy of muzzled arms. Grenades had been intensely employed in seventeenth-century tactics (when a grenadier was a special physical type, like a shot-putter). It came into its own again in the Russo-Japanese war. The field mortar, with its high trajectory, would also have done wonders at Devil's Den, with its freestone breastworks and God-given sniper nests. Civil War battle seems to have been imagined as

something that takes place on a field, between massed armies. The grenade and mortar, conceived of as suited to storming fortresses, were inscrutable in 1863, even though all the technology was in place for the manufacture of the lightweight grenades that reentered the armory half a century later. The weaponry determined the order of thematization; particularly the field between the ridges on which Pickett's charge was to take place on July 3 was something generals understood, or thought they understood. Longstreet knew they did not.

On July 3, Lee had determined to attack Meade's center. This was his reasoning: Meade, he believed, would infer that Lee was seeking to turn his flanks and would renew the attack on the anchoring hills. So Meade would move reinforcements to right and left, leaving the center weak. Meade's reasoning, however, was this: Lee would reason as he in fact reasoned, so the right thing was to reinforce the center. In classical warfare there is a kind of language: armies communicate through guns (as in this century the United States and the Soviet Union communicated through nuclear testing); a cannonade announces a charge. All that morning the Federal officers and men watched the enemy concentrate its artillery— 150 guns focused on the Union center. It was "a magnificent sight," according to Henry Hunt, chief of artillery on the Union side. "Never before had such a sight been witnessed on this continent, and rarely, if ever, abroad." The Union employed about 200 pieces in that battle, and a duel opened up at about 1 P.M. that lasted nearly two hours. Nothing on that scale had ever taken place before. But the state of explosive chemistry in the mid–nineteenth century raised severe cognitive problems for the Confederate force. What was used then was black gun powder, which created dense smoke. The exploding shells cast a smoke screen over Cemetery Ridge, concealing from Confederate artillery chief Porter Alexander that he was shooting too high and that his shells were falling behind the Union line. By accident, he hit a dozen caissons of ammunition to Meade's rear. Union major General Hunt decided to conserve ammunition for the attack to come and ordered fire to cease. Alexander took this as a sign that he had silenced the Federal guns and

signaled Pickett to move forward. Smoke still hung blackly over Cemetery Ridge, but at a certain moment-of-no-return a breeze lifted it and Pickett's men saw, in Allan Nevins's words, "the full panoply of Union strength in its terrifying grandeur, a double line of infantry in front, guns frowning beside them, and reserves in thick platoons further back." Until that moment, none of Lee's officers had any real idea of what power had been building up behind the sullen ridge. Had his cavalry been operative, Lee would not have charged. He was fighting blind.

It was in Pickett's grand charge up the slopes of Cemetery Ridge that the tragic contradiction between arms and uniform became palpable. Pickett's superb veterans, fresh in this battle, marched according to a magnificent code into a wall of fire. It was the brutal end to an era of warfare, the last massed charge. The triumph of slaughter over chivalry gave rise to Sherman's horrifying march through Georgia and South Carolina, to total war, to the firebombing of Dresden, to Hiroshima and Nagasaki, to the rolled grenade in the full jetliner. "It was the most beautiful thing I ever saw," exclaimed Colonel Fremantle, a British observer at Longstreet's side. The sentiment was widely shared. Pickett's charge was what war was all about in that era, it had the kind of beauty that made Lee remark, at the Battle of Fredericksburg: "It is well that war is so terrible—we should grow too fond of it." Longstreet wrote: "That day at Gettysburg was one of the saddest in my life." I think he was more or less alone in this feeling. I do not think Gettysburg was perceived as the awful defeat it was by the South, at least not then, since news of Grant's victory at Vicksburg had not yet come, nor do I think it was received as a great victory, least of all in Washington, or by Lincoln, who cared only that Meade should press his advantage. What no one could see, just because the doors of the future always are closed, was that beauty on that occasion was only the beginning of terror.

The bodies were rolled into shallow trenches, and the armies moved off to other encounters. Some 3,500 Union dead are today neatly buried in concentric arcs alongside Evergreen Cemetery. Seventeen acres were set

aside for this, weeks after the battle, and it was here, before the land-
scaping was altogether completed, that Lincoln delivered the address
that is so enshrined in the national consciousness today that it requires
an effort of severe deconstruction to perceive it as a cry of victory as
gloating as anything that issued from the coarse throat of Ajax. The
Gettysburg Battlefield Memorial Association was chartered in 1864 and
began acquiring land, which was absorbed into the National Military
Park established, without debate so far as I can discover, by an act of
Congress in 1895. In 1933 it came under the jurisdiction of the Na-
tional Park Service, which transformed it in an unforgiving way. There
is at Gettysburg a historical preservation I applaud but a political over-
lay that distresses me.

It is always moving to visit a battlefield when the traces of war itself
have been erased by nature or transfigured by art, and to stand amid
memorial weapons, which grow inevitably quaint and ornamental with
the evolution of armamentary technology, mellowing under patinas and
used, now, to punctuate the fading thematizations of strife. The first can-
non to be fired at the Battle of Gettysburg stands by the memorial to Bu-
ford near MacPherson's Farm, like a capital letter to mark the begin-
ning of a ferocious sentence. Four cannons form Cushing's battery stand,
like four exclamation points, to mark the battle's end at the point where
Pickett's men penetrated the Union line only to be surrounded. Gen-
eral Francis Walker uses a Homeric metaphor to describe Pickett's charge:

> As the spear of Menelaus pierced the shield of his antagonist, cut
> through the shining breastplate, but spared the life, so the division
> of Pickett, launched from Seminary Ridge, broke through the Union
> defense, and for the moment thrust its head of column within our
> lines, threatening destruction to the Army of the Potomac.

When I was a soldier I was often struck, as by a paradox, that at the
very moment that artillery was pounding somewhere, somewhere else
men and women in soft clothing were clinking glasses and carrying on

flirtations; and that before and after this moment, but in this place, the peaceful pursuit of human purposes would go innocently forward, that families would picnic where men were being killed. And I was overwhelmed after the war by the thick peace that had settled back over places I had seen sharded: Salerno, Velletri, Cassino, Anzio. There is that sense today at Gettysburg, as tourists consult their maps and point across to not very distant hills and ridges or listen to patient guides rehearse the drama of those three days in July 1863. The statue of General Lee, on his elegant horse, Traveller, stands just where Lee himself stood, and faces, across the open field traversed by Pickett's division, to where an appropriately less flamboyant effigy of Meade looks west from Cemetery Ridge. The copse of trees that Lee had singled out as the point to head for still stands not far from Meade's statue, segregated by an iron fence, as if a sacred grove. Ranks of cannons point across, from ridge to ridge, and the sites are strewn with touching, simple monuments, placed by the units that were there so that it would always be remembered that they were there. The most florid monument celebrates the Pennsylvania presence (there are 537 Pennsylvanians buried in the National Cemetery, and 867 New Yorkers—the largest representation by state there). An art history of Gettysburg remains to be written, but the meaning that comes through, even without it, is that a momentous collision occurred here, and that it was connected with the high and generous feelings that are appropriate, after a battle, between those who fought it.

The Park Service pamphlet of 1950 recommends an itinerary with fourteen stops (it maps onto the Stations of the Cross, if you have an appetite for numerical correspondences). It is chronological. You begin where the battle began, at MacPherson's Ridge at 8 A.M. on July 1. You now follow a trail south along Seminary Ridge, and you may pause in front of Lee's statue and recite the thought Faulkner insisted was in the breast of every Southern boy: it is, there, eternally "still not yet two o'clock on that July afternoon in 1863." Edging the Peach Orchard, where Sickles formed a reckless salient and lost a leg, you mount

Round Top and head north to the Copse of Trees and Meade's head-quarters. You pause at the cemetery and end, not quite appropriately, at Culp's Hill. In 1950, as today, you would leave 1863 from time to time and enter the present, for the acreage of the Battle Park is intersected, here and there, with fragments of mere unthematized Pennsylvania, along whose roads tractors and trucks drive past restaurants and service stations on one or another civilian errand. The almost cubist interpenetration of past and present, war and peace, is semiotically moving in its own right.

The itinerary of 1950 was dropped from revised editions of the pamphlet, in 1954 and 1962, and today the visit has a different structure. Today you enter the park, amid many monuments, along "High-Water Mark Trail." There are no Confederate markers among the celebratory monuments; instead, there is "High-Water Mark Monument," erected by "us" to show how far "they" reached. It was not really a high-water mark: there was no flood. This was not Genghis Khan, but one of the gentlest occupations the world has ever seen. It was, exactly as General Walker put it, a spear point that penetrated but did not slay: a Homeric poet would have supposed a god or goddess deflected the weapon. Lee was the spearman—Menelaus, if the analogy appeals (except Menelaus triumphed). If we construe the military park as a monumentary text, it now reads *not* as the history of a great battle between heroic adversaries, but as the victory of the Union. The text begins where the victory was won. As a text, the park is now a translation into historical landscape of the Gettysburg Address. Small wonder it "fell like a wet blanket," as Lincoln afterward said. Small wonder the *Harrisburg Patriot* editorialized the president's "silly remarks" this way: "For the credit of the Nation we are willing that the veil of oblivion shall be dropped and that they shall be no more repeated or thought of." Half the men who fell there did not fight for what Lincoln said was achieved there, and of those who might have, Lincoln's were not in every case the reasons they were there. The address was an inappropriate political speech on an occasion that called

for generosity, vaunting and confessional. The language is concealingly beautiful, evidence that Auden is after all right that time worships language "and forgives / Everyone by whom it lives."

I can understand, or might be able to understand, how a literary scholar, though patriotic, might find the Wars of the Roses of greater interest than the American Civil War, even if he should have no special concern with the ambitions of Lancaster and York. Henry VI, after all, the subject of an early tragedy of Shakespeare, founded Kings College, Cambridge. But the main reason, I should think, for being interested in the civil wars of fifteenth-century England is connected with one main reason for being interested in our Civil War. The Wars of the Roses were of an unparalleled brutality and were fought by mercenaries. It was total warfare, and the sickening experience of having one's land run over by one's countrymen but acting like brigands and in the royal pay lingered for centuries in British consciousness. Henry VI also founded Eton, on whose playing fields the British Empire is said to have been won by practices governed by the rules of fair combat and respect for the opponent. The unspeakable conduct of battle on the Continent (think of the Thirty Years War) until the eighteenth century, when anglicization began to define the moral outlines of military conduct, must have confirmed the legacy of the Wars of the Roses in the English mind.

My sense is that the high-minded perception of the soldierly vocation is embodied in the uniform, the insignia, the flags, and the vulnerability of the militia depicted in sculpture of the Civil War. The other form of war is embodied in the weapons. If there is a high-water mark in the history of modern war, it was in Pickett's gallant and doomed assault. It has been growing darker and darker ever since. I am not certain this is a basis for seeing the Civil War as "our" Trojan War. In a sense, something cannot be a Trojan War if it is *ours:* the Trojan War speaks to what is universal and human, regardless of political division and national culture. I

am not certain that the idea of union has any more meaning than—or as much meaning as—Helen of Troy as justification for pitched combat. If the Civil War is to address humanity as the Trojan War does, it must itself be addressed at a different level than any that has so far been reached. Gettysburg is a good place to begin.

Art and Taxpayers

THE CORCORAN GALLERY'S PREEMPTIVE DECISION in June to cancel a planned exhibition of Robert Mapplethorpe's photographs in order to forestall congressional indignation at their content brought far greater notoriety to the now-famous images than showing them would have. Many of the same photographs of men who engage in the sexual domination of other willing men were presented at the Whitney Museum in New York City last year to no greater stir than some isolated tongue-clucking and wonderment as to what the museum thought it was doing. Indeed, *The Nation* was nearly alone in drawing attention to the homoerotic content of those explicit images in a show whose works conveyed a homoerotic sensibility whatever the subject, even when flowers or faces.[1] The issue that had to be raised was how to respond to such charged representations in works of the highest photographic beauty. Mapplethorpe was still alive, although his sickness with AIDS was common knowledge in the artworld, and that gave a certain solemn urgency to the showing of those sexually unsettling pictures. It was Mapplethorpe's wish that they be shown, as if he regarded them as an artistic testament.

From *The Nation*, August 21–28, 1989. Reprinted by permission.

The position of many neoconservatives is that this is not the kind of art taxpayers want to support. Hilton Kramer advanced this view in the *New York Times* on July 2, 1989. And this became the position of the United States Senate—as a result of the July 26 passage of Jesse Helms's amendment banning federal support for "obscene or indecent" art. But the issue could not be more obscurely framed. It is imperative to distinguish taxpayers from individuals who pay taxes, as we distinguish the uniform from the individual who wears it. As individuals, we have divergent aesthetic preferences. Kramer, for one, has little interest in supporting art that others find of great interest. But aesthetic preference does not enter into the concept of the taxpayer, which is a civic category. What does enter into it is freedom. It is very much in the interest of every taxpayer that freedom be supported, even—or especially—in its most extreme expressions. However divided individuals are on matters of taste, freedom is in the interest of every citizen. The taxpayer, as a taxpayer, does not support one form of art and withhold support from another, except in the special case of public art. The taxpayer supports the freedom to make and show art, even when it is art of a kind that this or that *individual* finds repugnant.

Mapplethorpe did not make these photographs to test his freedom. They are disturbing images for many, exciting images for some, but were not intended to strike a blow for artistic liberty (though perhaps for sexual liberty). They very much belong to an intersection of the artworld and a certain erotic underground, and they have never been easy to view. The Whitney, however, demonstrated that they could be shown to a wide audience without inducing riots.

Although there may never come a time when one can look at their subjects as commonplace, like female nudes or landscapes or still lifes, these works contrast completely with the now also notorious photograph by Andres Serrano of a plastic Jesus in a pool of pee. They contrast as well with the recent gesture, by a senior at the School of the Art Institute of Chicago, of laying a U.S. flag on the floor in a student exhibition so that visitors found it necessary to walk on it. Both works were

intended to offend, and did offend. People responded indignantly and directly, by confrontations, demonstrations, protest. It would have been absurd to argue that they ought not to have done this on the ground that the objects were art. Art has the privileges of freedom only because it is a form of expression. And to be seriously interested in making an expression is to be seriously prepared to endure the consequences of making it. It is also not an offense to counter outrage with outrage. On the contrary, it is taking art seriously to do so. One cannot distance the flag and think of it simply as an arresting composition of stars and bars, any more than one can distance one of the powerful religious symbols of the West and view a derogatory photograph of it merely as a formal composition.

It is healthy for art to vacate the position of pure aestheticism in which conservative critics seek to imprison it, and to try to affect the way viewers respond to the most meaningful matters of their lives. It is healthy for the museum to play a role in the life of its time rather than to stand outside as a cloister for aesthetic delectations. Art has been primarily aesthetic only throughout a very brief interval of its history of political, moral, and religious engagement. As taxpayers our interest is solely in everyone's freedom to participate in the thought of the age.

Whatever grave reservations regarding Congress may have motivated the directors of the Corcoran, they weakened the entire social fabric by yielding their freedom. Their decision should have been to show the work, whose merit they must have believed in to have scheduled the exhibition. Since then individual members of Congress have revealed themselves as enemies of freedom by letting their aesthetic attitudes corrupt their political integrity as custodians of the deepest values of a democratic society.

NOTE

1. Danto, "Art," *The Nation*, September 26, 1988.

Art and the Discourse of Nations

NOW THAT THE CENTRAL DISPUTE concerning the National Endowment for the Arts has passed from the issue of moral sensibilities of the taxpayer and the artistic rights of free expression and how these are to be reconciled, to the issue of whether there is any justification for the artistically indifferent taxpayer to sustain what those hostile to the arts do not hesitate to stigmatize as an elitist preoccupation, those of us who favor the continued existence of the endowment have had to cast about for arguments to show how central to the political health of the nation art is, however attenuated the interest in art of the average taxpayer may be. For example, I was struck by the almost universal excitement aroused by the newly discovered cave paintings in the Ardèche a few months ago, said to have been painted twenty thousand years ago. Whether neolithic culture had a concept of art, the production of these vital images of charging animals had to have had a profound meaning for that society as a whole. It clearly could not have been an elitist distraction to paint and to appreciate these images, and since artmaking, however conceptualized, seemed to spring spontaneously from human beings whose genetic endowment was in every respect the same as our own, it must lie very close to whatever is distinctively human, as much so as our power of language. There are more than two hundred known

caves with paintings in them, representing something like an Ice Age high culture, and it is at least thinkable that many of these were independent of the others, so that the same impulses arose spontaneously wherever there were people. It is similarly thinkable that images were affixed to surfaces which did not have the lasting power of the cave walls—to bark, skin, bone. Anything that inherent in the human essence grounds a right, indeed a human entitlement, as compelling as the other rights a government exists to guarantee—health, education, security—and hence, it seems to me, an internal connection between this remarkable trait of human nature and a governmental responsiveness may be asserted, which has nothing to do with the division of society into elites and non-elites. To be human is to have a natural, indeed an inalienable interest in art, whether or not one does anything about it—just as people have a right to healthy lives even if as individuals they neglect their physical well-being in innumerable ways.

I have very little expectation that this argument, which I developed as an editorial for *The Nation*, is going to elicit a reprieve from the budget-cutters who foresee an easy lop in the National Endowment for the Arts, but possibly it may temper the rhetoric with which they seek to score points with a supposedly unaffected electorate—the very people, in fact, who were charmed and amazed by the Ardèche bears and horses. Beyond that, the need to seek arguments which connect the existence of art with practices that imply certain very deep human beliefs and attitudes is one of the indirect benefits of what on the surface seems to be a conflict in the responsibilities of government. I think, even for those of us close to art, who produce and write about art, who take for granted the institutions within which producing and writing about art are enabled, it is rare that we rise to a level of reflective self-consciousness on the nature of what we are doing. And having to defend ourselves from charges of social irrelevance forces us to think a little more deeply than we otherwise might. So let me draw attention to a couple of seemingly marginal matters that might help us think of what art means in the larger political life of the world's states.

About a year ago, there was a message on my voice-mail at Columbia from someone in Johannesburg, asking me to write a catalog essay for the First Johannesburg Biennale, to be held February 1995, details to follow. As it happens, the Venice Biennale is a hundred years old this year, and I enjoyed the idea that having written an essay for the oldest of the biennales in 1993, I might write one for the newest, so of course I accepted. The exhibition in Venice for which my essay was written was called *Punti Cardinale dell'Arte*—the cardinal points of art—and it was a kind of compass of world art, featuring major artists, sixteen in all, from sixteen cardinal points of the world of art. Johannesburg was not on that map in 1993, largely, I suppose, because, in the view of the show's organizer, there was not an artist there of the magnitude of those included in this exhibition, but 1993 was the first year South Africa was represented in the great exhibition since apartheid was first established as a national policy. Coming almost immediately on the heels of the elections that brought Nelson Mandela to the presidency, the Johannesburg Biennale was a declaration on the part of the responsible agencies that South Africa belonged once again to the world in which artists could be invited to show their work and critics invited to write catalog essays, that a country despised for its politics had claimed standing in the commonwealth of civilized powers, and this claim was accepted in people's acceptance of the invitations. Moreover, it all at once came home to me that the art exhibition had taken on the meaning of a language of recognition and reconciliation. When the German nation put on the exhibition Documenta in Kassel in the late 1940s, it demonstrated that it wished to acknowledge its readiness to participate once again in civilized discourse. And in people's participation in that exhibition, the gesture itself was acknowledged. After World War II, Austria and Japan sent exhibitions of reconciliation to America as a sign that hostilities were over. When detente set in in the 1980s, there was no better sign of this reconciliation than the exchange of exhibitions of impressionist and postimpressionist paintings between the then Soviet Union and the United States.

I think this is the bright side of something found deep in ancient human practices; namely, that victors declare their power by taking the art of the defeated as trophies, which is a kind of cultural rape. To rob a society of its art is symbolically equivalent to violating its women, a way of destroying its seed and humiliating it totally. Agamemnon took the gold of Priam from Troy to Mycenae; in turn this booty was, in the last war, carried off by Russians from the defeated Germans. The Germans under Hitler and Goering did the same, as did Napoleon, to whose wholesale confiscation of art we owe the museums of Europe: as temples for the display of artistic trophies from defeated nations—or, in the case of the Altes Museum in Prussia, as a temple for art treasures reclaimed. It is possible to argue that by *not*, at least not officially, engaging in that practice, the United States has behaved consistently with the senatorial rhetoric that art is so much frill. But the entire testimony of international practice, on both its dark and bright sides—on the side of humiliation by taking an enemy's treasures, and on the side of establishing exchanges of treasures in the confidence that they will not be taken hostage—stands opposed to this pretended indifference. Art is a language in which nations convey so much to one another that one has to ask how they would do this if art did not exist. Then too the question arises of what it is in the nature of art that enables it to play this extraordinary symbolic function.

My sense is that to answer this question we must go back to the caves of Lascaux and the Ardèche. While I would not expect this exploration to sway minds on the future of the endowment, I would argue that something as deeply embedded in the meaning of victory, defeat, recognition, and acknowledgment as art is cannot seriously be stigmatized as of concern only to elites. The Swedish troops who bore off the prizes of Prince Rudolph's collection in Prague and the Aztec king who sent examples of the art of his culture to Charles V—a king he had never heard of in a country he would not have known about had his own land not been invaded—understood the meaning of art. As did the Parisian populace that crowded into the galleries of the Louvre to see the art that had

become theirs by overthrowing the king whose power was defined through that art. As do the artists from the compass points of the world of art who converged on Johannesburg as a symbolic handshake of moral acceptance.

I want to conclude with an observation based on a contrast between the art of the First Johannesburg Biennale and the trophaeal art that almost concurrently went on display at the Hermitage Museum in Saint Petersburg—art the Russian troops had taken away from a Germany defeated as an emblem of that defeat. These belong respectively to the bright and the dark side of art as moral currency, a distinction unaffected, a distinction perhaps even underscored, by the fact that none of the art sent to Johannesburg was in the nature of treasures that might in some future war be candidates for trophies. The most interesting art of our time is nothing it would occur to anyone to steal, and I think it a matter of tremendous significance that art and what I might call tresoriousness have gone in different directions. Moctezuma felt that only gold was a suitable medium to convey the advancement of his culture, as did King Priam. Media today can be videotape, plywood, newspaper, discarded garments, industrial paint, shattered glass, or bodily gestures. The magic is unaffected by the detresorification of art, and the mystery of its acknowledged significance remains. In some respect too hidden for me to say anything further about it, it is connected with what it means to be human, and I salute you new graduates of the School of Visual Arts for your dedication to this profoundly human calling. It has been a privilege to be your speaker as you cross the line into a practice whose meaning is as momentous as its absence would be unthinkable in the lives of peoples and nations. I know of no philosophical theory of art that explains its evident importance, and I leave this as a problem to ponder as well as a pennant to flourish when you are challenged to defend your choice of lives.

Index

Absolute Spirit: art, philosophy, and religion as moments of, 10, 63, 186
abstract expressionism, 16, 28, 62, 74, 78–80, 164 (*see also individual artists*); and Jewish Museum, 127; surrealism's effect on, 20, 24; as target of pop art, 75–77, 78–79
academic chair, 144–49
action, causation of, 29, 38n. 31
Adams, Ansel, 66
Aeneid (Virgil), 238
aesthetics, 6, 124, 135, 139, 207; and freedom of expression, 251–53; Kantian, 125–27, 129, 133–34
After the End of Art: Contemporary Art and the Pale of History (Danto), 8–9
Age of Bronze (Rodin), 174
Alexander, Porter, 241, 244
Alpers, Svetlana, 119
Altamira Elegy (Motherwell), 33–34
Altes Museum, Prussia, 257
Amaravati, Buddhist stupa of, 151–56
analytic philosophy, 87–88
Anaximander, 193
Andy Warhol Museum, 11
Angelico, Fra, 107, 113
Antin, Eleanor, 141

Antonioni, Michelangelo, 224
apples, connotation of in painting, 115
archai, in Kahn's philosophy of architecture, 190, 193–203
archetypes. *See* form/Form(s)
Architectural League of New York, Chair Fair, 145
architecture, 229; and Chicago Armory exhibition, 141; Giotto's use of, 117–18; of Louis Kahn, 10, 185–204; of museums in the 1960s, 135; of national galleries, 132–33; Roman, 195–96; of Warburg mansion and additions to Jewish Museum, 142–43
Arch of Trajan, 195
Ardèche, cave paintings in, 254–55, 257
area, distinguished from space by Kahn, 187–88
Arena Chapel (Padua), 115
Arensberg group, 73
Ariadne auf Naxos (Strauss), 222–23
Aristotle, 156, 193, 208
Armory Show (New York, 1913), 141
Arnheim, Rudolf, 36n. 8
art: and Breton's concept of automatism, 19–20; the chair as work of, 154–57, 162–63; the chair in works

Compositor:	BookMasters, Inc.
Text:	10/15 Janson
Display:	Gill Sans
Printer:	Data Reproductions Corp.
Binder:	Data Reproductions Corp.